Bali
Modern
The Art of Tropical Living

Bali
Modern
The Art of Tropical Living

photography by Luca Invernizzi Tettoni
text by Gianni Francione

PERIPLUS

Published by Periplus Editions (HK) Ltd
Copyright © 2002 Periplus Editions (HK) Ltd

ISBN 962-593-466-9

Distributed by:

North America
Tuttle Publishing
Distribution Center
Airport Industrial Park
364 Innovation Drive
North Clarendon
VT 05759-9436
Tel (802) 773 8930
Fax (802) 773 6993

Japan & Korea
Tuttle Publishing
RK Building, 2nd Floor
2-13-10 Shimo-Meguro
Meguro-Ku
Tokyo, 153 0064
Tel (03) 5437 0171
Fax (03) 5437 0755

Asia Pacific
Berkeley Books Pte Ltd
130 Joo Seng Road
#06-01, Olivine Building
Singapore 368357
Tel (65) 280 1330
Fax (65) 280 6290

Indonesia
PT Java Books Indonesia
Jl Kelapa Gading Kirana
Blok A14 No 17
Jakarta 14240
Tel (021) 451 5351
Fax (021) 453 4987

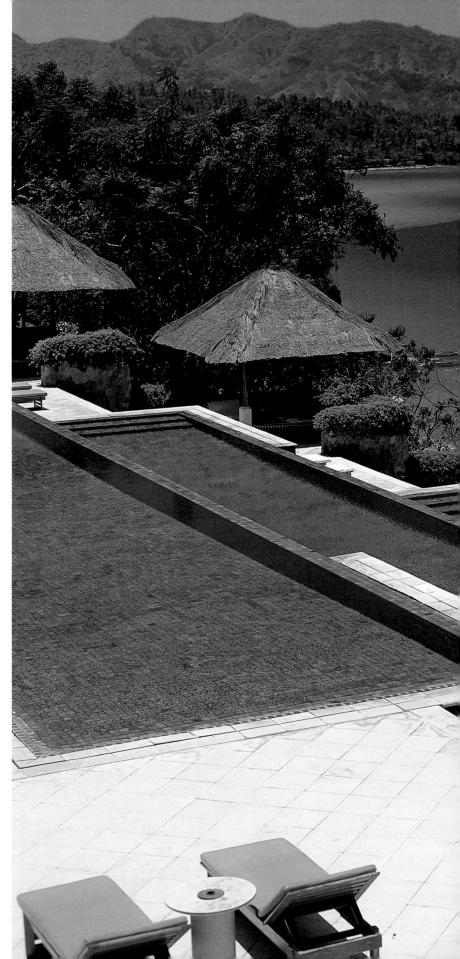

Endpages and page 1: Stone wall and woodcarving realized by
Made Jojol of Gianyar-Sukawati in the lobby of The Legian.
Previous page: Bright doors in primary colours at Waterbom,
a water park in the heart of Kuta.
Right: Designed by the architect Ed Tuttle, this majestic, open-
to-the ocean pool at Amankila resort is characterized by total
symmetry accompanied by a scrupulous attention to detail.
Overleaf: Tropical relaxation on the deck of a pool with a
view; set amongst trees overlooking the Ayung river valley,
it was designed by the architect Cheong Yew Kuan.

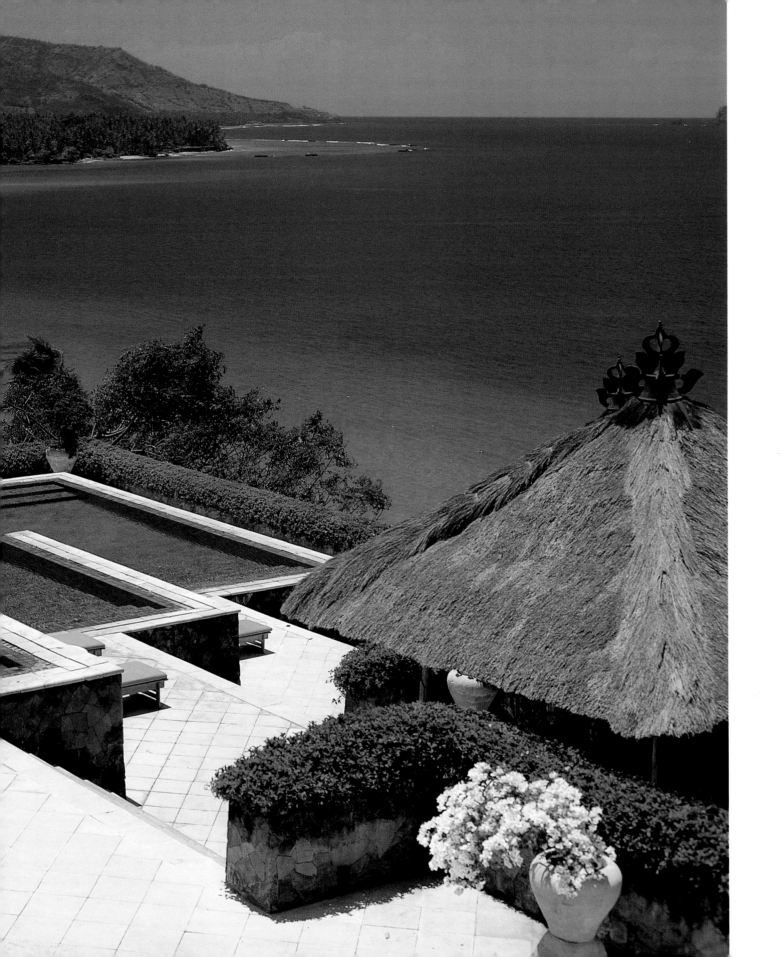

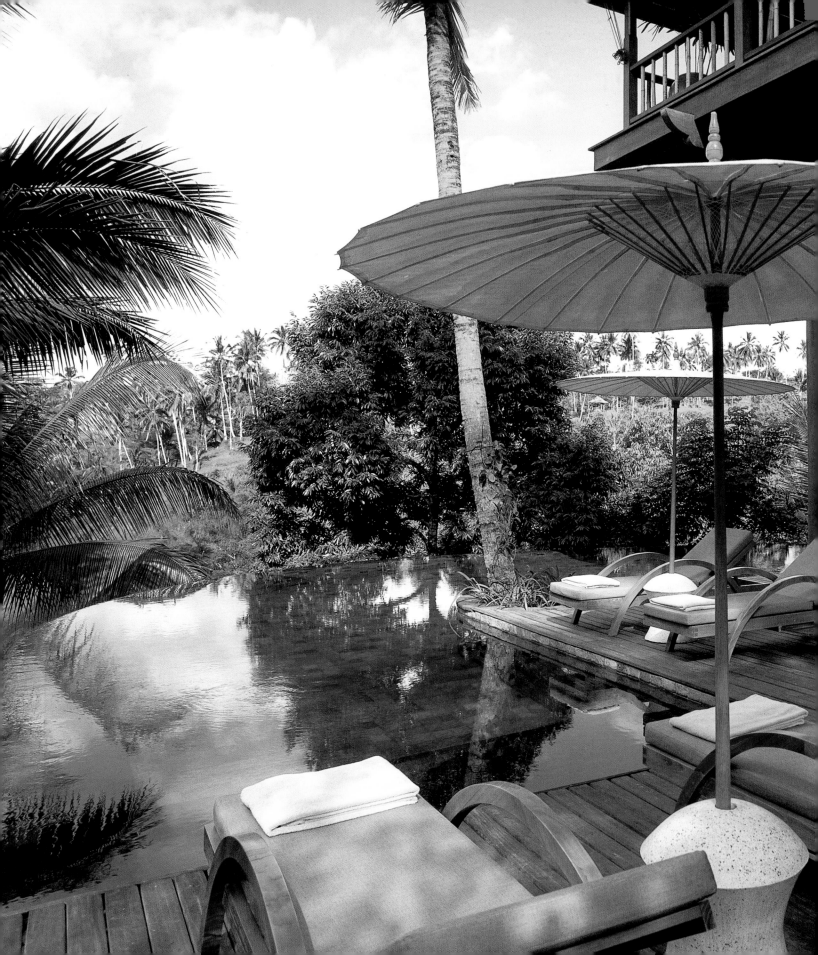

Contents

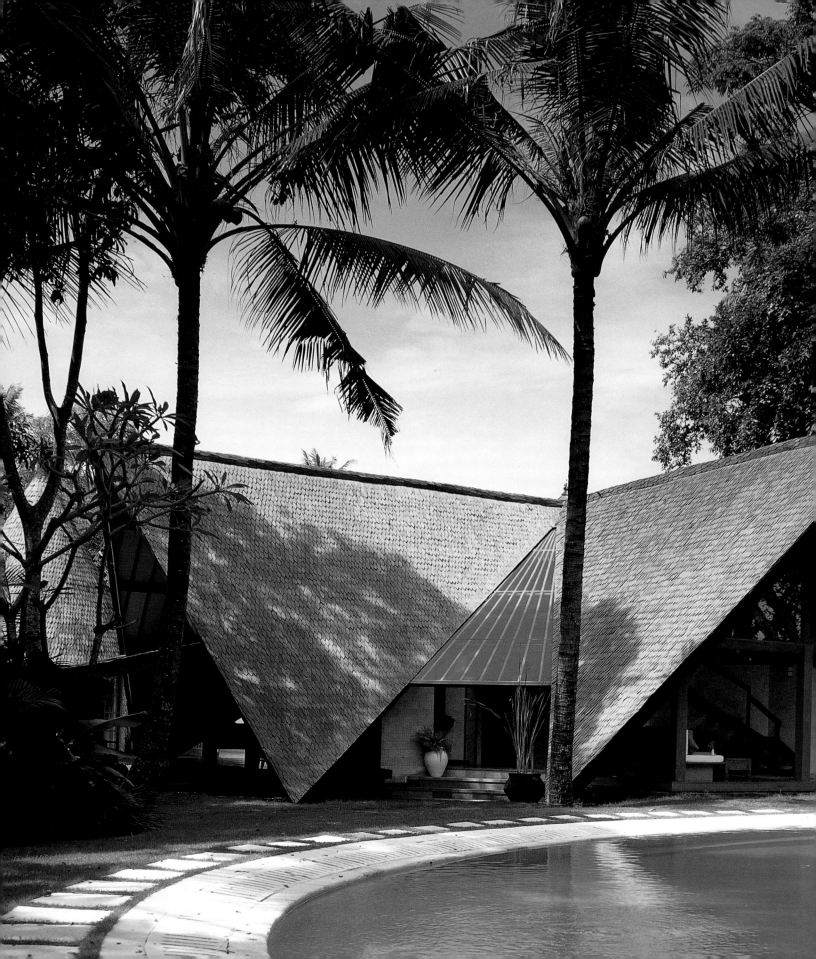

The New
Bali Style

A Fresh Approach

The "Bali style" of architecture and interior design is renowned and increasingly popular the world over. How it came into being is a story of cross-cultural legacy and an amalgamation of different design elements. In this chapter, we explain the connection between religion and architecture in traditional Balinese design, trace the development of new styles in both commercial and residential buildings and see how a thoroughly modern, international architectural form has been born.

Bali – one of the smaller of the islands that comprise the Indonesian archipelago – has long been a magnet for foreigners. Just eight degrees south of the equator, it offers a landscape of great contrasts: beautifully modulated rice terraces, majestic mountains, fiery volcanoes, serene lakes, coastal lowlands and limestone fringes. This landscape – along with the unique culture of its inhabitants – has attracted artists, travellers, anthropologists, or simply the curious, who have flocked to the fabled isle in ever-increasing numbers.

In their desire to settle and forge a new life, many have sought to replicate the comforts of home but reinterpret these in a "Balinese" way. They have built – or had built – tropical dream homes that take elements from their own heritages and combine these with Asian influences and styles. The result has been a plethora of residences in many different designs, but all loosely gathered under the umbrella term of "Bali-style". To accompany the architecture

has come the interior design: a type of indoor-outdoor living style that has its roots in the climate of the tropics, but its application in Western traditions of comfortable furniture and furnishings.

To understand how this has happened, one needs to look back in history. Separated from its neighbour Java only by a narrow strait less than two miles across, many of Bali's people are descended from the last of the Hindu-Buddhist kingdoms in Java, the Majapahit dynasty. Others stem from what is known as the Bali Aga, an older stratum of society with animist beliefs. The merging of the two resulted in the present Balinese Hindu religion and the so-called post-Majapahit Balinese style of architecture. This is described by Julian Davison in *Balinese Architecture* (Periplus Editions, 1999) as "grounded in a metaphysics that presents the universe as an integrated whole...where microcosm is perceived as a reflection of the macrocosm. Correct orientation in space, combined with ideas of ritual purity and

Previous page: This villa, with strong, elegant lines yet still undisputably "tropical", is an example of the new style of architecture appearing in Bali today. It was designed by GM Architects.

→ A *Plumeria* tree shadows this emerald green pool designed by the architect Gianni Francione; it sits comfortably in the tropical environment and enjoys an uninterrupted view of rice fields around.

→ → The pure rectangular volume of this infinity-edge pool protrudes above the wooden deck. This very refined composition was designed by the architect Cheong Yew Kuan, for the villa Tirta Ening at Begawan Giri Estate.

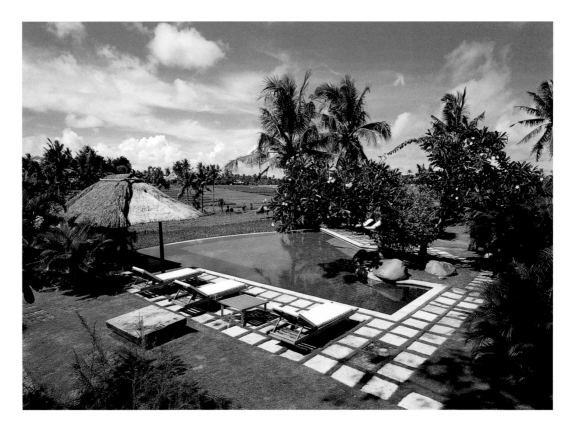

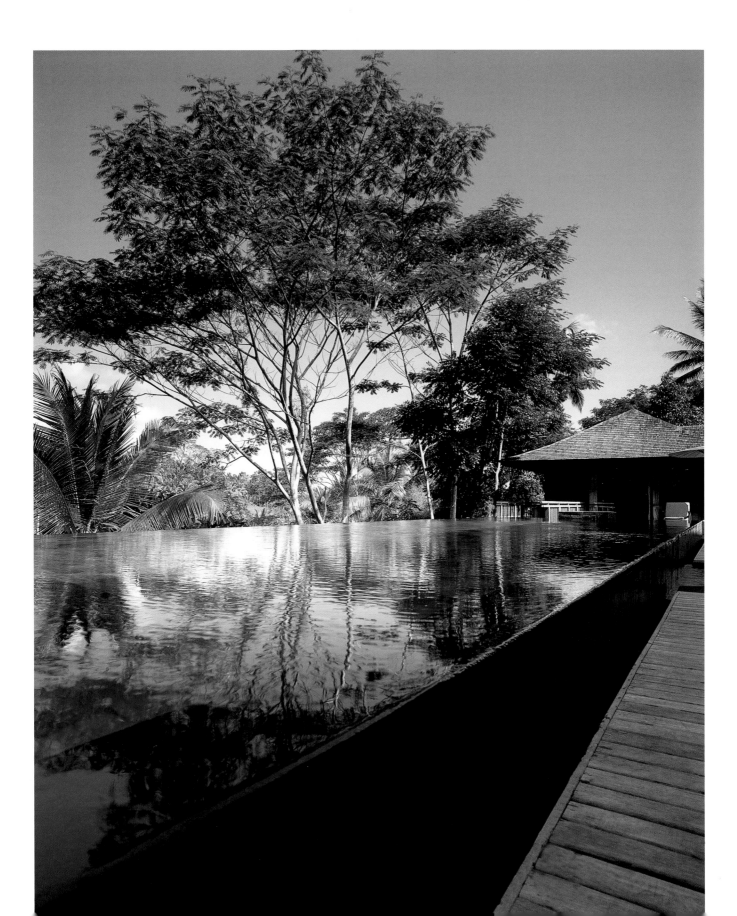

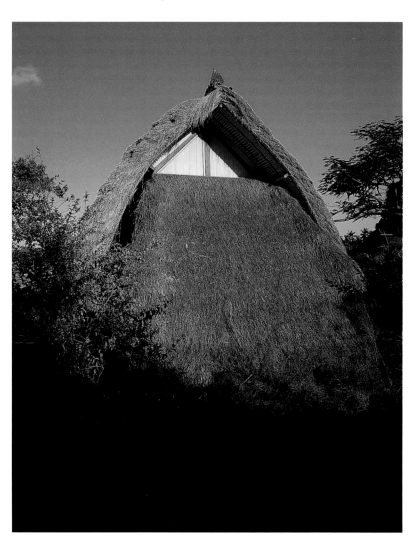

↓ The characteristic shape of the roof of the Balinese *lumbung* or rice granary – here reinterpreted in a modern compound – has its own aesthetic appeal.

→ The Ibah hotel in Ubud employs extensive use of *alang-alang* thatching in its roofing. Perched on the edge of a gorge in Campuan, it is modern in concept, but traditional in its use of materials.

pollution, are key concepts providing a cosmological framework for maintaining a harmony between the man and the universe. This view derives from the Hindu idea of a divine cosmic order (*dharma*), qualified by a much older animistic tradition which attributes spirituality to the natural world."

The tripartite organization of the Hindu cosmos and micro-cosmos and proper spatial orientation dictate the layout of all buildings in Bali: the Gods are on high, bad spirits are in the lowest regions and mankind comes somewhere in between. Before any structure is built, the *undagi* or local "architect" and expert in rituals, consults the ancient and sacred

building manual "Asta Kosala Kosali". Here, every aspect of construction and design following strict rules of orientation, position, shape and size is predetermined. His job is to act as an interpreter of these sacred texts to produce a building that is in harmony with the human body, which in turn will be in harmony with the Balinese Hindu cosmos. It can be seen, therefore, that architecture, as such, is not a secular art with aesthetic or functional or decorative intent, but rather a religious ritual. It is *adat*, a vital thing, not an art form in itself.

Many outsiders misrepresent this idea of Balinese architecture. When they use some thatched material for the roof, or incorporate a small carved door or *kori* as a gate, or install a partition wall or *aling aling* at the entrance, they are not participating in an evolution of Balinese architectural style. Rather, they are taking these traditional elements, putting them in a modern context and reinterpreting them in a decorative and aesthetic way. This "dipping into" the Balinese cultural box started when the first foreigners settled in Bali; it has evolved through the years and has left behind a rich architectural legacy.

Many of Bali's first settlers, the most famous being the painter Walter Spies, built houses that were Western interpretations of traditional Balinese constructs. Spies' house, built in Campuan on the outskirts of Ubud in the 1920s, may still be viewed today. A simple, two-storey structure in pavilion style, it utilized Balinese materials and craftsmen, and was decorated with local paintings and carvings. It is the precursor of many similar houses that were built by Westerners who followed in his footsteps.

The late 1960s and the early 1970s saw the advent of western tourism on a scale unprecedented before. The first response to this was the construction in 1963 of the 8-storey Hotel Bali Beach in Sanur, a Japanese government reparation gift to Bali. The building, an example of Tokyo international style, dominated the skyline and caused major damage to the local environment. Luckily for Bali, it was a one-off rather than the beginning of an indiscriminate

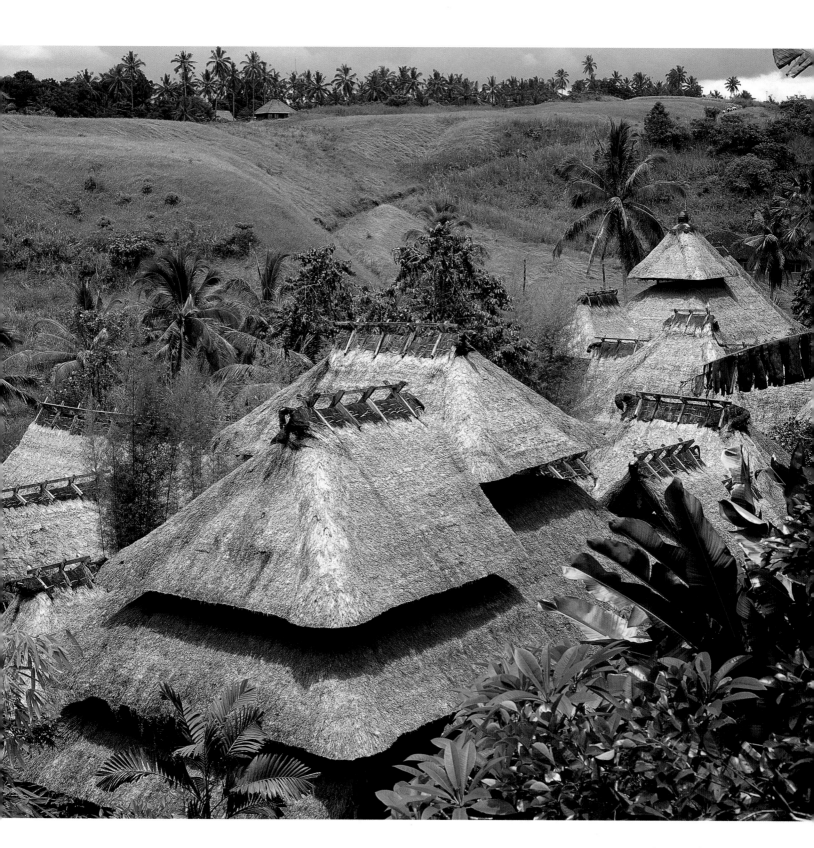

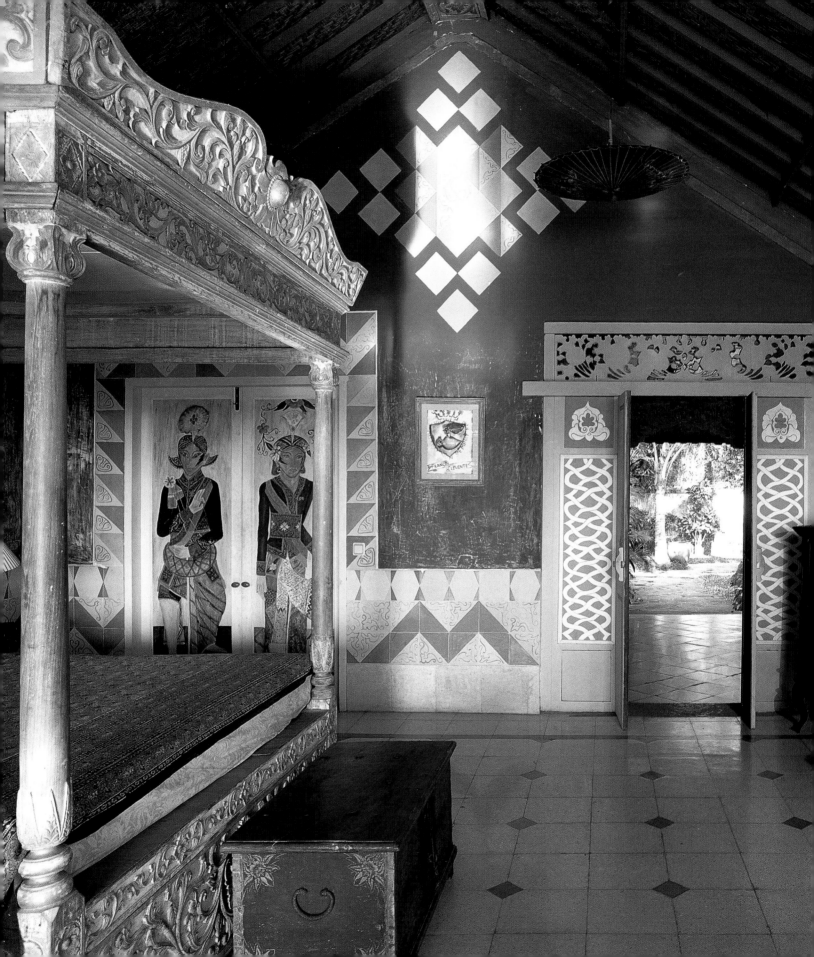

concrete building boom. On a more tasteful level, these were also the years of the Oberoi Hotel designed by the architect Peter Muller, and Kerry Hill's Bali Hyatt in Sanur. Both works were the first interesting responses to the problem of how tropical architecture could and should be adapted for the tourist industry in Bali.

These years also saw the arrival of a certain type of tourist interested in the spiritual and artistic aspects of Balinese culture. Be they '60s flower children, Hari Krishna acolytes, Australian surfers or simply the young rich in search of new "eastern" sensations, their arrival precipitated the construction of many small, very basic houses and *losmen* (inns) built by the Balinese in the tourist areas of Kuta and Ubud; at the same time, some more sophisticated dwellings supervised by Western designers, were springing up in trendy Sanur. By 1977, a local government directive stipulated that all new urban buildings had to be "Balinese in character"; this resulted in some of the more grotesque styles of the 1980s.

← The walls of The Royal Suite at Taman Bebek hotel, Sayan, as realized by Stephen Little, feature geometric patterning and a modernistic paint finish.

↑ The elegance of this traditional floral motif is highlighted in these hand-painted panels by the artist Pierre Poretti.

→ Colonial and antique furnishings are combined with the modern lines of a central staircase and painted steel trusses in this interior composition by the architect Beppe Verdacchi.

Overleaf: A contemporary tropical blend: a modern vision of space, local natural materials and antique furnishing from the Archipelago are all combined in this villa designed by GM architects.

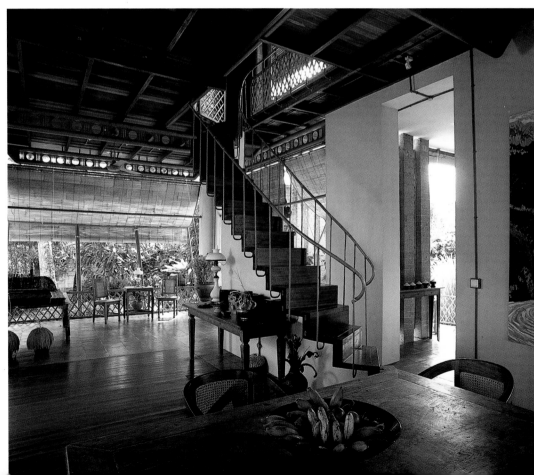

The '80s and early '90s were crucial for Bali. The vertiginous expansion of mass tourism, combined with the need to cater for the requirements of ever-increasing numbers of visitors, produced major changes in the built environment. Huge investment led to the construction of literally hundreds of hotels in Kuta, Sanur and Ubud. The new areas of Jimbaran and Nusa Dua were developed for luxury resort complexes. The *losmen* demand began to fall off and was substituted by a new wave of people coming to Bali for commercial purposes, mainly in the import/export sector. These individuals began to build their own private houses, in cabana- or palace- or mansion- or adobe-style; mimicking the traditional Balinese compound, but attempting to import Western standards, unfortunately the main characteristic of these private residences was a lack of professional competence.

Largely as a result of the influx of a new breed of visitor, new standards began to develop in the mid '90s. Demand for a higher degree of sophistication and Western "professionalism" provoked major changes in the development and quality of public facilities. Balinese craftsmen have an innate ability to copy or reproduce any design, and a whole plethora of new styles and designs in the form of shops, restaurants, hotels, public parks such as a well-designed Bird Park or a water-theme park in the heart of Kuta, began to appear. Now, the larger hotels all vie for business by offering better service, higher levels of accommodation and more aesthetic appeal. Interiors have undergone a major upgrade too: Garuda-style has been replaced with the production of artefacts that would look as *au fait* in a New York loft as they would in the Kuta beachbar. In the private sector, long-term residents want less makeshift accommodations. Following architectural trends from outside, rather than from within Bali, their new villas represent the birth of an eclectic, international style. The architecture is no longer the "trad-Bali-style meets western plumbing"; it is more a style that extracts Balinese designs from a religious context and utilizes them in a decorative, aesthetic manner: in short, a new art of tropical living.

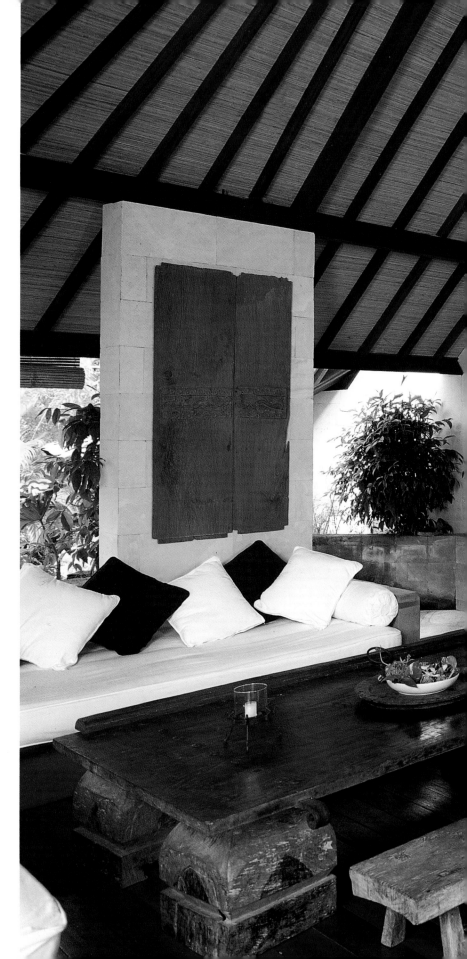

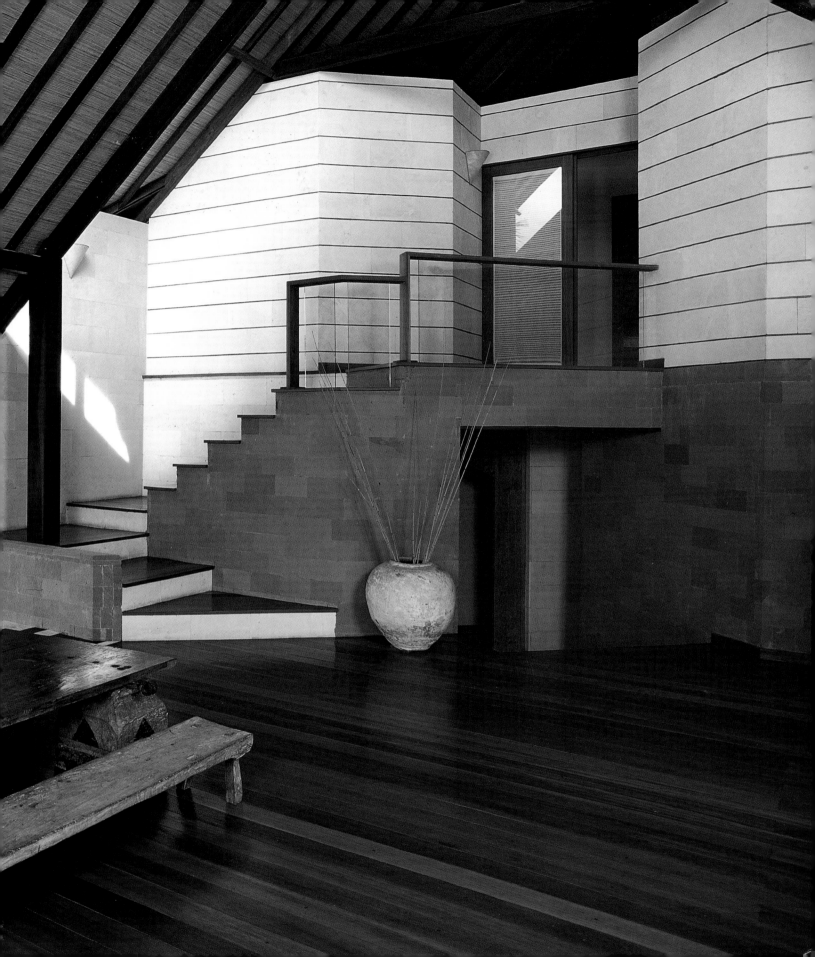

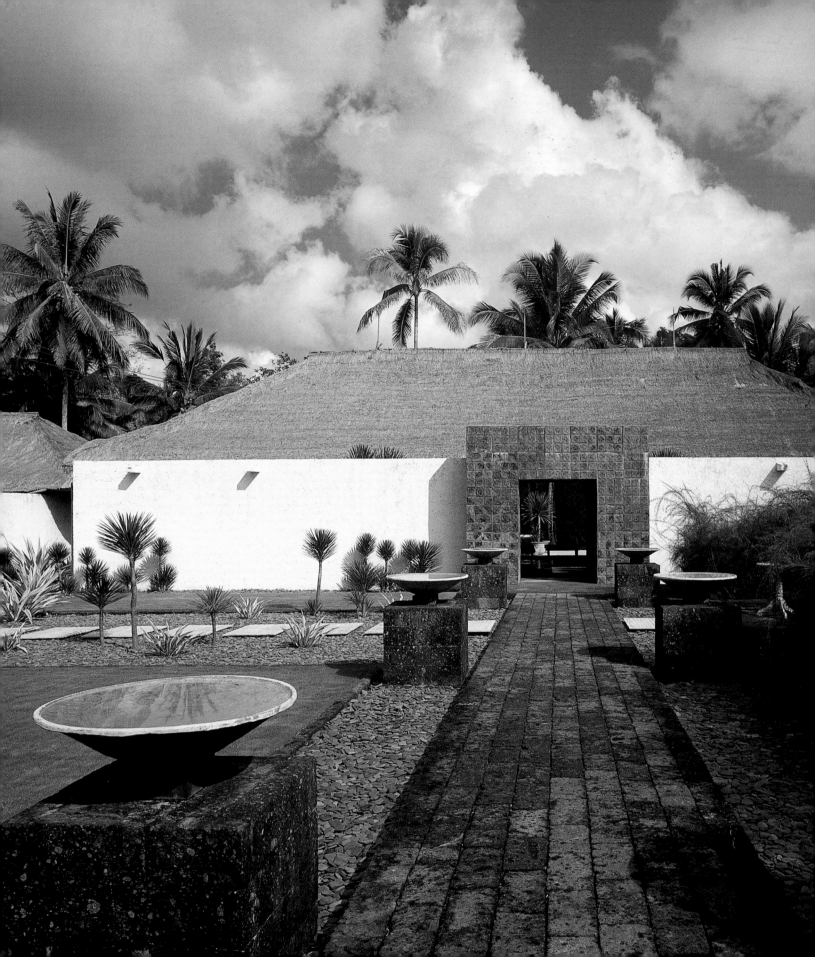

The Art of Tropical Living

New Architecture and Interiors in Bali

The island of Bali has long been a magnet for the
Western culture-hound – and over the last 100
years many people have set up home there. Most
built their tropical dream villas in vernacular style.
Today, however, a new internationalism is emerging:
along with the wood, *alang-alang* and bamboo are
ceramics, stone and glass; pavilion-style is being
replaced with a more modern vision of space.
Here, we showcase the most inspiring examples
of contemporary residences, shops, restaurants,
studios and resort homes the island has to offer.

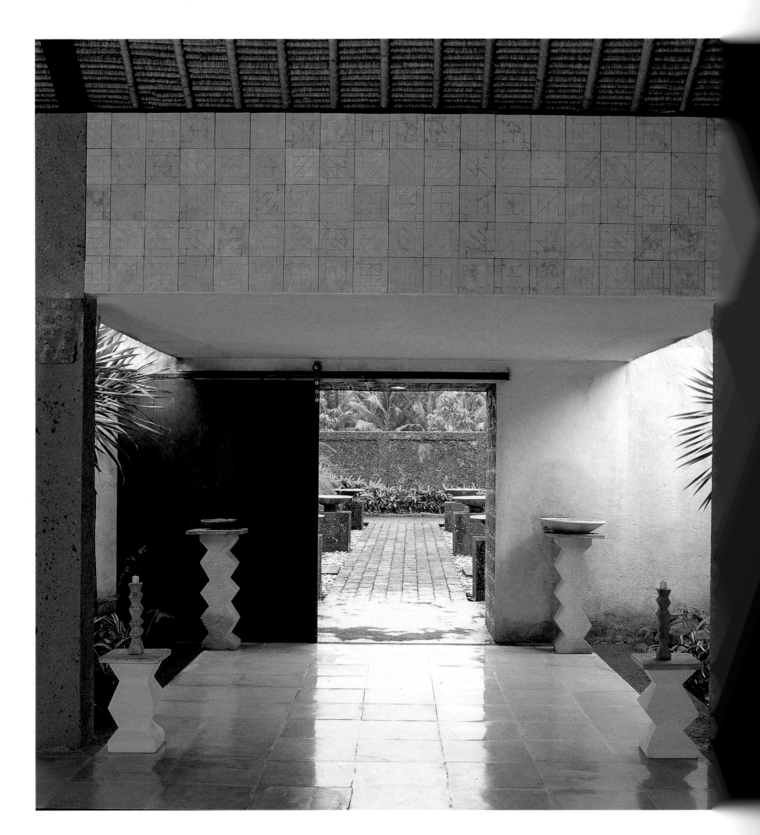

Tropical "Joie de Vivre"

Clean architectural elements combined with pure geometrical volumes create a well-balanced, almost minimalistic composition at the entrance of this villa. Owned and designed by two young Australian artists living and working in Ubud, it is deceptively simple. The villa consists of a large thatched roof raised over an open living space where a long white wall acts as a partition between the outside and inside. A big square arch – clad with a medley of light and dark blue ceramic tiles made by the owners and used as a doorway – acts as the main focus point of the whole structure.

The resulting perspective is remarkable. From the large external walkway, one's attention is captured and tunneled through the interior of the villa and out to the back garden and on to the pool beyond.

The formal purity of the external forms contrasts with the richness of the interior. Here, an eclectic explosion of forms, objects and vivid colours greets the senses. An imposing sliding entrance door crosses a square foyer, which is enclosed, but lightened on each side by two open-air garden niches. Immediately adjacent is a vast multi-functional living space, housed under a typical traditional Balinese thatched roof. This looks on towards an expanse of emerald green tiled pool and yet further to a spectacular multi-coloured tropical

Previous page: The main entrance pathway is formed from hard-chipped *Kerobokan* soft stones and *batu Singaraja* detailing. Shallow sand-cast ceramic round bowls rest on stone plinths.

← The floor of the square foyer is laid with 50 x 50 cm handmade highly polished cement tiles. The rusted black steel sliding door is flanked by tall pedestal tables carved from *palimanan* ivory stone and topped with hand-cast ceramic.

↓ The mosaic effect of the front portal is achieved with cladding of 50 x 50 cm relief cast ceramic tiles. Spare landscaping gives a distinctly "Arabian Nights desert" appeal.

valley. The sleeping quarters are the only private spaces in the house. These are separated by walls and sliding doors from the main rectangular space. The rectangle is the focus of the house: here living, relaxing, dining and cooking are all carried out.

What makes this house particular is the attention paid to the textures of all the structural elements, as well as the style of interior decoration. The internal flooring is laid with hand-made, highly polished tiles made out of a special aggregate of local stones mixed with cement. The walls and columns are texturized by a thick finishing layer made up of crushed local *paras* sandstone and white cement. The external walkways consist of sand cast ceramic tiles. Table tops for dining and coffee table, pottery, accessories, flower vases and wall lamps have all been designed by the owners. The extensive and imaginative use of sand cast ceramic creates not only an impressive collection of colourful and eclectic art pieces, but leaves one with a distinctive impression of tropical *joie de vivre*.

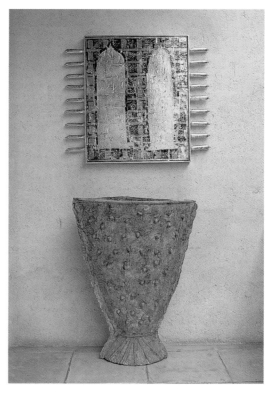

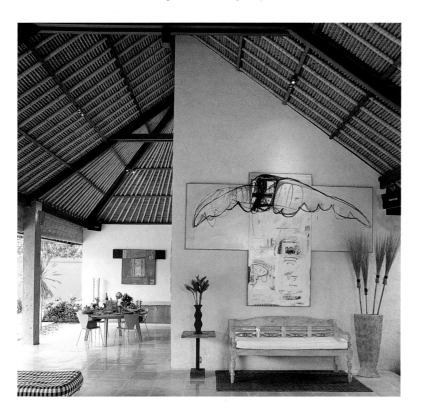

← A bright yellow painting acts as a backdrop to a decorated Javanese timber bench seat, a big ceramic urn and a black steel side table with vase. In the background a view of the open dining area.

↑ A hand-cast ceramic urn and a mixed-media collage.

→ The completely open living area is a colourful parade of objects and pieces of art, testifying to the creativity of the two Australian artists who own and live in the house. The foreground square *Madura* wooden table is texturized with a ceramic top. Sand cast ceramic, *palimanan* stone, recycled tin, sand painted and carved timber are used to produce varied furniture and furnishings.

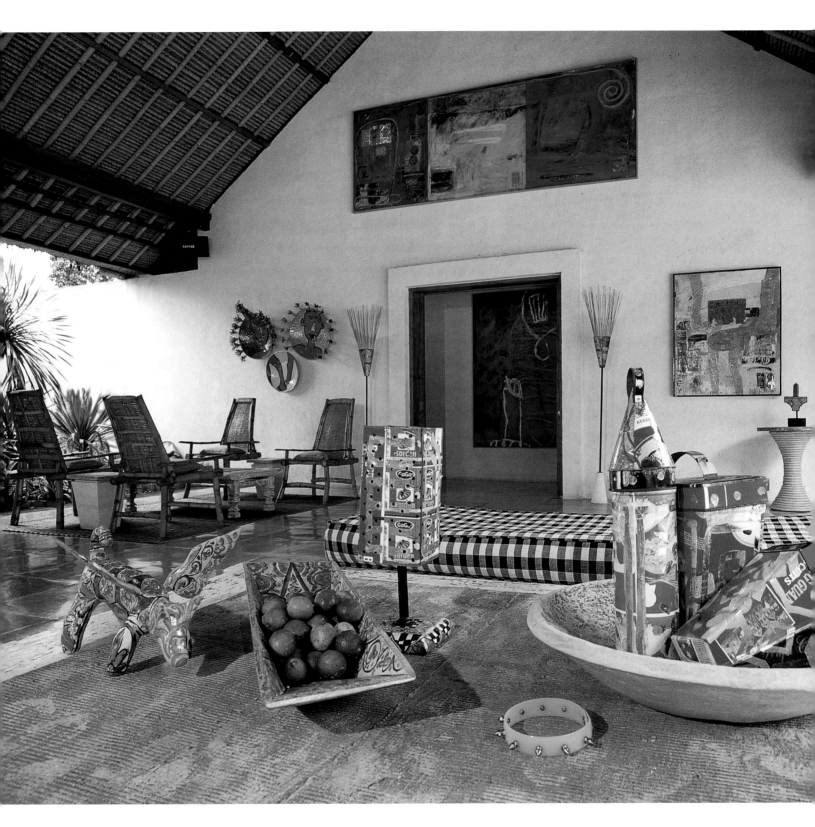

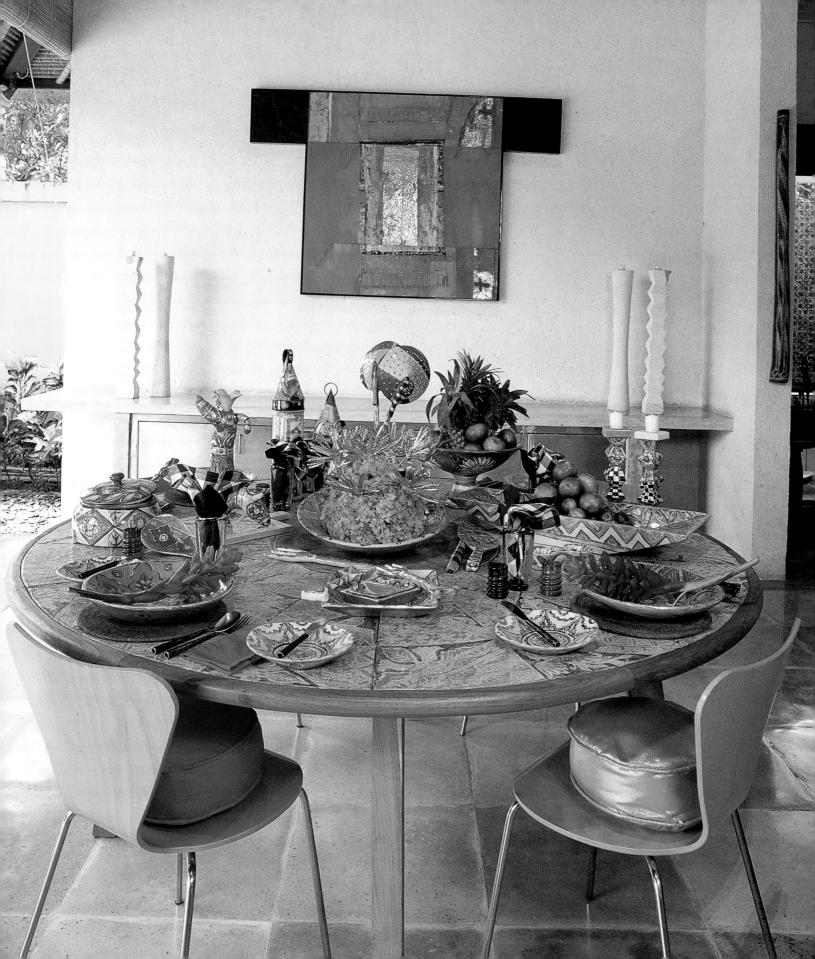

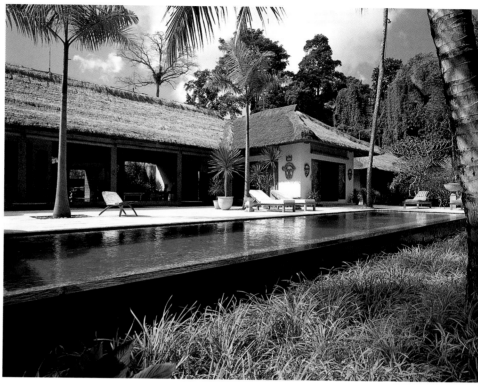

← ← The dining table, vibrant with vivid colours and forms, makes a strong statement against the subtle backdrop of the dining area.

↖ Sand-cast ceramic tiles become 120 x 80 cm stepping stones over a fish pond.

↙ A close-up view of a sand-cast ceramic round bowl with delicate patterning.

↑ From the vast ivory-toned stone sun deck surrounding the emerald green-tiled pool, one can enjoy uninterrupted views of the valley below.

Forest in the Mist

Legend has it that long ago Bali was covered in
lush forests, disturbed only by cool rivers curving
through its valleys. In these forests lived ghouls
and spirits, strange wild animals and fantastical
creatures. Mortals were too afraid to enter the
forests, but those who sought spiritual enlighten-
ment were drawn to them as if by magic. It is said
that three holy men, or Begawantha, stayed in one
of these forests and cultivated the hills and valleys
nearby. Eventually, they built a shelter which
became known as the village of Begawan.

Nine years ago, next to this village, businessman
Bradley Gardner and his wife Debbie conceived a
similar dream. Gardner "sat with the land" for many
months, eventually building five residences on eight
hectares high above the Ayung River. He called the
site Begawan Giri, or Wise Man's Mountain.

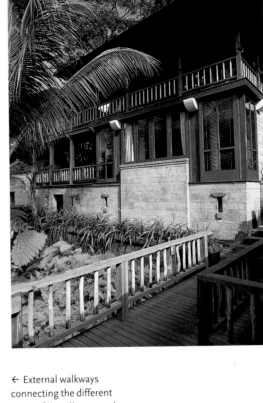

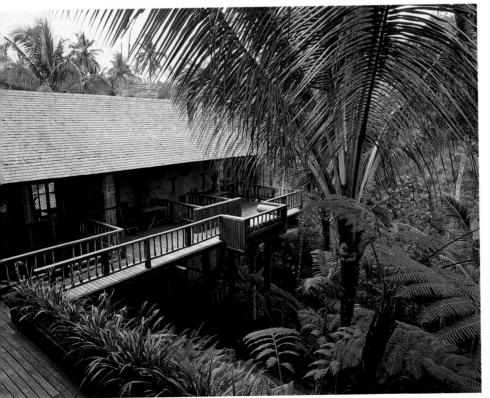

← External walkways
connecting the different
areas of the villa are made
out of wide and long
ironwood planks.

↑ Careful planting
connects all parts of the
villa and integrates them
with the surrounding
landscape.

→ As if suspended in
mid-air, the main pavilion
overlooks a semi-circular
infinity edge pool and the
Ayung River gorge far
below.

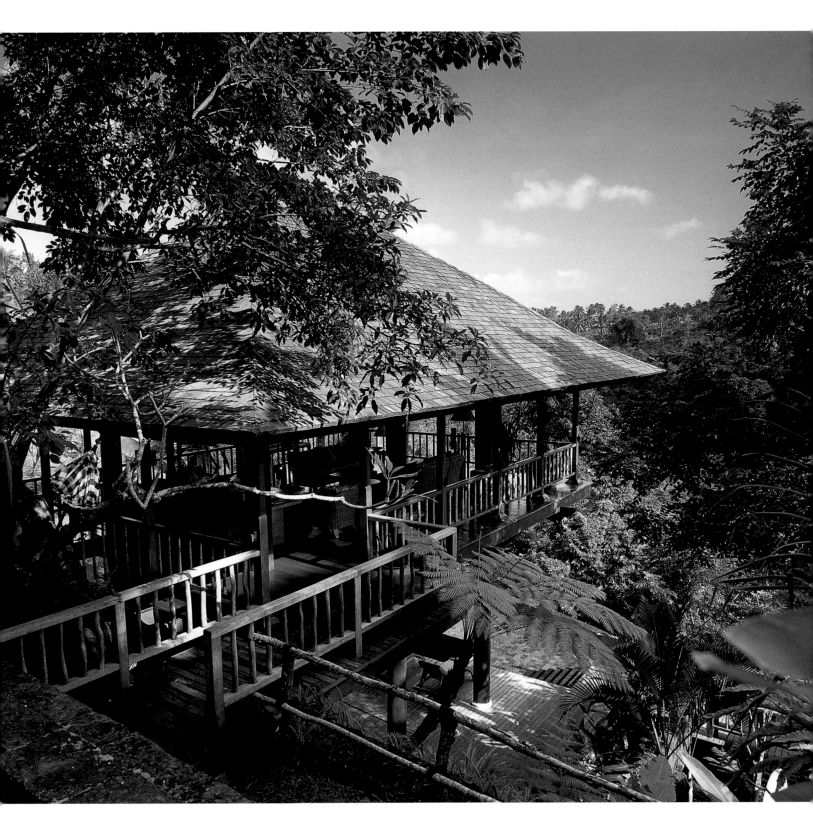

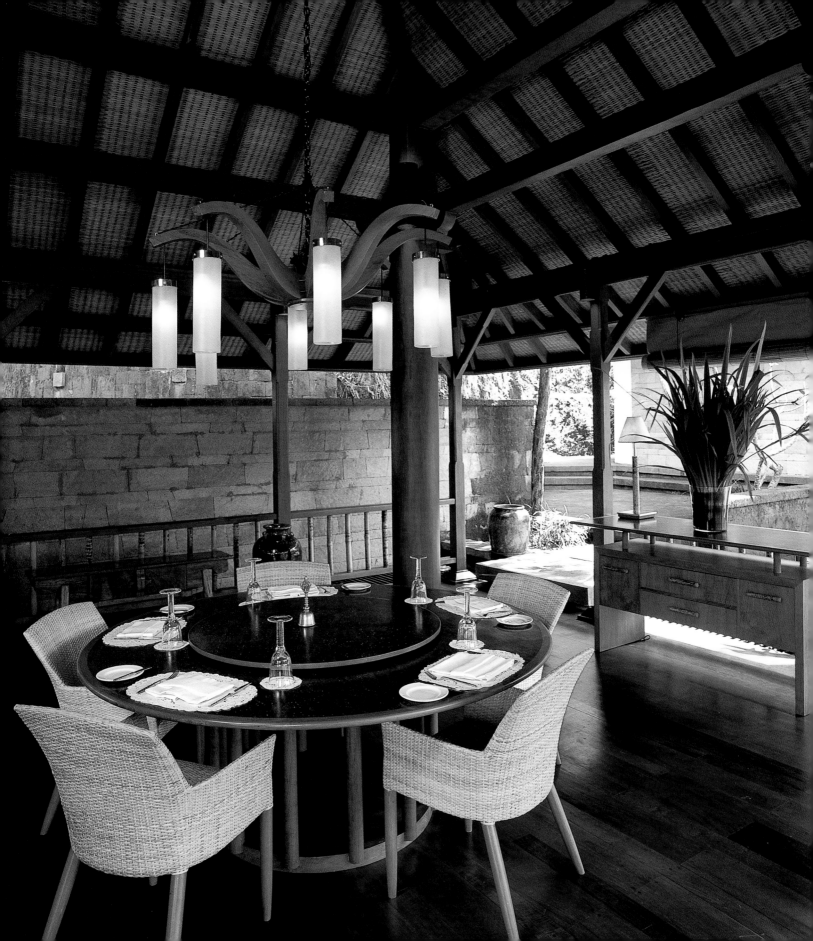

Each of the five palatial residences was designed by Bali- and Singapore-based architect, Cheong Yew Kuan. This particular villa, called "Wanakasa" or "Forest in the Mist", was designed around a central Holy Tree which became an integrated part of the overall design. In fact, it acts as the central pivot. Overlooking the river and the drop to the valley 100 metres below, the villa's modern design closely interplays with the surrounding vegetation resulting in a feeling of "the forest within".

Aged teak planks and ironwood shingles are used extensively for flooring and roofing, and these further contribute to the feeling of forest intimacy. Similarly, simple furniture with hand-woven, natural fabrics are used extensively. Nine-metre *bengkerai*-wood poles support the open pavilion that houses the main living area enhancing the lightness of the whole structure. Wooden walkways connect the various rooms and further contribute to the drama of this ultimate tree-house. It is as if one has invited the outside in, and kept it at floating level high above the jungle.

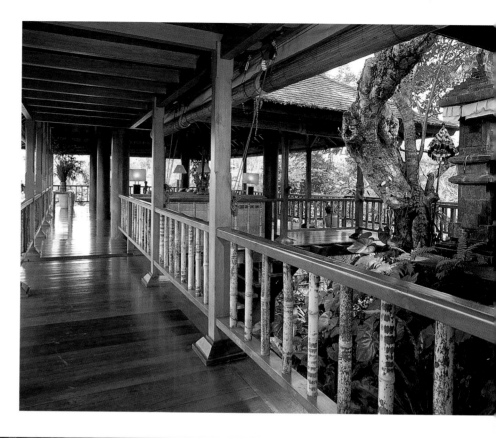

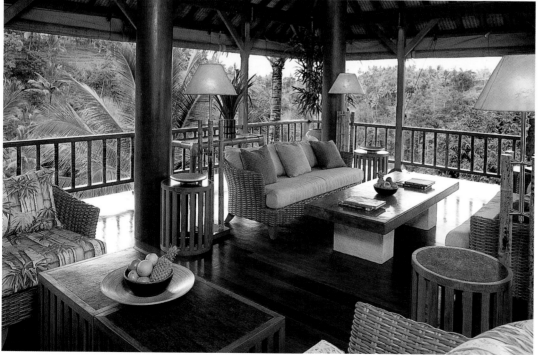

←← The furnishings and furniture, combining European and Asian influences were designed and hand-made *in situ*.

← The jungle acts as the perfect backdrop for the living room, where bamboo, ivory-coloured stone, pastel-coloured fabrics and aged teak are utilized for harmonious effect.

↑ The Holy Tree, with its adjacent blanketed altar with offerings, stands at the entrance. The existence of this tree well before the creation of Begawan Giri and the importance of its mystic history dictated the layout of the villa, which was literally built around it.

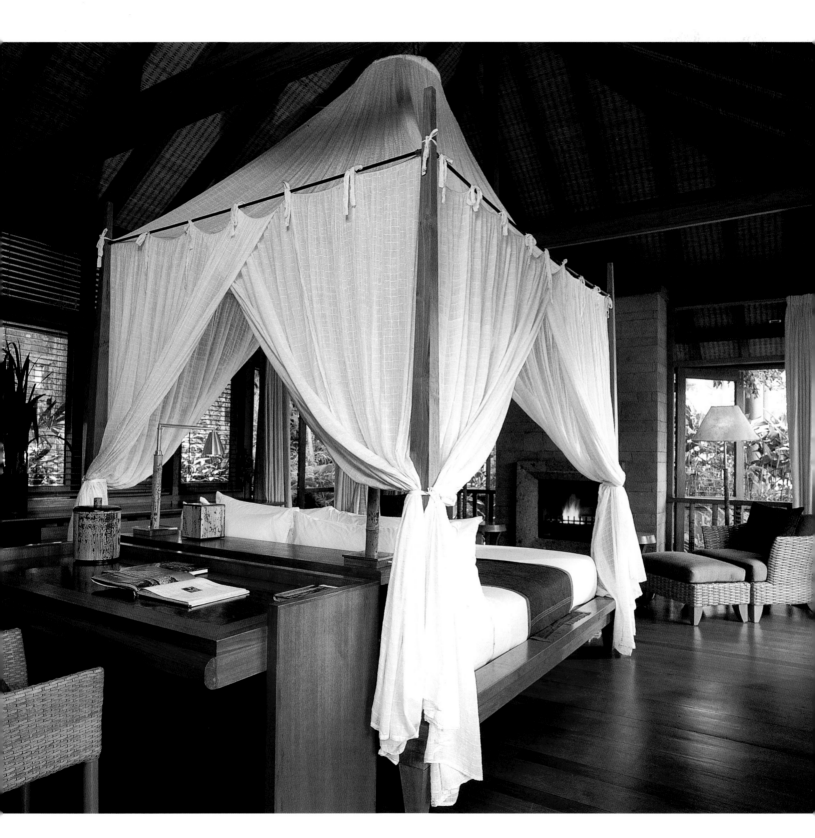

← The tropical landscape view all around enhances the jungle-magic of this four poster king-size teak bed. The fireplace and the hand-woven mosquito net add a romantic touch.

→ The highlight of the master bathroom is the bathtub: a large block of stone, brought from Java, is hand carved, polished on the inside and rough hewn on the outside. The ceiling sports hand-cut coconut tiles.

↘ A hand-made round copper basin stands on a white coconut vanity.

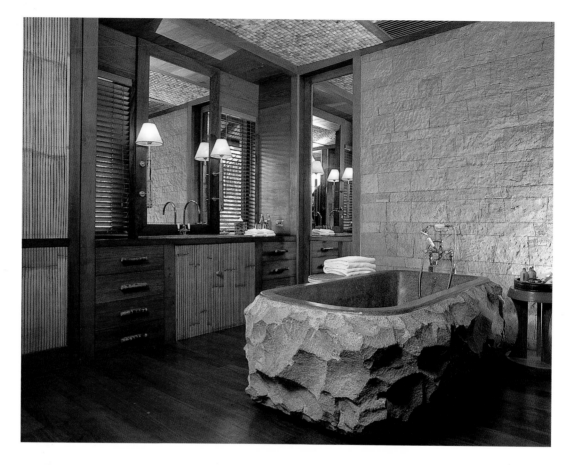

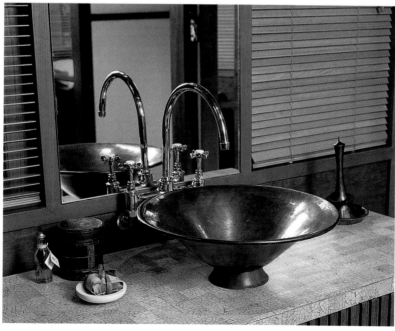

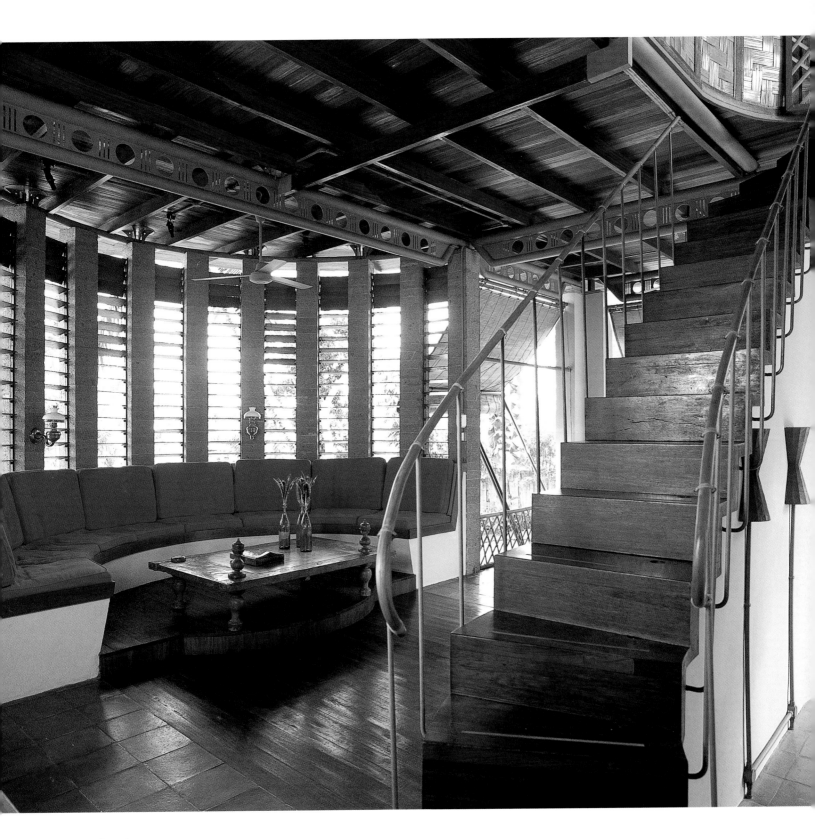

An Eclectic Mixture

An unusual semi-circular apsis, shaped by free-standing columns and supporting a light wooden deck, gives character to this compact double-storey villa. Designed by Italian owner and architect Beppe Verdacchi, it offers an interesting dialogue between modern and traditional elements through careful attention to architectural and interior details. Steel, wood, terracotta, rattan, volcanic stone and glass are cleverly utilized to shape and define the inner elements of the house. The variety of textures is well balanced, while a few different shades of colour provide a sense of lightness: pale orange fabric-lined split bamboo curtains and sage painted steel trusses are two examples. In many cases, these elements have structural as well as decorative functions: for example, the trusses bear the weight of the second-level flooring, but also provide colour.

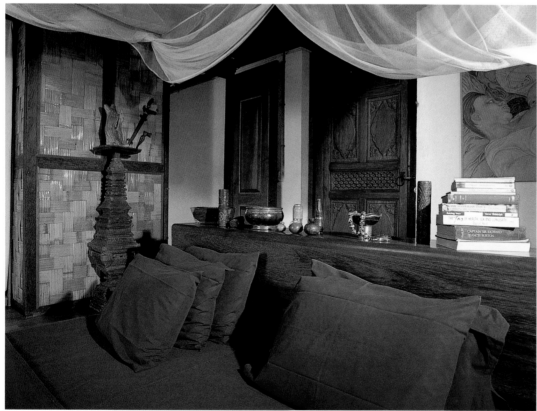

← ← On the ground floor, the apsis, shaped by free-standing *paras* volcanic stone columns, houses a semi-circular built-in red sofa. The overhanging staircase leading upstairs is in solid *merbau* tropical wood, while the slim handrail is made of rattan and painted stainless steel.

↖ The all-around colourful fabric-lined bamboo blinds, supported by stainless steel frames, provide shade for both the ground and first floor of the house.

← In the bedroom, table top accessories designed by the owner are made of various local materials.

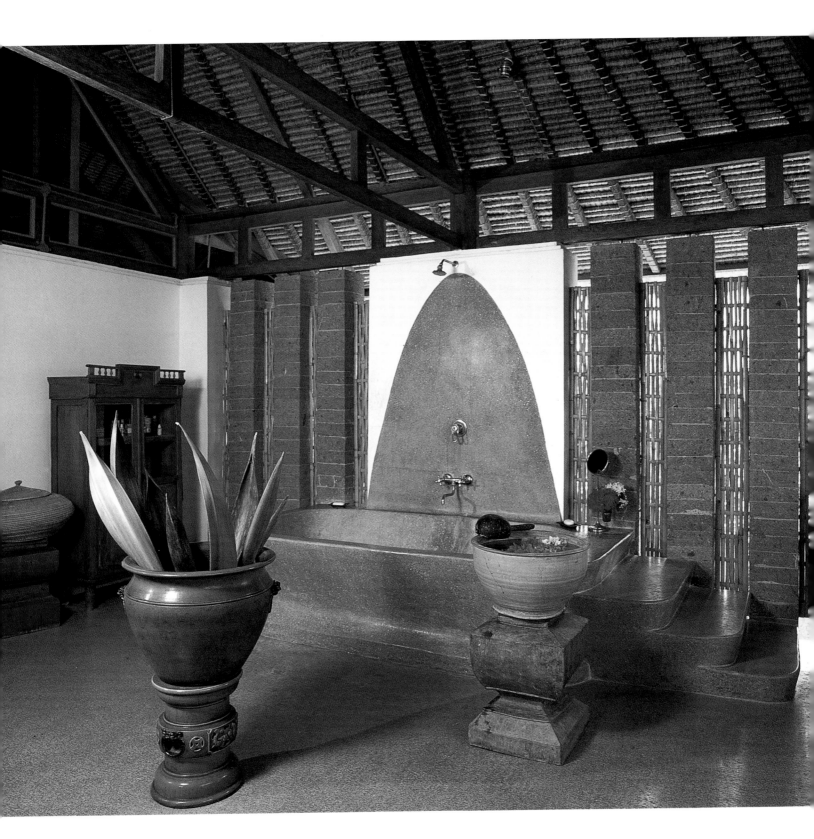

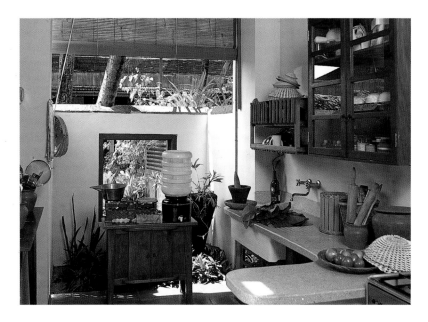

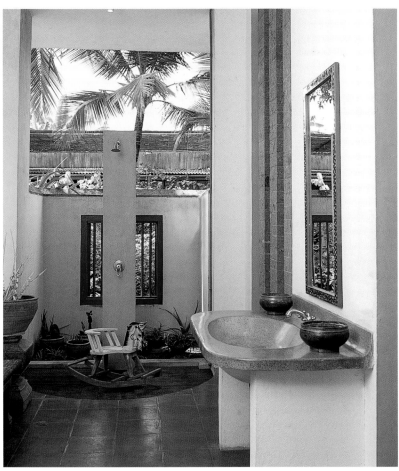

←← A cast-in-place light sage green terrazzo bathtub is the focus of the spacious bathroom upstairs. On both sides, free-standing elements of *paras* stone interplay with split bamboo *bedeg* inserts. Chinese terracotta bowls, a rattan basket and Javanese furnishings add a touch of the Tropics.

← Simple vertical and square elements are used as a backdrop for the shower in this completely open bathroom. Ochre and white ivory hues help to bring the outside in.

↑ A thoroughly modern kitchen; a wicker blind and open arch are the partitioning elements between inside and outside here.

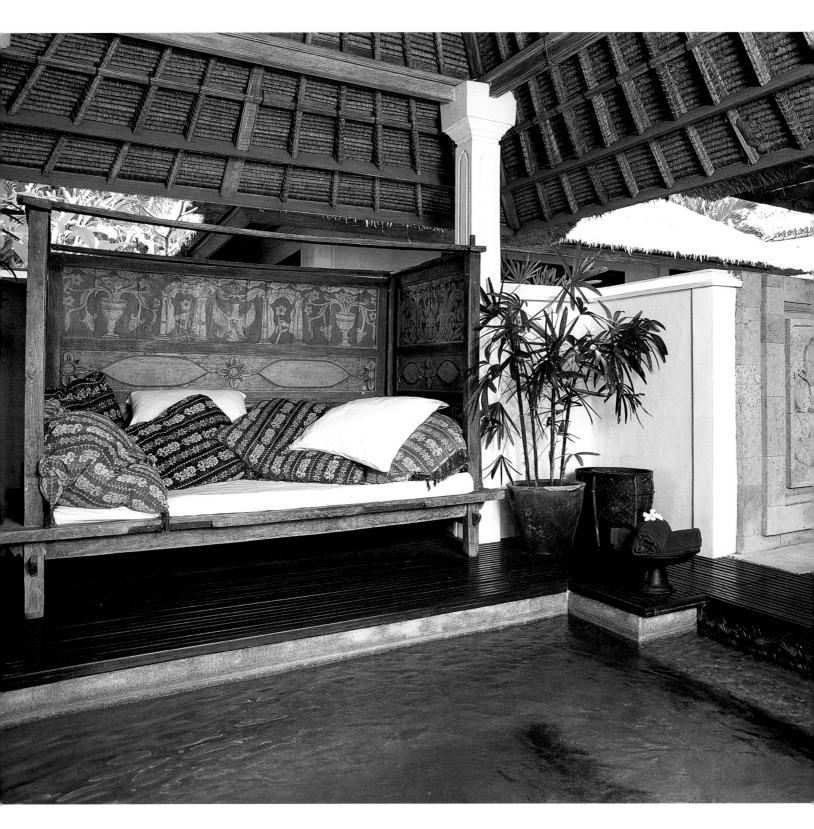

A Hybrid House

This villa near Kerobokan was designed nine years ago by the Australian Ross Franklin and is widely considered as one of the first significant attempts to combine traditional Balinese techniques with a contemporary concept of space.

A covered walkway, flanked on both sides by cooling lotus ponds, leads from the entrance directly to the living and dining area which is housed below a large, cone-shaped *alang-alang* roof. This strong architectural element is the focal point of the whole house. It faces the garden and westwards to the pool and has commanding views of the rice fields beyond. Acting as a central hinge for all the other areas of the house, the other rooms radiate from it. One such radiation is a finely carved white stone wall that lines the corridor connecting the living area to a unique room housing an internal fresh water whirlpool. One of the surprises of the house, it is a luxurious, relaxing area, complete with water feature and suitable lounging space alongside.

← An antique Javanese bed with a casual array of cushions contrasts attractively with the modern rigorous lines of the internal whirlpool.

→ A view of the villa and garden from the pool. The feeling is tropical, but the interpretation is essentially modern.

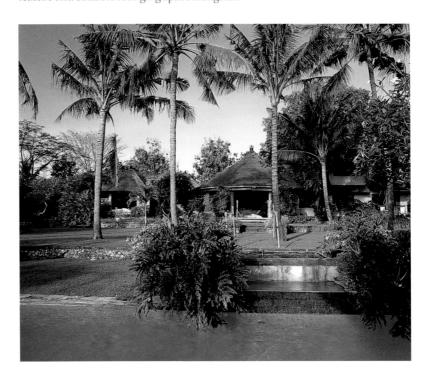

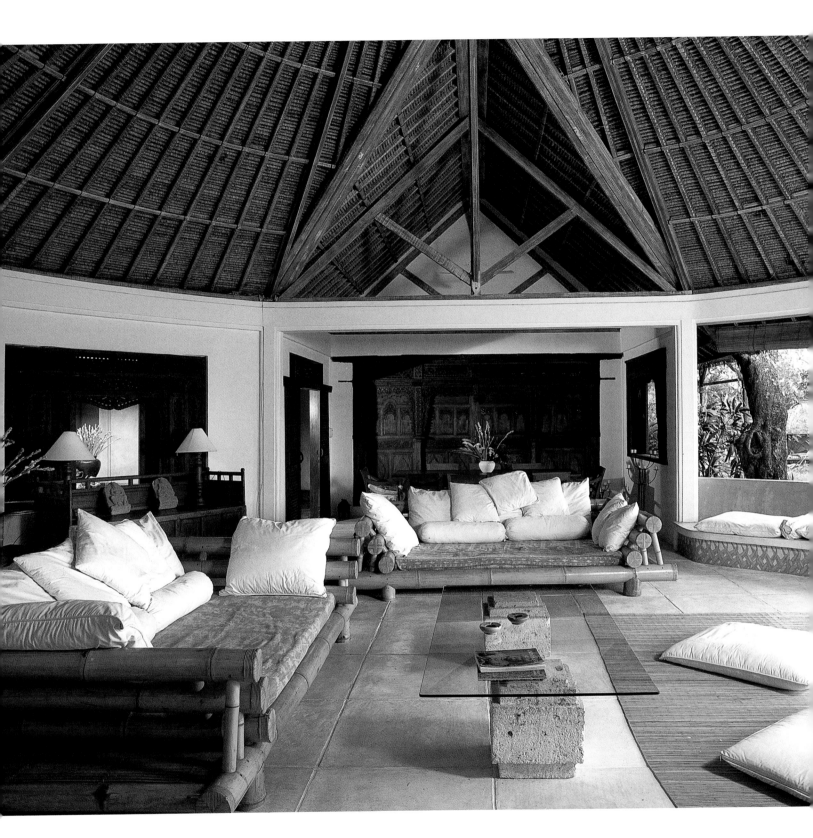

← Below the towering central conical volume, the vast living room is comfortably furnished with contemporary classic bamboo sofas set around a minimalistic glass and stone coffee table. In the background splendid Java wood paneling defines the dining area.

→ The covered walkway with its glossy *bengkerai* wood planks acts as a bridge from the entrance way to the living area.

↘ A glimpse of the lily pond and attendant plantings which divide the bedroom quarters from the central living area.

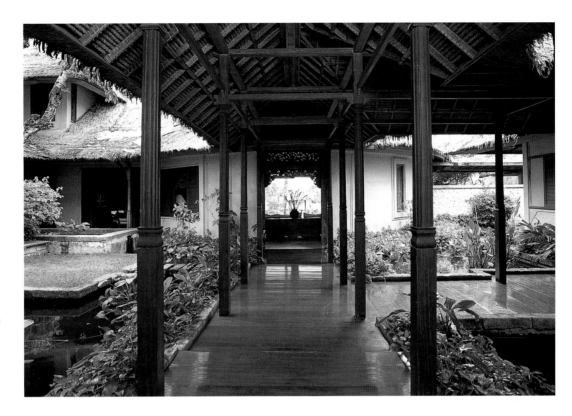

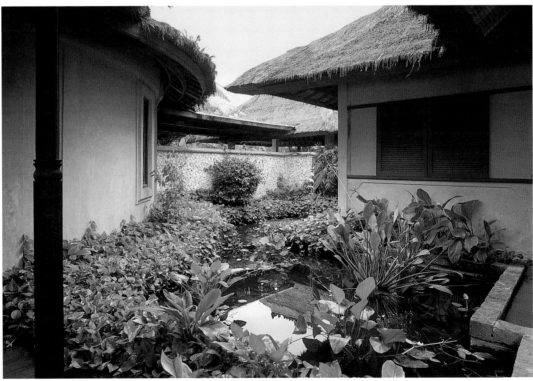

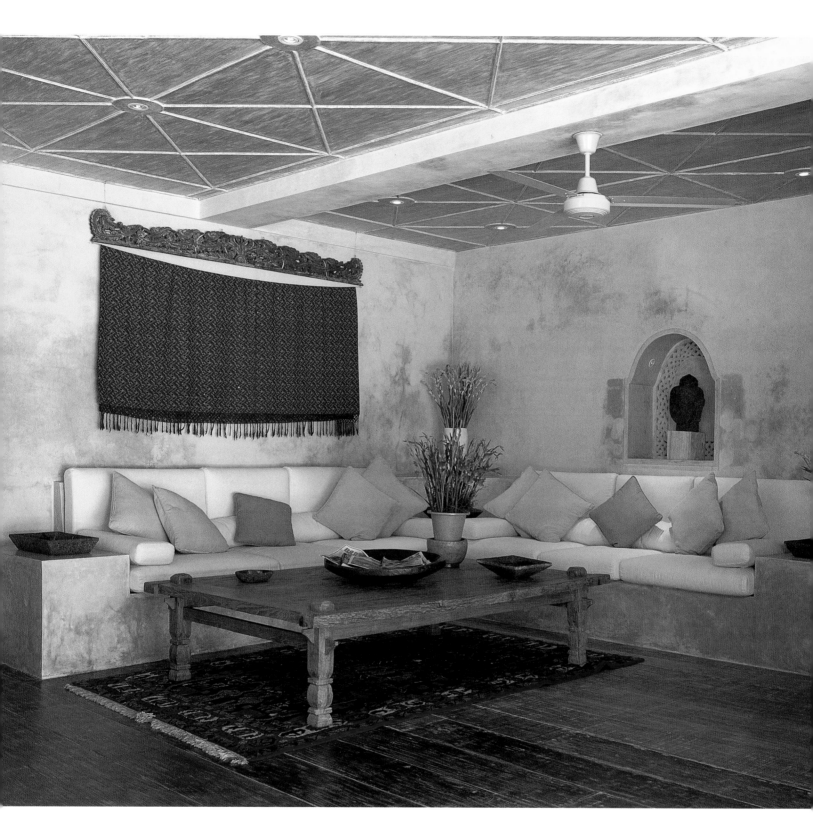

A Pale Palette

This villa, set on a relatively small plot of land in the heart of the Legian area, comprises a compact two-storey main building and a detached guest pavilion. The interior and the exterior of the villa and pavilion, created by the French designer Fredo Taffin, are rendered with a mixed ivory-coloured cement. These soft tones were created by mixing lime with the cement; this causes a pigment to form naturally through a process of oxidation.

Treating the walls in this way has resulted in a palette of pale ivory colours flowing across all the floors and walls in the property. Starting in the house, they continue out to the *balé* and lunch area next to the swimming pool. Here they offset the acquatic blue of the pools and the fecund greens of the garden; in short, it makes for a fluid space. Simple furnishings add to this feeling of cool, composed and well-defined calm.

← ← Recessed lights in the geometrically patterned lime-washed ceiling softly illuminate a corner niche with built-in sofa and an old Javanese coffee table. An antique textile and a recess with sculptured stone head provide background impact.

↑ Lunch is laid out in the *balé* near the pool; from here a pristine paved path leads through the garden to the main house.

← This spacious verandah is furnished with locally crafted furniture and ceramic pots. The stone paving, patterned by bleached timber inserts, visually extends itself into the garden.

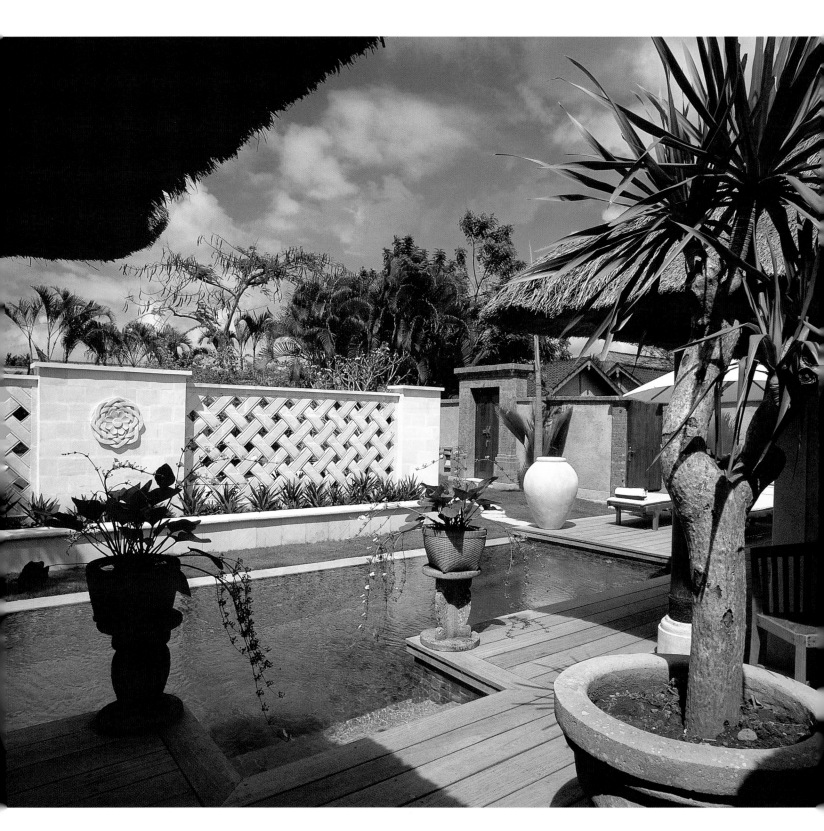

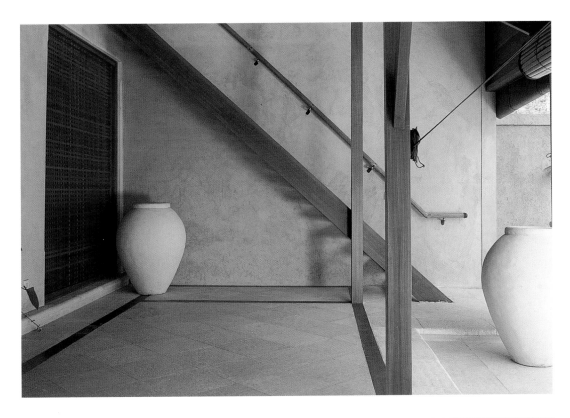

← ← A carved sandstone lattice wall separates the guest pavilion pool from the main pool; it not only provides privacy and a suggestion of intrigue, but also becomes a major feature of the property.

← A geometrical composition of varying soft-toned textured surfaces and limed timber. The elegant feature pots, moulded in concrete and rendered with a mix of crushed sand stone and white cement, alleviate the rigorous lines.

↙ This immaculate, almost monastic, bedroom is striking in its calm simplicity.

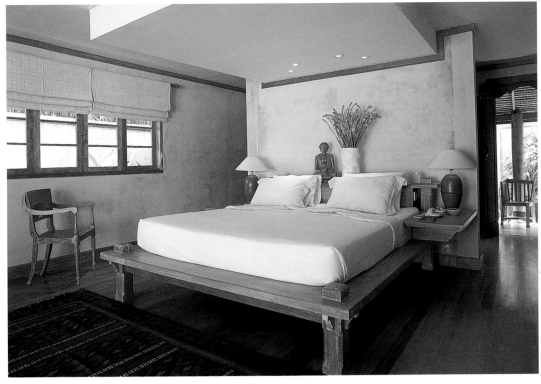

An Artist's Retreat

A high ridge with incomparable views of the volcanoes and coconut groves above the Ayung River valley in Sayan, Ubud, is the perfect location to inspire any artist. Here, the Greek sculptor Filippos has designed and built a personal retreat where he lives and works.

An outdoor curved staircase leads down to the villa's entrance, where – unexpectedly – white Doric-style Greek columns and a brilliant red-painted wood door welcomes the visitor. The over-all design, based on the principles of the Chinese art of geomancy or *feng-shui*, is simple and flowing. Countless examples of the sculptor's work are displayed throughout the house: their variety of size, shape and materials testifies to the eclectic richness of Filippos' art and leaves one with the impression that the house is truly a "work in progress".

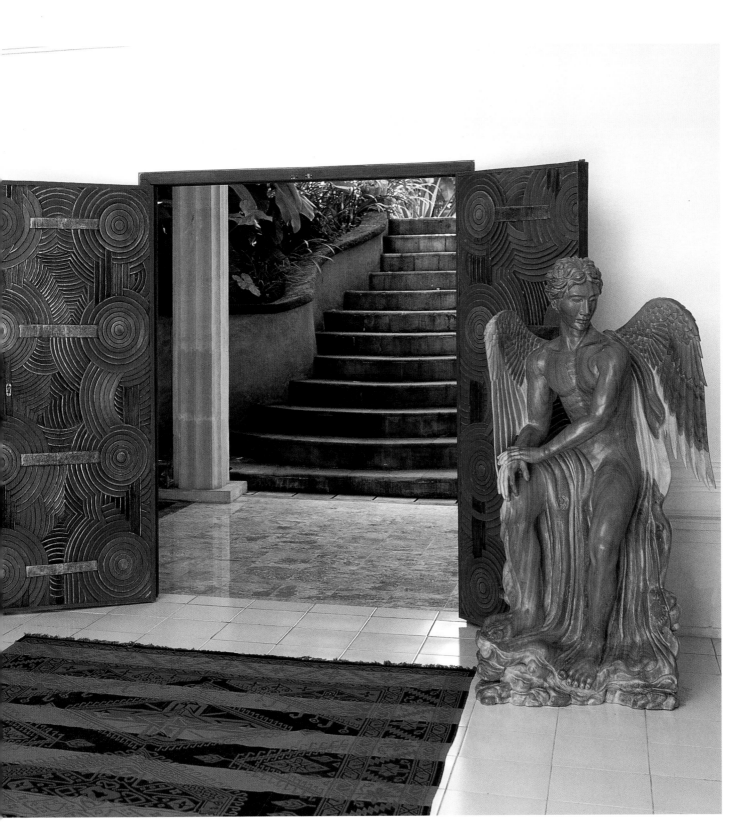

Previous page bottom left: Mixed media sculptures of lapis, silver, onyx, wood, marble and copper grace the wooden teak table. Textiles from Timor and Sumba, Chinese vases and a marble table complete this eclectic scenario.

Previous page, main picture: A marble floored hall showcases carved wood painted doors: the decoration symbolizes cosmic energy flowing in. An ethnic hand-woven Greeek carpet reflects the brilliant red and orange colours continued in the living room. A life-size mahogany archangel stands to one side while other small sculptures are placed on a colonial desk.

↓ The outdoor studio contains many works in progress. A giant white sandstone head, an "Egyptian Spirit Boat" supporting a vast "soul egg" of onyx, an angel torso of jackfruit wood and a life-sized mahogany sculpture are just a few examples of Filippos' work.

→ A view of the jacuzzi corner where a white sandstone bas-relief acts as an elegant backdrop and a Doric-style column supports the second floor. The onyx "God eye" features multi-faceted crystal inlaid in silver.

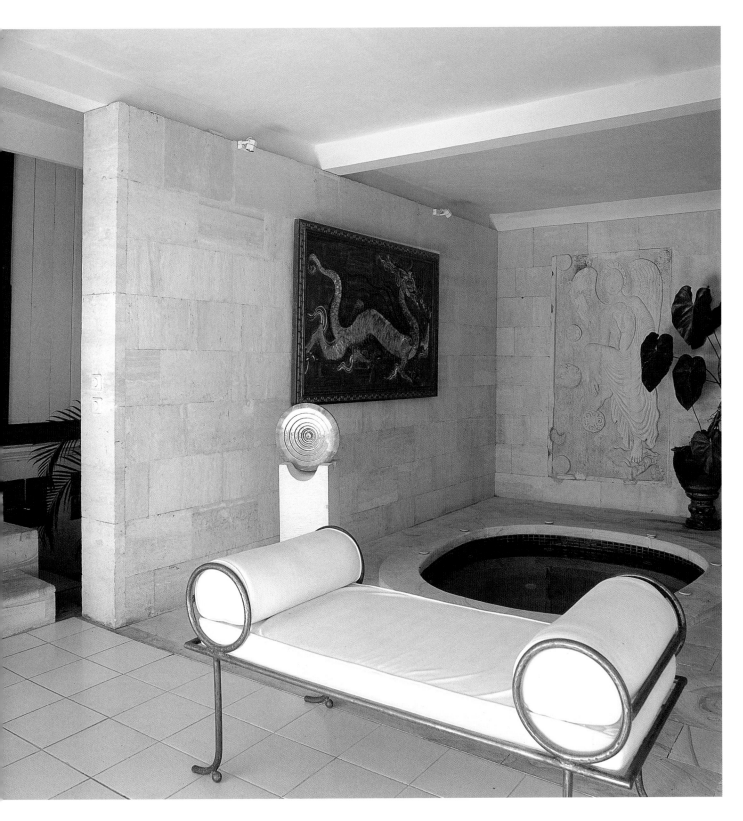

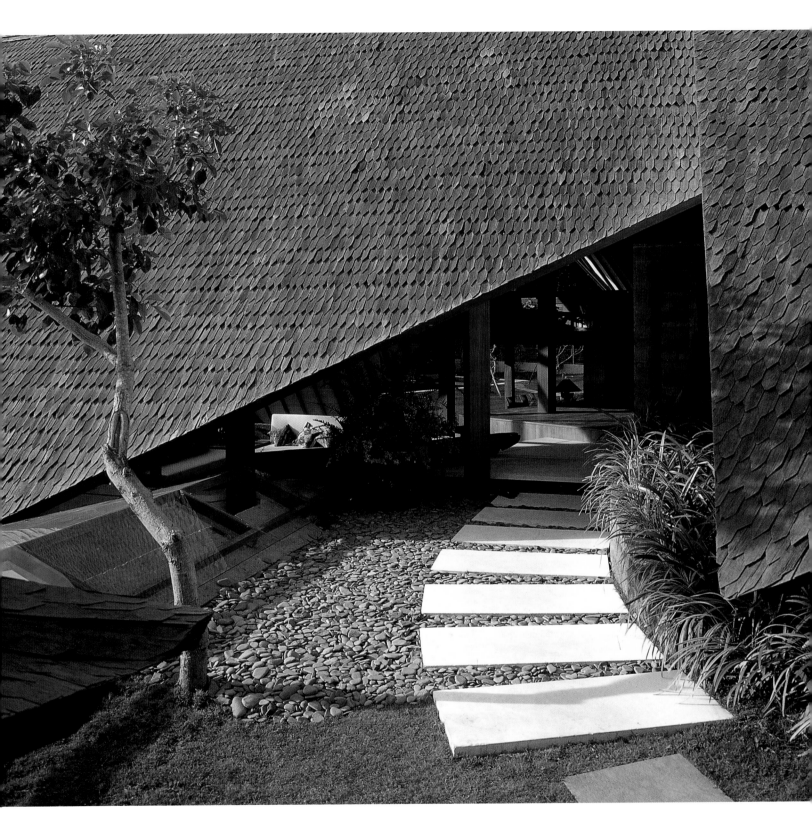

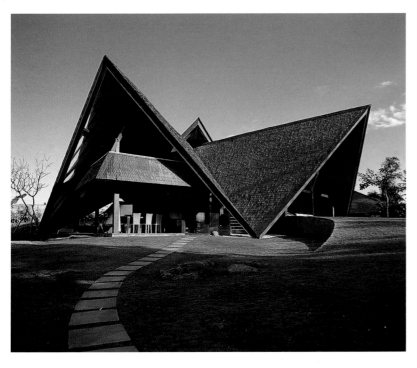

Contemporary Tropical

The most recent project of Italian GM Architects features a bold, contemporary design. This throws down the gauntlet, as it were, to the traditions of Balinese craftsmanship. The designers combine an overall use of local materials with the application of appropriate structural technology to express an original architecture based on strong clean lines. It is certainly an innovative approach to tropical living. Three triangle-shaped ironwood shingle roofs supported by an articulated all-wood structure, define the volume of the main building. An adjacent pair, with 12-metre ridges and pitches reaching down to the ground, open out to the garden. The entrance and the living and dining area are housed below. The real beauty, however, is the combination of an enviable sensation of privacy with a spectacular open-to-the-sky view of the tropical outdoors.

← Rectangular *wonosari* white stone slabs lead to the entrance located below two wide inclined wings of the shingle roof. A bed of pebbles "breaks" the lawn of the garden and defines the indoor-outdoor transition area.

↑ A view of the modernistic, angled outline of the villa with the front; triangle-shaped twin roofs opening wide on to the garden.

→ A view of the lily pond adjacent to the dining area.

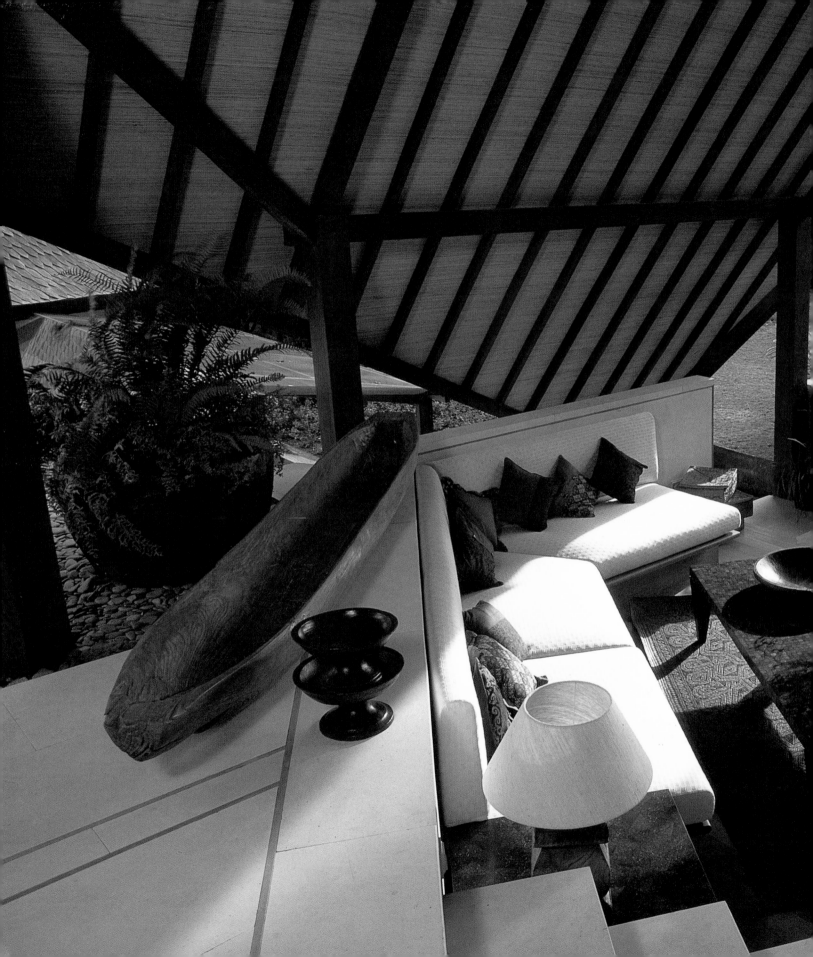

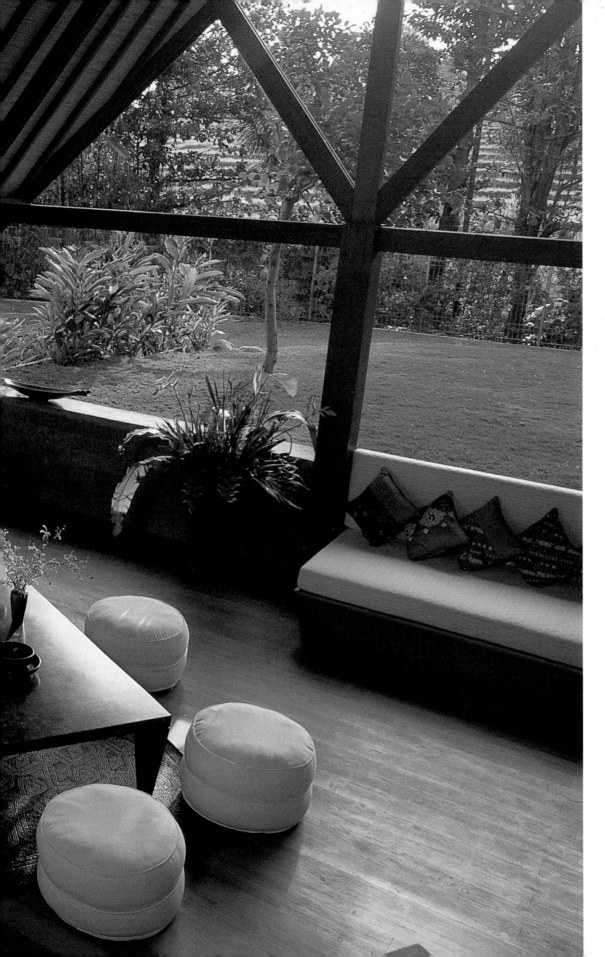

← The smooth texture of white local stone defines the floor of the entrance and carries down to the living area which is fully open to the garden. The simplistic décor, produced by the combination of modern furnishings and primitive objects, is refined, yet comfortable.

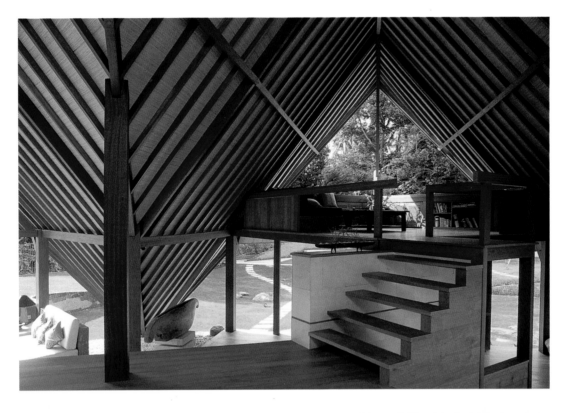

← One of the bold triangle-shaped roofs houses the dining area and, above it, an all-wood mezzanine relaxing area which overlooks the garden and the pool. The woven matting and the exposed wooden beams of the roof add decorative effect.

↙ The interior space, shaped by the strong, modern lines of the roof, is articulated on different levels and marked by the subtle change in flooring materials.

→ In the living area, an ivory sandstone wall, lightly patterned with teakwood strips, supports the wooden mezzanine and acts as a backdrop for an antique Javanese *grobok*. On either side are two modern standing lamps with a veneer of dark and white coconut shell.

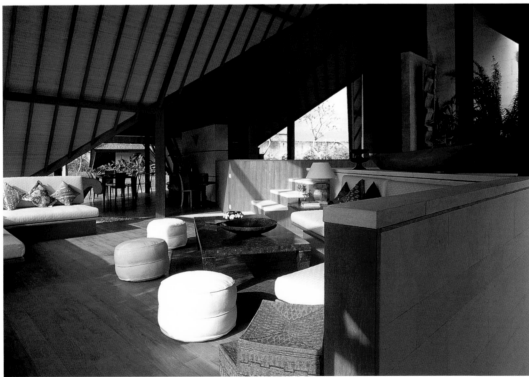

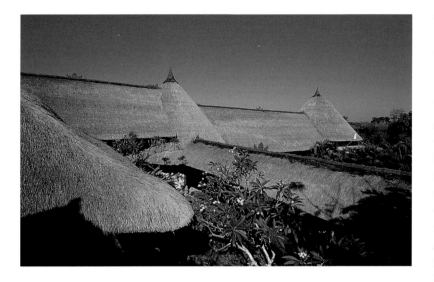

The Conical House: West Timor Influence

This villa, which sits on a hilltop in the Canggu area, enjoys an uninterrupted all-round ricefield view. Designed by a French architect, the overall form of the property is linear: made up of simple single pitched roofs, the house is characterized by conical elements. These take the form of round volumes, typical of West Timorese architectural tradition. Used as granaries and called *lopo* by the Atoni people, they have been incorporated here in a modern residential setting. The result is the harmonious fusion of a particular vernacular form and a modern context.

A covered walkway, open on both sides to a calming lotus pond, white flowering frangipani trees and multi-coloured bougainvillias, leads to the interior of the villa. The dimension of the internal structure, based on the traditional use of wood and *alang-alang*, imparts a hint of grandeur without detracting from an overall sense of intimacy. The geometry and the proportions of the structural elements are well-studied. Local ivory marble and sandstone are used extensively for flooring, staircases and walls; their cold feeling of solidity juxtaposes nicely with the warm vibrations of the wood and grass.

↑ ↑ The conical pavilions inspired by Timorese *lopo* are connected with narrow roof-lines; the results are innovative in a residential setting.

↑ The use of various tiles on the pool floor produces a multi-faceted mosaic effect in the water of this crystal blue pool.

Set within a frame of natural sand-coloured stones and surrounded by colourful plants and lawns, the overall effect is inviting, cool and clean.

→ A simple wooden foot-bridge straddling a lush water garden leads to the main entrance of the villa.

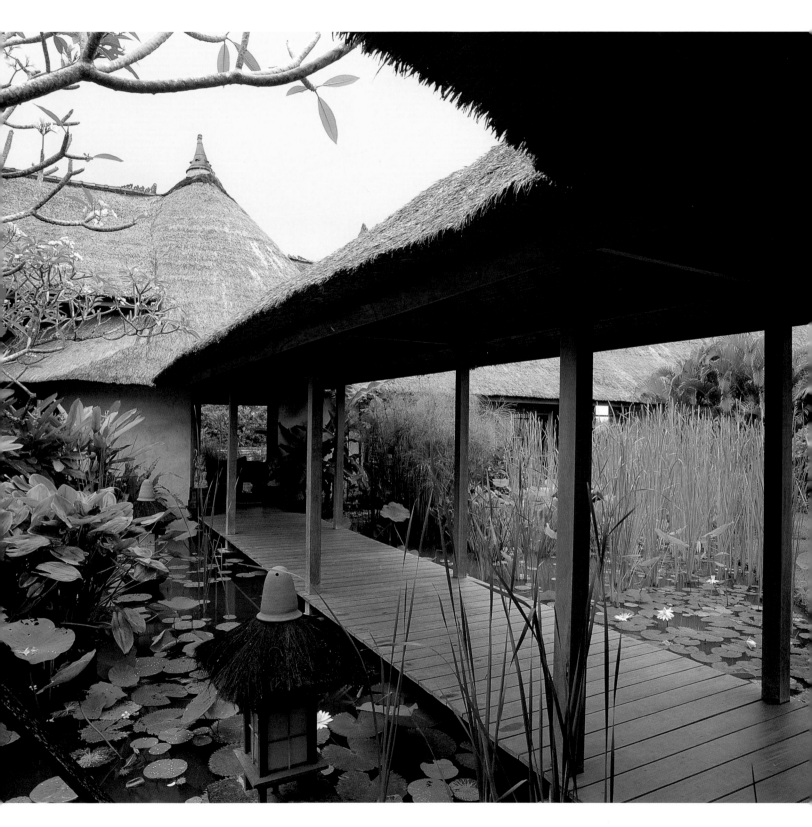

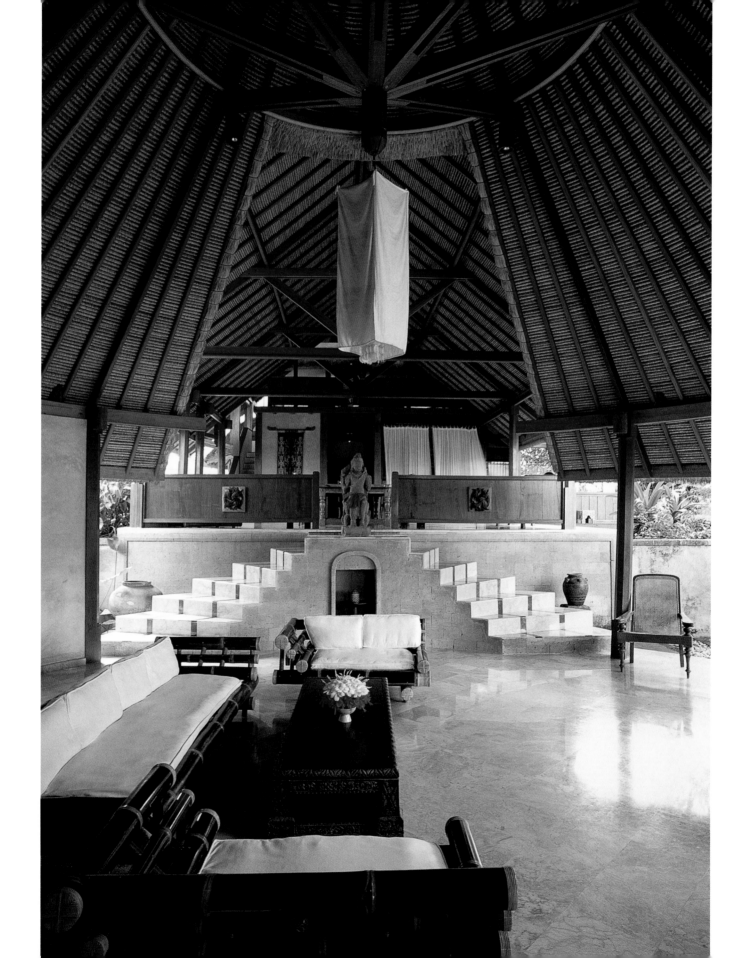

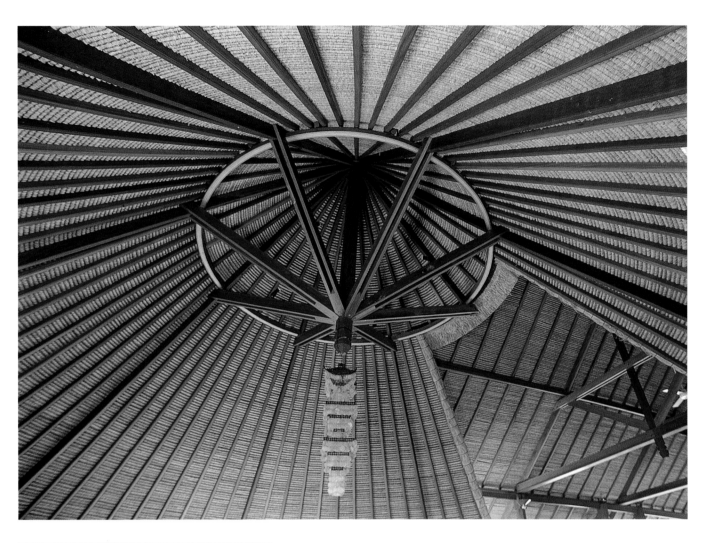

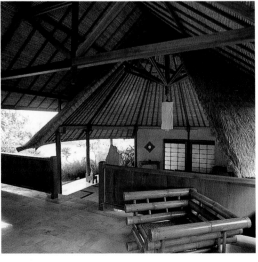

← ← Underneath a complex octagonal roof structure sits a grand living room, dual stone staircase and mezzanine above. In the foreground, the seating area is furnished with black bamboo furniture that provides a striking contrast with the light earth tones of the overall composition.

← A view from the mezzanine above offers another angle on the interplay between the different geometric applications of the roof line.

↑ A close-up view of the internal structure of the conical roof shows the ability of local craftsmen to deal with complex designs while using traditional techniques and materials.

Shingle Wings:
A Tropical Butterfly

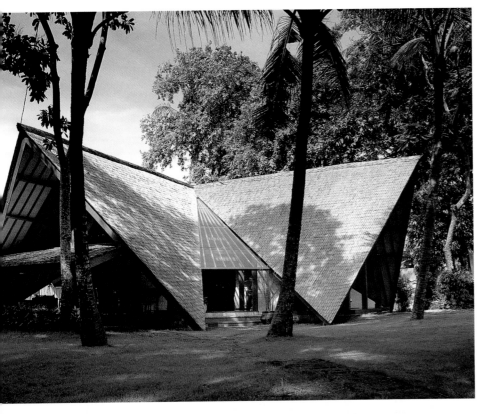

Simplicity and the strong geometrical composition of a bold butterfly-wing roof are the salient features of this house (*see also page 8*). Set amongst dense tropical vegetation in the Seminyak area, it was designed in 1997 by Italian GM Architects. The design is very compact. It hinges around a central internal lower volume, which houses the bedroom area and the kitchen. This is outlined by ivory limestone clad walls, above which two spectacular "shingle wings" open out to the exterior. The living and the dining areas find their natural position below each of these two "wings". They benefit from an uninterrupted view of the surprising inwards roof lines as well as an outwards private view of the surrounding garden. The particular shape of the roofs, with their pitches touching the ground, provides a sensation of intimacy but also allows for a continuous and refreshing in-and-out air flow. The entrance is cut centrally between the two "wings" and under a triangular-shaped sheet of tempered glass. The transparency of this architectural breaking element allows light to enter and affords a rare sky-view from the internal mezzanine situated directly below the apex of the glass triangle.

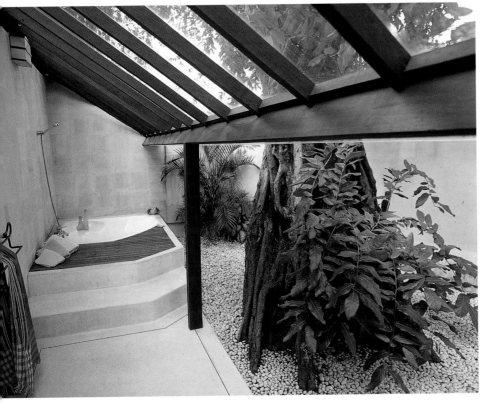

↖ The villa rests elegantly amidst tall palm fronds next to a clear sheet of water; the overall feeling is of light and space.

← An old tree, emerging from a bed of white pebbles, shadows the open-to-the-garden bathroom of the master bedroom.

→ The strong modern line of the transparent roof at the entrance. *Bengkerai* wood is used for the roof, the structure and the flooring in natural contrast with the white pebbles and the green lawn outdoors.

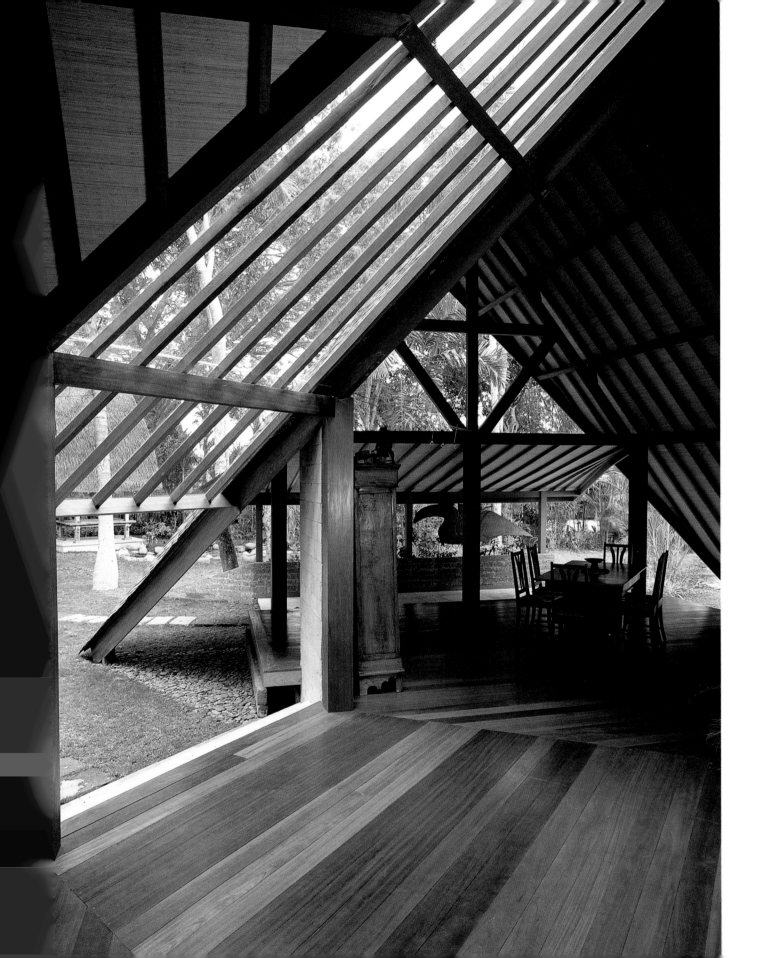

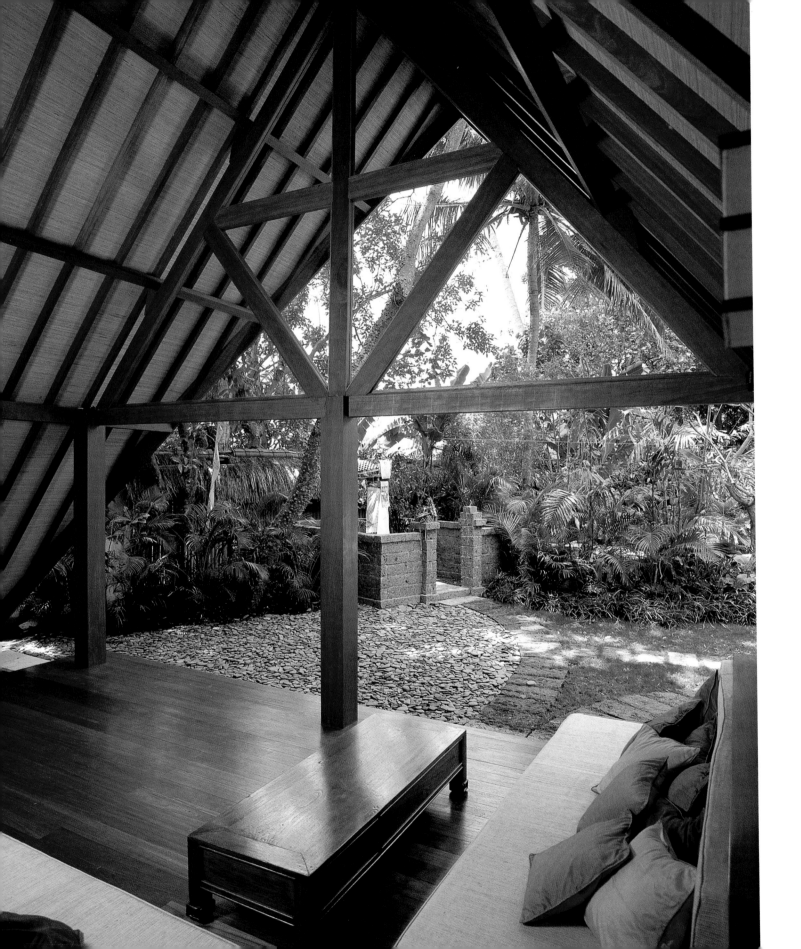

← The living area, which is located below one of the "shingle wings", opens up to a secluded corner of the garden where a Balinese traditional "home shrine" mingles amid the garden shrubs.

→ Behind the living area, an aerial wooden staircase leads up to the mezzanine: here there is a perfect relaxing niche with a view of the sky above.

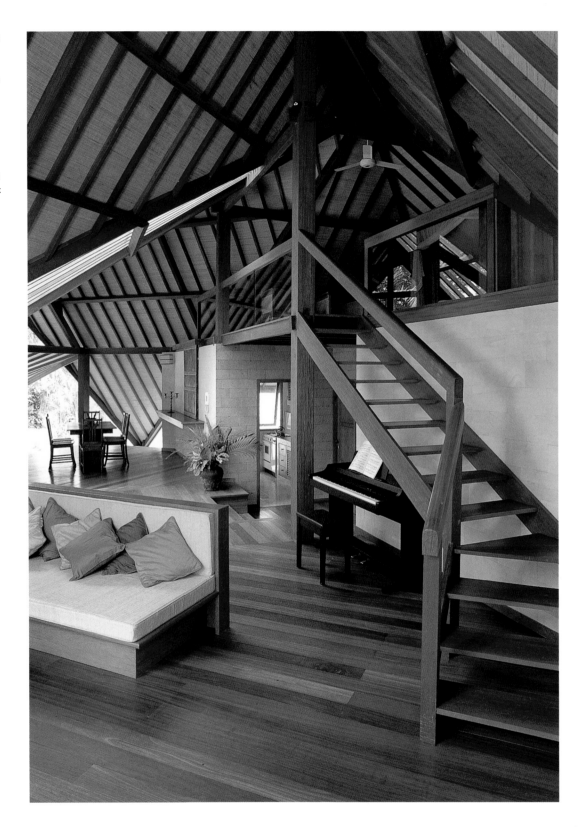

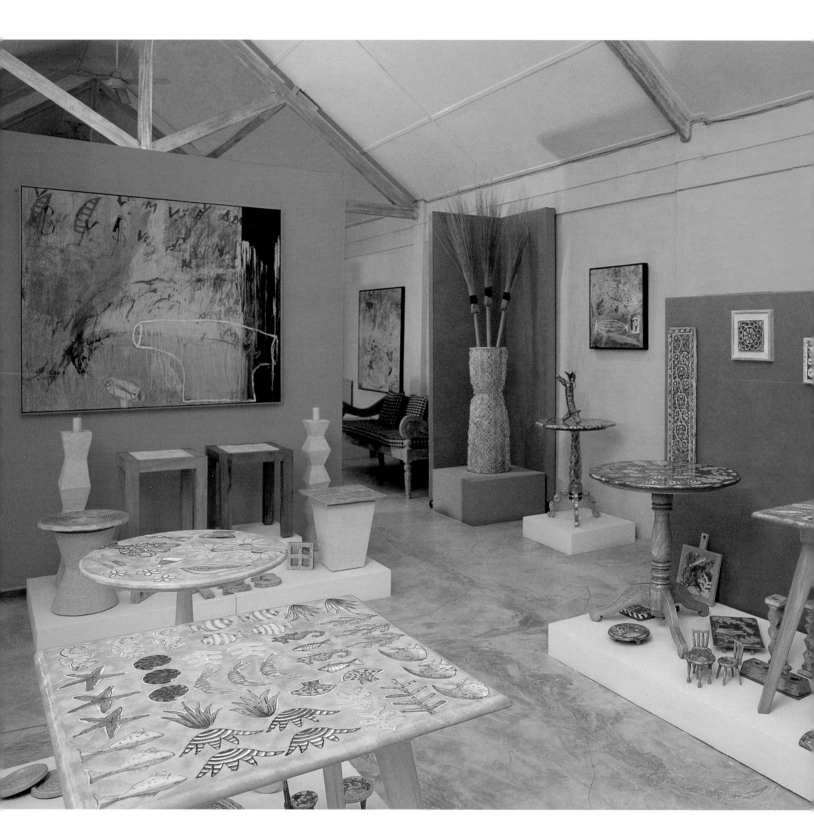

An Artists' Showroom

The studio of painter Graham Oldroyd and ceramic artist Philip Lakeman is full of vibrant colour. Set about here and there are an amazing array of exciting, contemporary ceramics which fully illustrates these two young Australian's combined skill. All the tiles and architectural features are cast on sand moulds, rather than by the traditional pressing techniques used by the ceramic industry. No two pieces are identical which is part of the beauty of the hand-made process.

Displayed in their stylish showroom, located in Sanur, are not only hand-made ceramics but also a wide range of other household goods and interior accessories in *palimanan* ivory stone and teakwood, as well as a collection of contemporary oil and mixed-media paintings. When you walk around this *mélange* of patterns, textures, tones and forms, it makes for a wonderfully sensory experience.

← Vibrant colours catapult the viewer into the fascinating mélange of pattern, texture, tone and form representing the artist's work.

↓ A group of carved stone candle-holders form a sculptural backdrop to a collection of other larger ceramic artefacts.

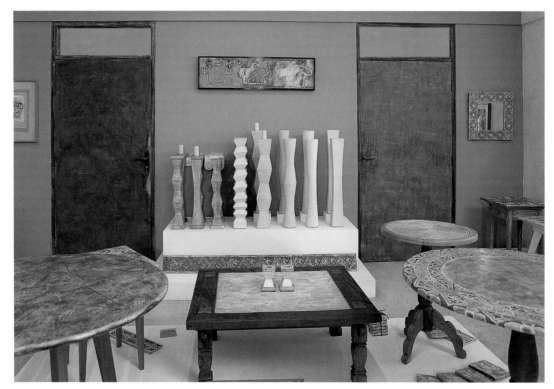

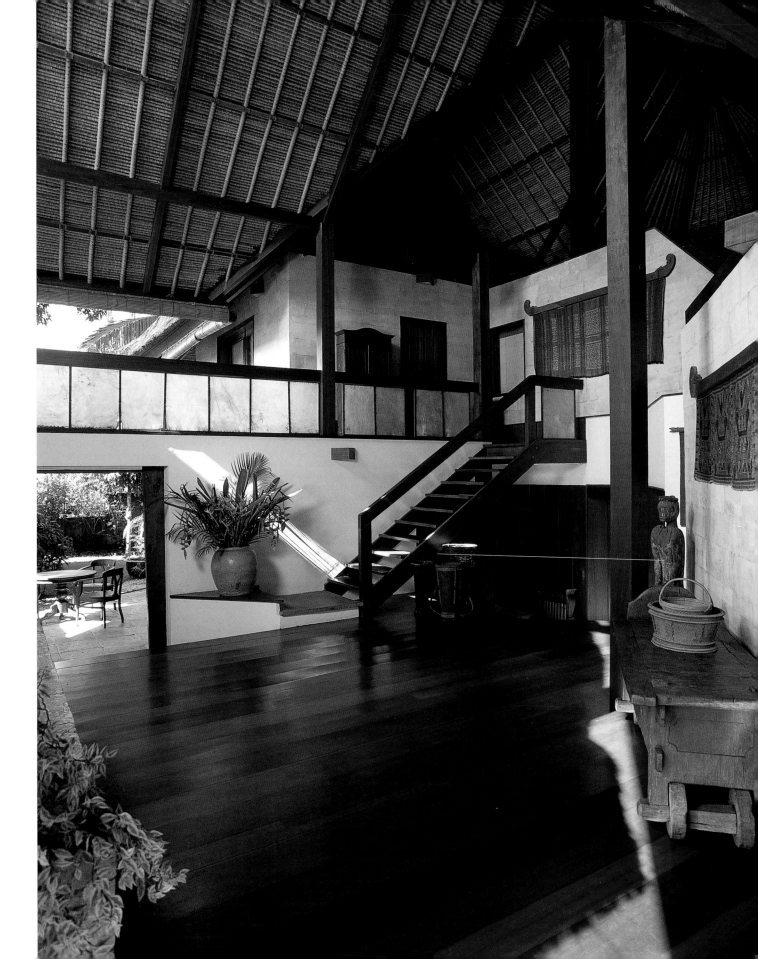

Evolving Architecture: A Point of Departure

Although it was designed seven years ago by the architect Gianni Francione, this house is still considered a fine example of the evolving dialogue between traditional and modern in the new Balinese architectural panorama. Perhaps its most distinctive feature is that the architect has almost everywhere used local materials, but has combined this use with an international design style.

The house, which is located on the outskirts of the Seminyak area, is sheltered by a mature mango tree, and ensconced in a lush yet refined garden. A stone pathway cutting through a soft lawn of Japanese grass leads to the entrance which is unusually located underneath the conjunction of two steeply pitched grass roofs. The outdoor-indoor transition,

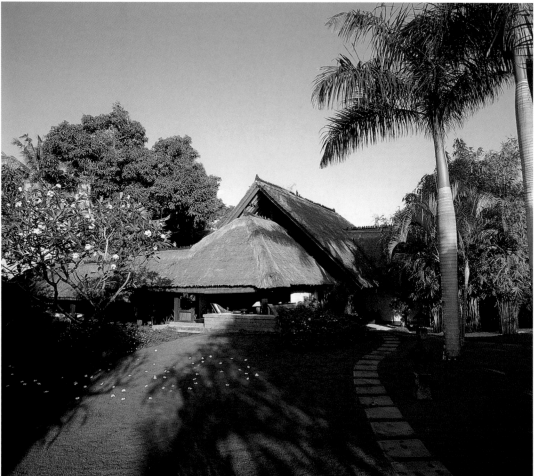

← ← The modern and the traditional are wisely combined here to produce an interior that is open, pleasant and airy. The warm wood tones and the local decorative elements contrast beautifully with the clean, spare walls and the modernist angles of the roof and staircase.

↑ The leafy fronds of tall bamboos and the elegance of a bonsai on a bed of white pebbles welcome the visitor with simplistic Japanese overtones.

← The soft Japanese lawn, dotted with frangipani flowers and adorned with tall king palms, surrounds the living area.

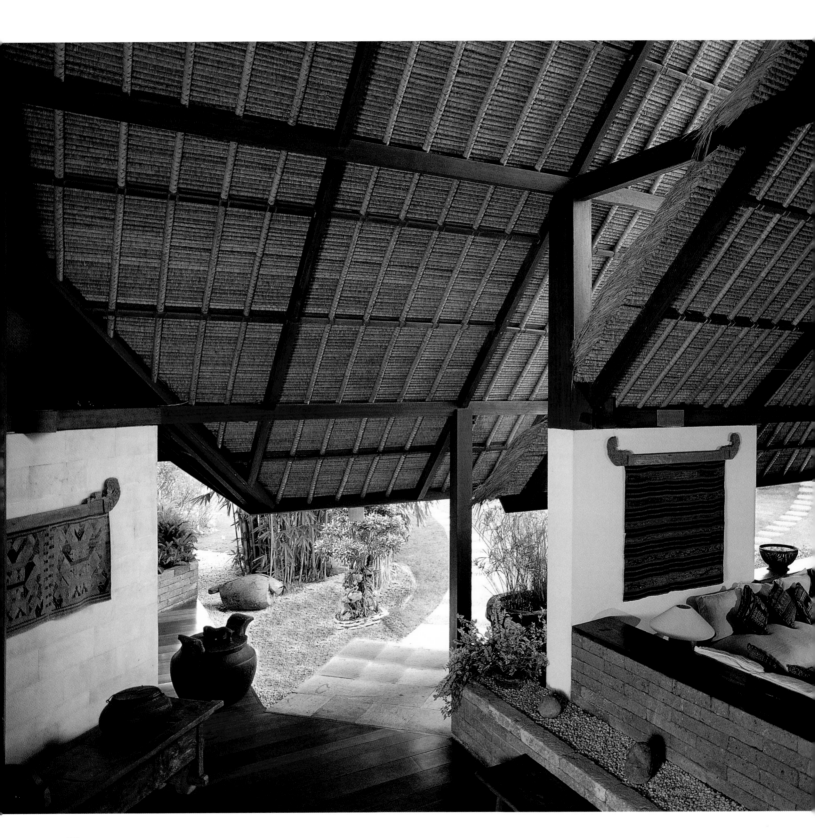

achieved simply by a change in flooring materials, opens up into an unexpected convergence of internal roof lines. A series of slim wooden columns of varying heights supports an articulated structure and interplays with planes and volumes to create a remarkable impression of light and space. This is further enhanced by the strong angles of both walls and roof. The warm texture of the traditional *alang alang* roof and the dark patina of the ironwood extensively used in wide planks for flooring, are set off by the smooth surfaces of the walls. These are either clad with *batu Jogia* – a Javanese sandstone – or are simply ivory washed.

Distinctive furnishings are placed thoughtfully throughout the villa and reflect both the owner's and the designer's passion for Indonesian tribal art: textiles, antiques, sculptures and other selected objects from all over the archipelago not only add character to the ambience but also become an integral part in the modern-traditional dichotomy expressed in this project.

← ← A view of the articulated internal structure of the thatched roof and the comfortable living area underneath. The change of flooring materials defines the outdoor-indoor transition at the entrance.

↓ The curved dining area, which is located on a lower level, opens into an internal private courtyard shaded by a mango tree.

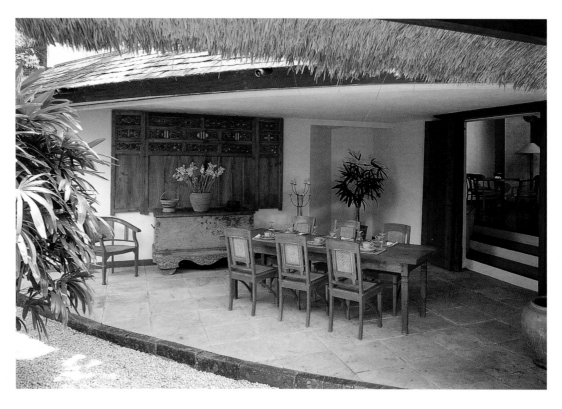

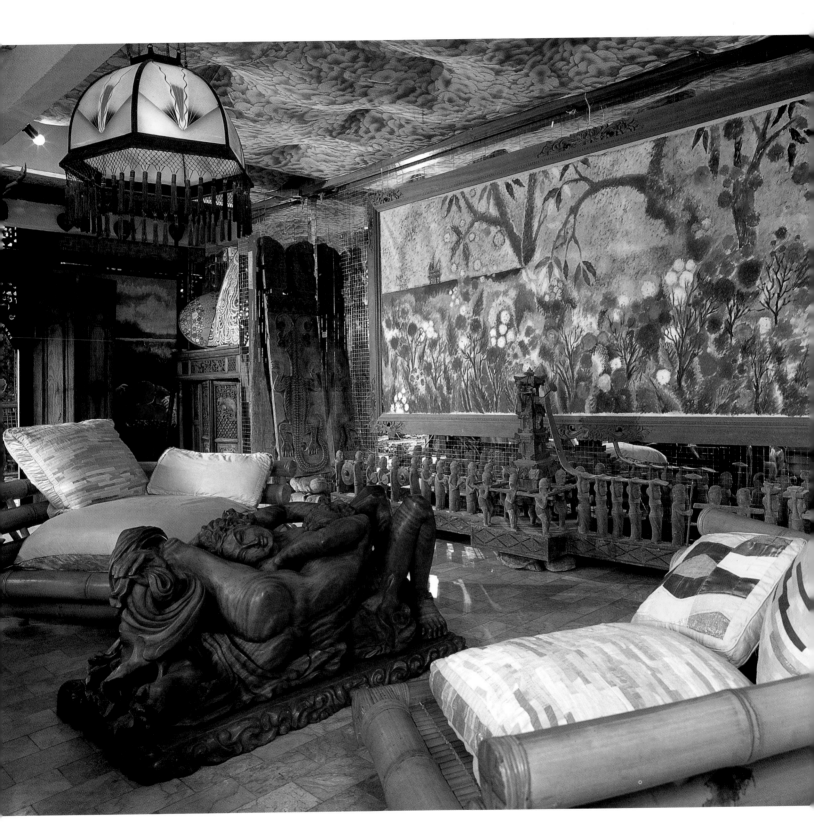

An Atelier Home

Ubud remains the cultural centre of the island, a crossroads for countless numbers of painters, sculptors and designers who exchange experiences and find inspiration in its thriving art scene. Naïf, Avant-garde, Neo-decorativism, Minimalism, Deco – all are embraced and practised here by Western, Indonesian and Eastern artists. One of these is the American artist, Nadya. In 1984 she built her atelier home, Puri Naga, using – almost entirely – a selection of recycled materials for walls, doors and flooring. Such usage illustrates the collaboration between the owner and local artisans and the latter's endless ingenuity in shaping and decorating her home. As she confirms, this has been an ongoing process for over 15 years and additions are still being made. A large collection of paintings and sculptures by Indonesian artist Wahyoe Wijaya are displayed in every available space giving the impression of a strong naïve eclecticism throughout.

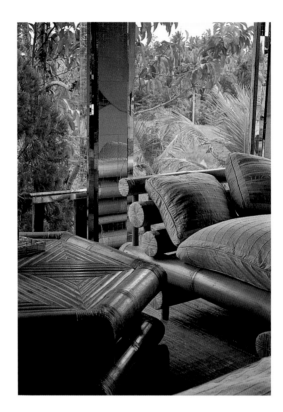

← ← Among the paintings, sculptures and objects by Wahyoe Wijaya, is an impressive, over 6 metre (20 foot) long, carved Balinese cremation procession in wood.

← An unusual mixed media sculpture made from a recycled plank of teak with inserts of gold leaf and white paint.

↑ A cosy corner on the first floor overlooking the tropical panorama. A glass inset pillar is a modernist touch.

A Symphony of Styles

The large variety of natural materials unique to the Indonesian archipelago, is a never-ending source of creativity for Bali's artists and interior designers. Countless types of stone with a wide range of textures and hues, as well as marble chip, pebble, terrazzo, coconut shell, seashell, mother-of-pearl and many more, are used in myriad ways. Often, they are not only used to decorate or face walls and floors, but also to create new artefacts, panels, utilitarian objects and pieces of furniture.

In this house in Sanur, the Italian owner Carlo Pessina has created a remarkably refined ambience by combining his talent for interior design with his passion for art. Firstly, he designed a complete collection of furniture using young coconut shell, plain or inlaid with mother-of-pearl, and resin-based terrazzo mixed with marble chips, crushed shell or brass. Various ensembles of tables, consoles, chairs, desks and household goods and accessories were thoughtfully assembled and matched with their various locales. Paintwork, flooring and wall finishes were also taken into due consideration. Alongside these contemporary pieces, Pessina placed a number of selected pieces of primitive and colonial art. The result is an interplay and merging of the modern and the traditional, a balanced "symphony" of materials and styles.

↑ ↑ The white coconut surface of the table top has a basket-weave pattern in local black "penshell".

↑ A close-up view of the finely crushed texture of a terrazzo chair.

→ A well-matched and balanced ensemble: The round table top is covered in young coconut shell geometrically patterned with mother-of-pearl, while the central base is made from an old Javanese mortar. The green terrazzo chairs match the tone of the colonial painted door from Java far in the background (and even further to the palms in the garden!). Some primitive art pieces and a selection of colonial furnishings are strategically positioned near the walls.

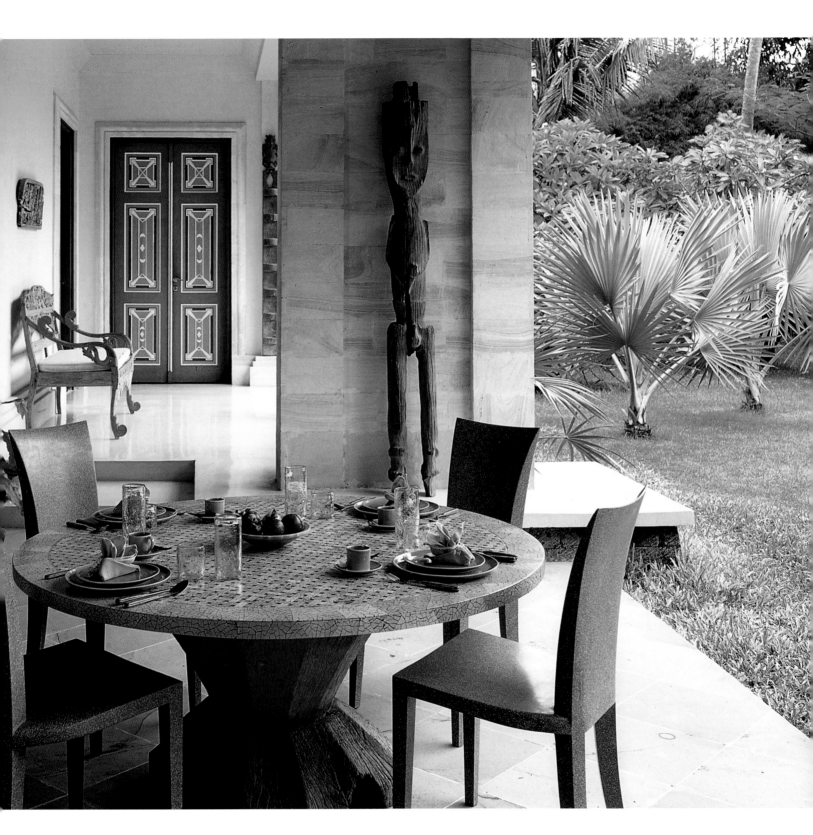

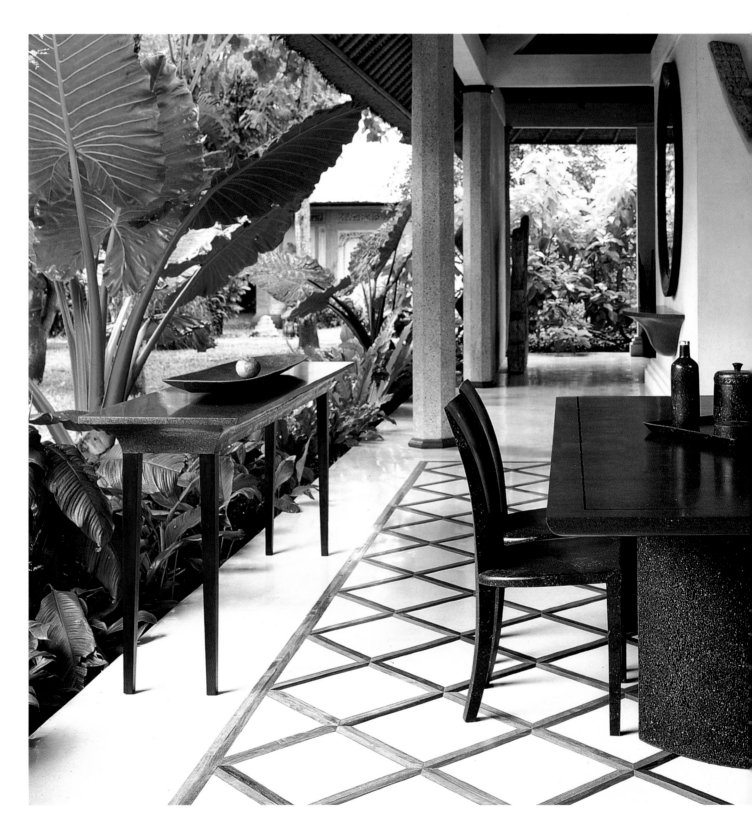

← A selection of modern furnishings designed by Carlo Pessina for his Nusa collection stand out against the wooden patterned white terrazzo flooring. The rectangular table top and console are made of a resin-based terrazzo with brass inserts, while the chairs are in dark coconut shell, as are the accessories on the table.

↑ A stenciled wall is the perfect backdrop for this coconut shell table lamp and set of side tables patterned with mother-of-pearl.

← The low table located at the foot of the bed shows another variation of the owner's skill with coconut shell patterning. Its modern lines contrast with the an overall antique Javanese accent of this romantic bedroom.

→ The highlight of the open bathroom is the layered mother-of-pearl basin inserted on a white coconut shell counter top. Add to these, the sheer size of the room, the marble and pebble combo floors and the tropical plants, and the result is back-to-nature bathing with lashings of style.

Modern Sensibility and Local Technique

"As the archetype of the delicate and feminine, the *legong* is the finest of the Balinese dances."
(Miguel Covarrubias)

The use of local materials to create functional decorative pieces is the hallmark of this house. Designed by the Italian Beppe Verdacchi and located in the Bukit area atop a hill overlooking Jimbaran Bay, the detailing was produced by many of the best local craftsmen. Verdacchi plays here with wood and stone, producing not only ethereal bas-reliefs or sunken bathtubs, but also clean and essential staircases as well as almost minimalistic beds. Each composition reveals the particular attention given by the designer to the smallest detail and shows how productive the dialogue can be between modern sensibility and the long tradition of remarkable local craftsmanship.

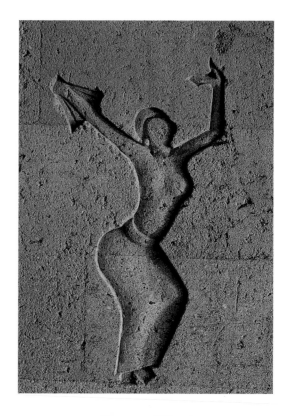

→ → The anchor of this room is the wall, made from volcanic sedimentary ivory tuff. Depicted on it are replicas of drawings from Miguel Covarrubias' seminal book *Island of Bali* (1937), showing the lively movements of the Balinese *legong* dance. It is the conversation piece of any gathering in the living room.

↗ → The bas-relief dancing silhouettes are miniature pieces of art.

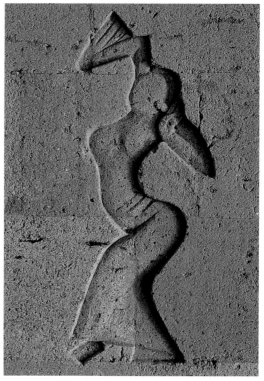

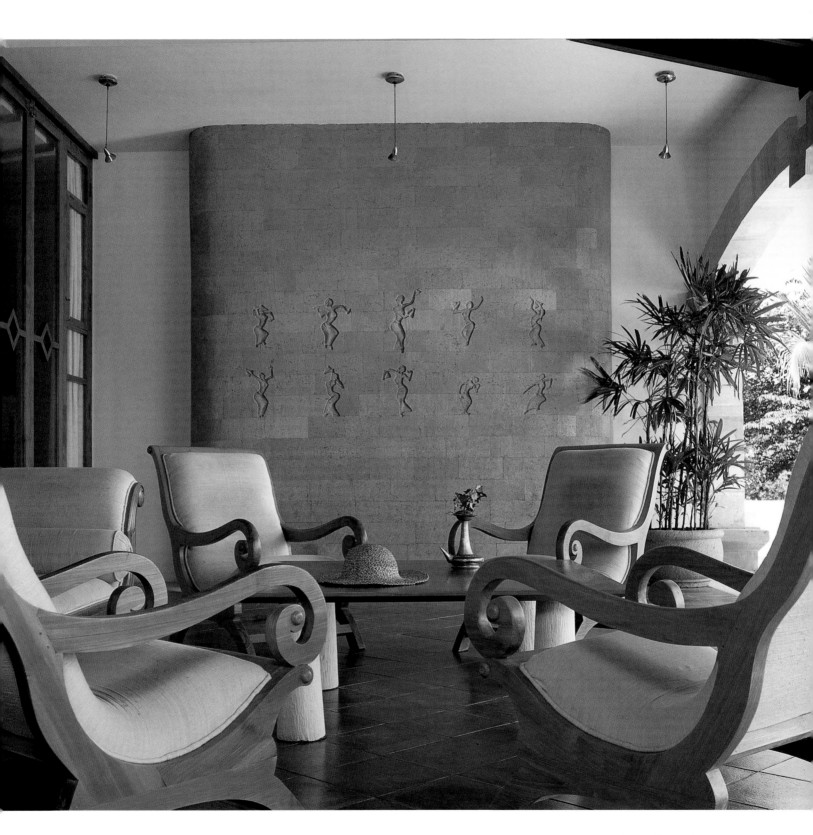

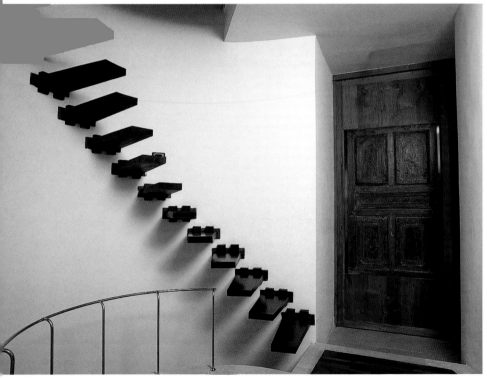

← The sunken bathtub of this open-to-the-garden bathroom is entirely made of modelled *palimanan* ivory stone, as is the floor which is patterned with simple square teak decorations.

↙ An elliptical staircase, composed from steps of dark *merbau* hardwood, becomes a contemporary installation in this gallery-type setting with its white backdrop. On right an antique Madura panel has been reframed in a modern manner with stainless steel pins onto a teak door.

→ A non-traditional bed with suspended canopy, made of stone and planks of teak is placed at the centre of the upstairs master suite. Its refreshing modern design is offset by the airy pastel paintwork and the stunning view overlooking the ocean.

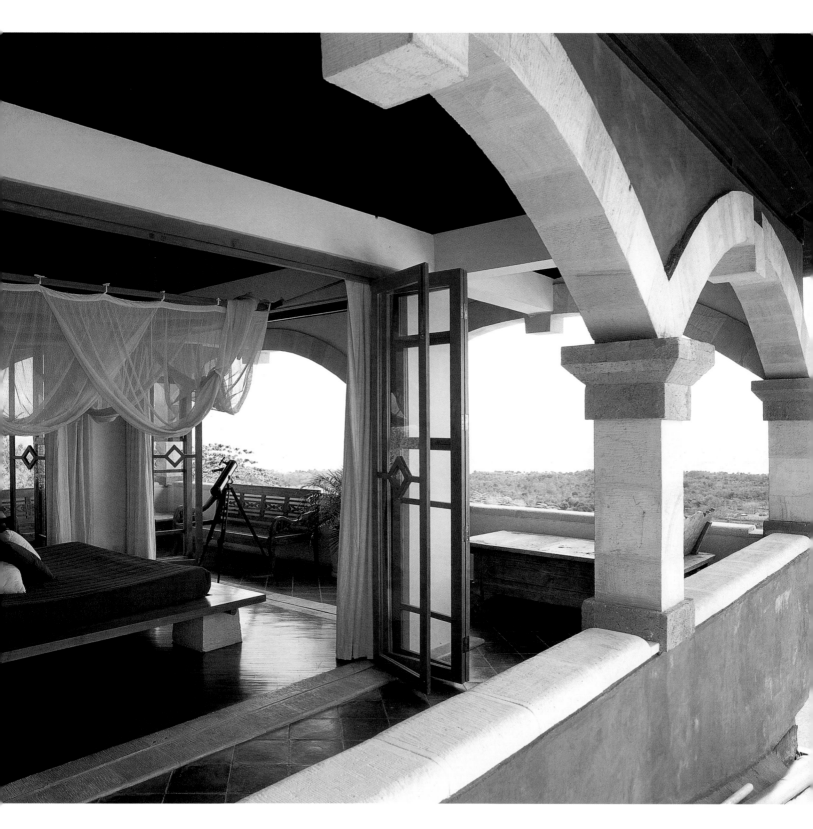

Octagonal Opulence

This is an atypical house in many senses. It is rich in symbolism, features an unusual number of strange shapes and makes extensive use of terrazzo on the surfaces. Set amidst dense tropical vegetation 100 metres from the beach in the Petitenggett area, the villa was designed by its Italian owner, fashion designer Milo. Its main inspiration comes from the principles of *feng-shui*, or the Chinese practice geomancy, but the house also utilizes some other mystical geometric elements.

At the entrance is a charming portal. This follows the traditional layout of any Balinese compound and acts as an *aling aling* or screening wall that deflects bad spirits and prevents them from entering. From here, one walks into the garden, where the main building is located in the centre.

It is housed beneath a grass roof and is composed of two concentric octagonal structures – these become the focal point of the overall design of the house, and give it both its form and meaning.

Home-made, high-quality terrazzo – in a wide range of patterns and colours and made from chips of marble set in concrete and polished to give a smooth surface – is extensively used indoors for flooring, walls, columns and furnishings. It is freely blended with bleached tropical wood, mother-of-pearl inlay, Venetian lamps, brass and stained glass for creative effect. Strong, shining and abstract, it creates an overall impression that is almost cabalistic. Eclectic, certainly, and infused with an atmosphere rich in mystical meaning, the villa is like no other in Bali.

→ A close-up view of a small terrazzo-made coffee table, in delicate hues and geometrically patterned by brass inserts.

→ → The inner octagon, housing a spacious relaxing area, is the focus of the indoor space. An aubergine-violet terrazzo dresses the flooring and the columns around, while the round, oversized floor cushions and the mirrors in the background produce a sensuous, intimate aura.

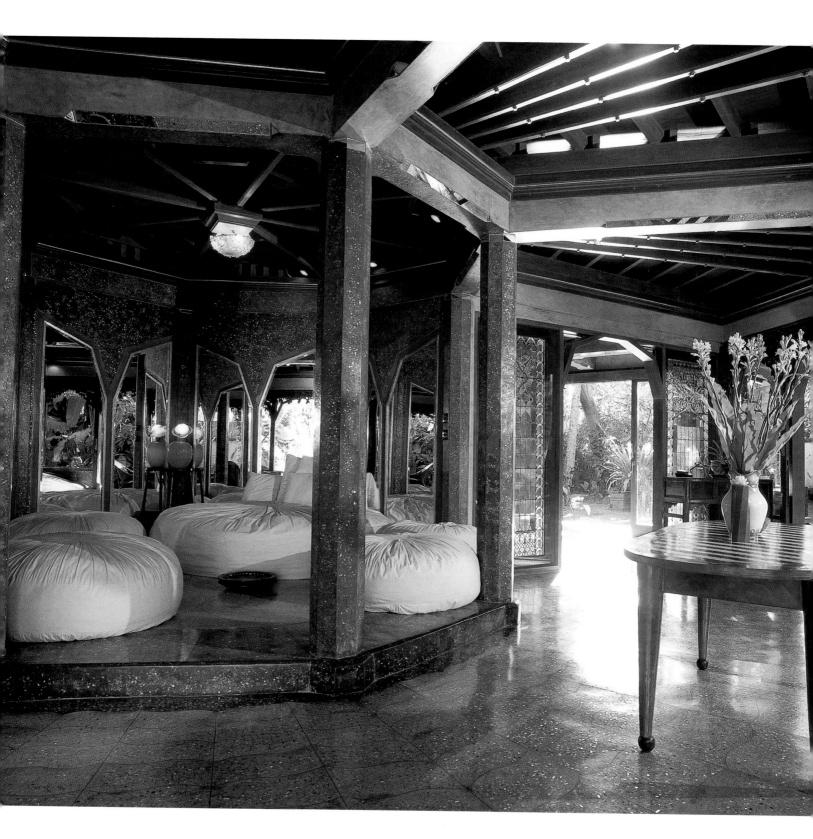

↑ ↗ High-quality, hand-made terrazzo with inserts of crystal and mother-of-pearl is used to form almost abstract compositions throughout the villa.

→ The ancient Egyptian symbol of mysticism or "the flower of life" is illustrated on the floor of the house's interior foyer. Made of white and blue terrazzo, it complements a lavish brass door.

→ → At the entrance, this highly decorative portal, sinuous in form, welcomes the visitor. A statue of Siva on a pedestal symbolizing human DNA stands at its centre.

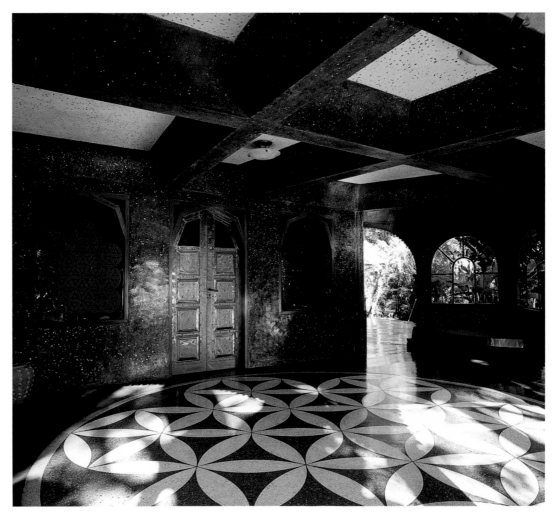

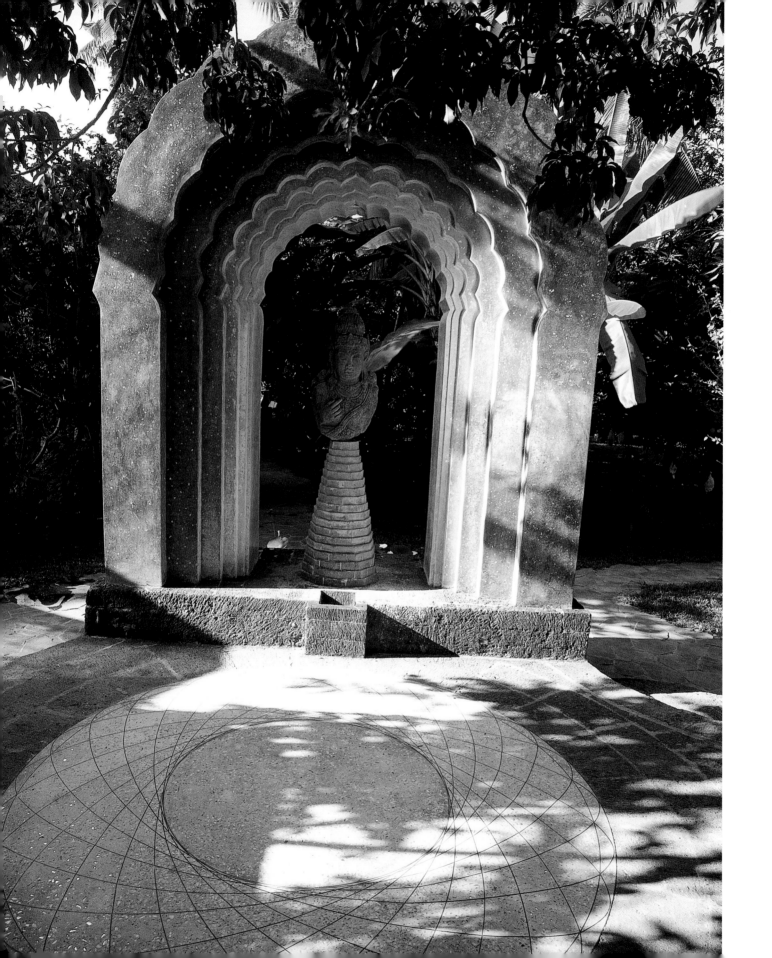

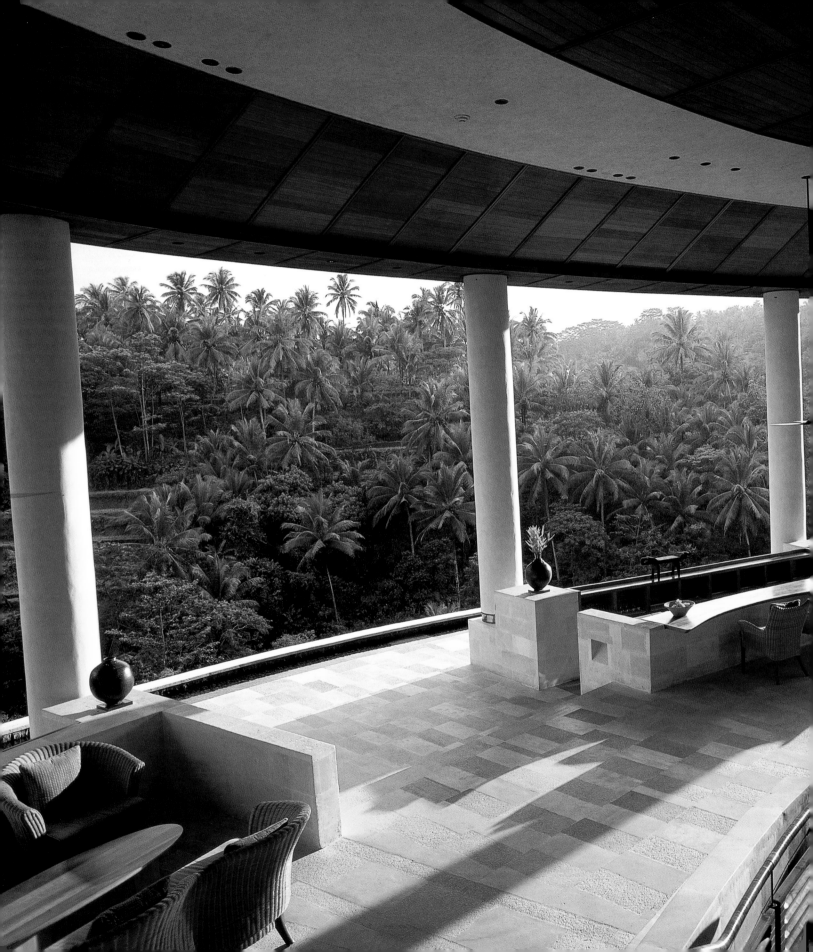

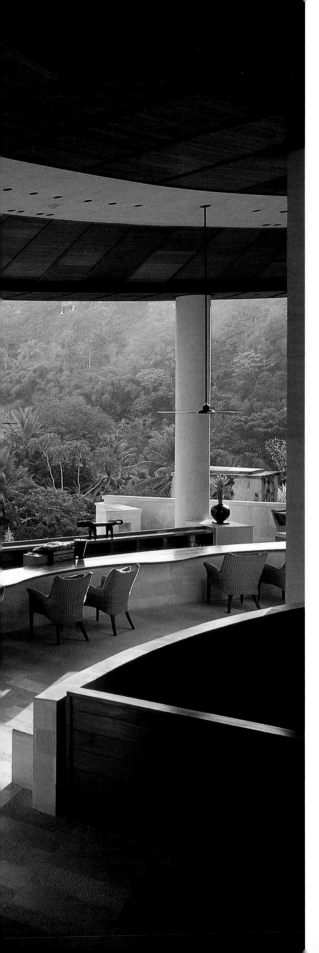

Challenging Nature

The sacred Agung River, meandering through the valleys and rice terraces of the Sayan Ridge, feeds the lush tropical vegetation, fills the paddy fields and provides water for the various temples and sacred bathing places. It is a truly special environment, and perhaps not one that immediately springs to mind for a five-star luxury resort. However, it is here that Mr Ong Beng Seng's Hotel Properties Limited envisioned Four Seasons Resort Bali at Sayan. The challenge of the project, designed by the studio of John Heah and Co, was to blend a strong contemporary architectural presence with the breathtaking beauty of an unspoiled tropical valley. The result is something unique and certainly quite innovative.

Twenty-eight private villas are spread at the bottom of the valley. An extensive use of flowing water, as well as natural ivory-toned cladding, helps to integrate them with the surrounding dramatic terrain. A well-tended landscaped garden designed in an accurate and sensitive manner, links in an organic way the areas where the villas are sited to the river. Alongside this, lies a free-form swimming pool on two levels surrounded by extensive wooden decking and relaxing areas.

← From the Jati Bar, a splendid space framed by natural ivory stone columns, walls and floor, is a panoramic view of the Ayung River jungle valley.

↓ Seen from above, a view of Four Seasons Resort Bali at Sayan in its unspoiled tropical valley setting. It exudes a strong contemporary presence in this untouched natural environment.

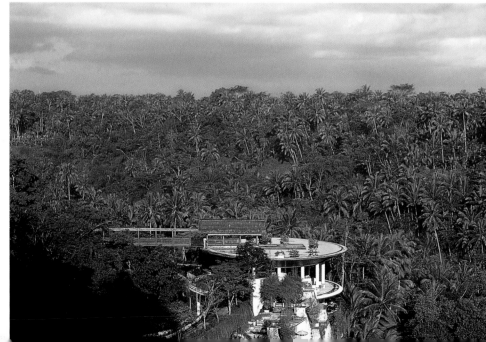

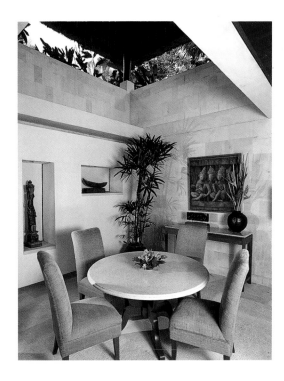

↑ Selected artefacts and sculptures are inserted in the white stone surface of the open-to-the-air sitting area of the villas.

→ This simply designed seating area, next to the Ayung Terrace, is enclosed by the strong presence of a densely carved round wooden panel.

→ → The lobby lounge area and the dining room are connected by a circular all-teak wood staircase, enclosed by cream plaster walls. The teak wood and steel railing is a blend of contemporary design and superb craftsmanship.

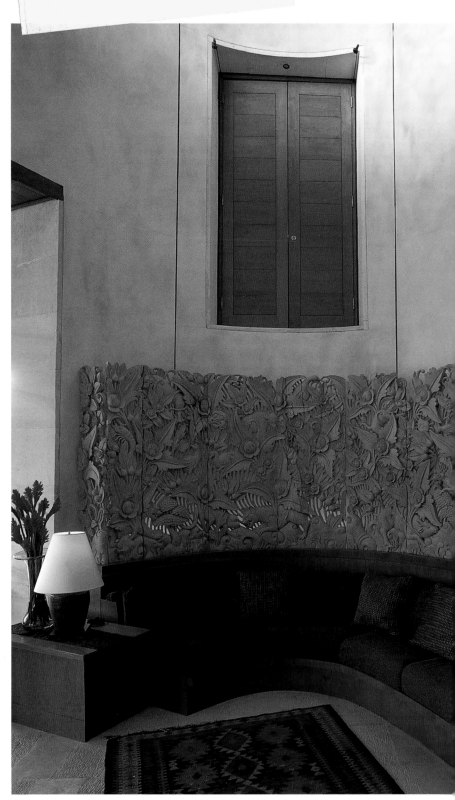

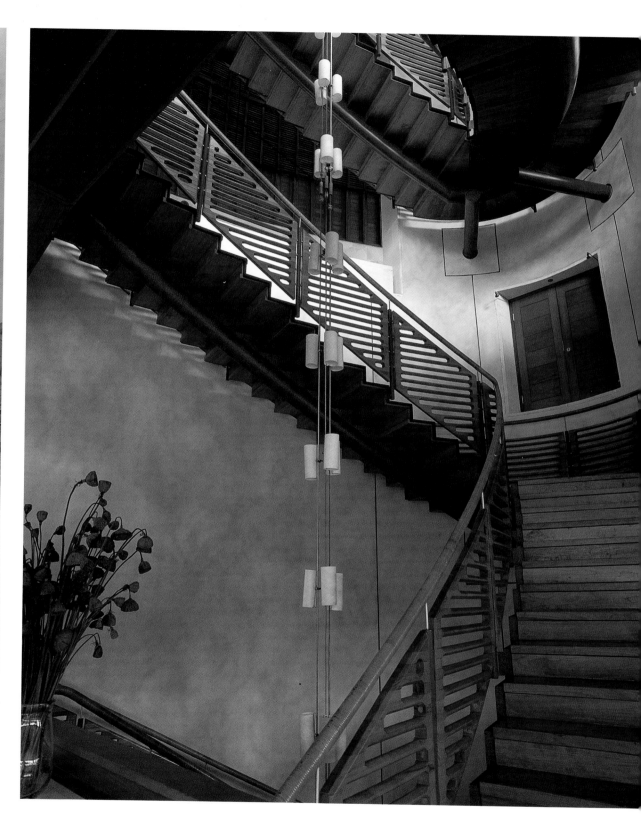

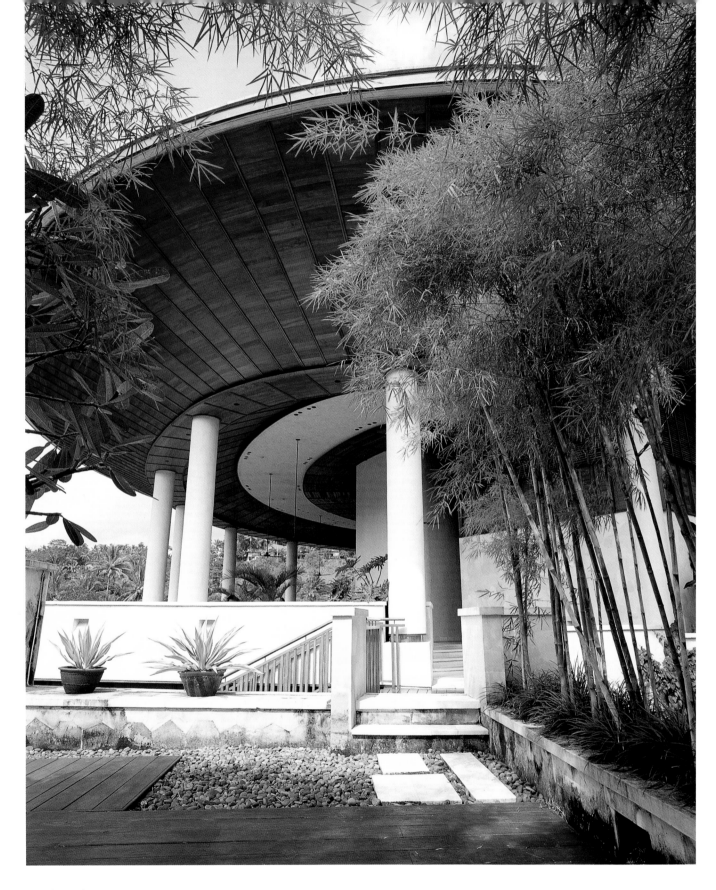

All these are relatively straightforward design-wise; but the central standing structure, with the lobby, restaurant, health club and spa, administration and 18 suites, posed the real challenge. It forms the focus of the property and is its most dramatic element. Approached via a 55 metres (180-foot) long teak and steel footbridge straddling 20 metres (65 feet) in the air, it opens out on to a large elliptical lotus pond. This fully covers the massive, three-storey cylindrical building set on the valley floor. The approach into the lobby is "through" the water – one literally descends a staircase that cuts through the pond and leads down to the reception. The views are dramatic and the experience as particular as the approach.

Walking through the property, in and out of the many galleries, bridges, staircases, passages, external and internal walkways, uncovers a dense and detailed architecture and a rich interplay of solids and voids. It is certainly a remarkable attempt to integrate a strong structural presence within a secluded and private environment.

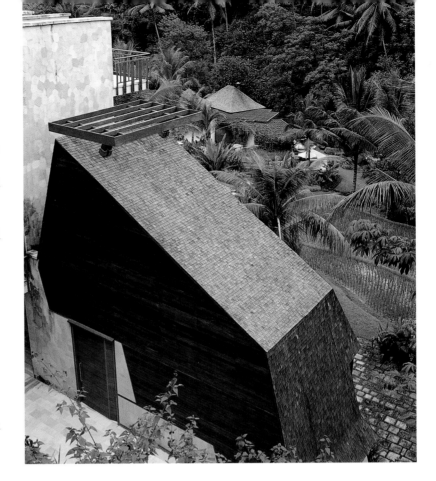

← The main building displays a strong architectural presence. A series of white columns supports the elliptical shaped volume. This is totally covered by a unique rooftop lotus and lily pond above (*see pages 174–175*) and is panelled below with concentric stripes of tropical wood.

↗ The contemporary shape of this meeting room is fully dressed with teak planks and ironwood shingles.

→ The reception area is designed to channel one's eyes towards the tropical scenario beyond. Ivory stone flooring, complete with refined pattern, offsets the darker tones of ironwood fixtures.

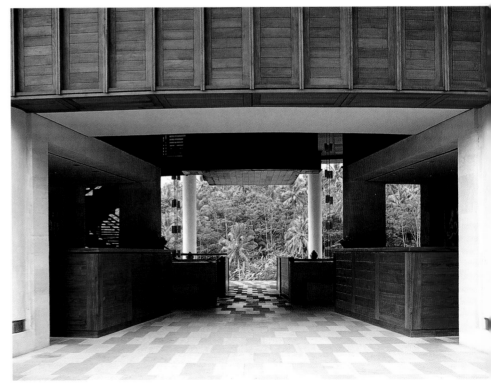

In a Coconut Grove

Situated on a relatively small two-hectare plot of land on the east coast of Bali, the Balina Serai hotel was designed by Singapore-based Kerry Hill Architects. The resort, which opened in 1994, was developed around a 20-square-metre (66 sq-ft) swimming pool. It comprises four separate double-storey blocks, all housing guest rooms; each has a remarkable view across the pool and coconut grove to the beach.

The architectural language, integrated in a lush coconut palm garden, is simple, with the repetitive use of rectangular traditional roofs over square arched, ivory-rendered facades. The restaurant is accommodated under a well-proportioned, square-thatched, pitched roof: wide, overhanging eaves create a close relationship to the ground. Clean, ivory-toned, covered walkways cadenced by squared columns link the restaurant to the lobby. Attention to both detail and materials in the interior and exterior spaces gives a strong definition to the overall design. It also helps to enrich the hotel's presence amidst the surrounding landscape, most of which has been left as it was before construction.

→ A plain, but appealing, column-lined walkway along the side of one of the blocks.

→ → A wide tent-like roof form provides shelter for the restaurant and becomes the visual highlight of the overall composition.

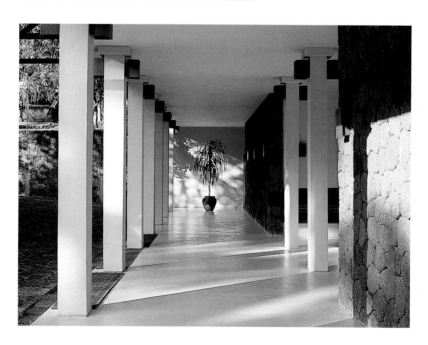

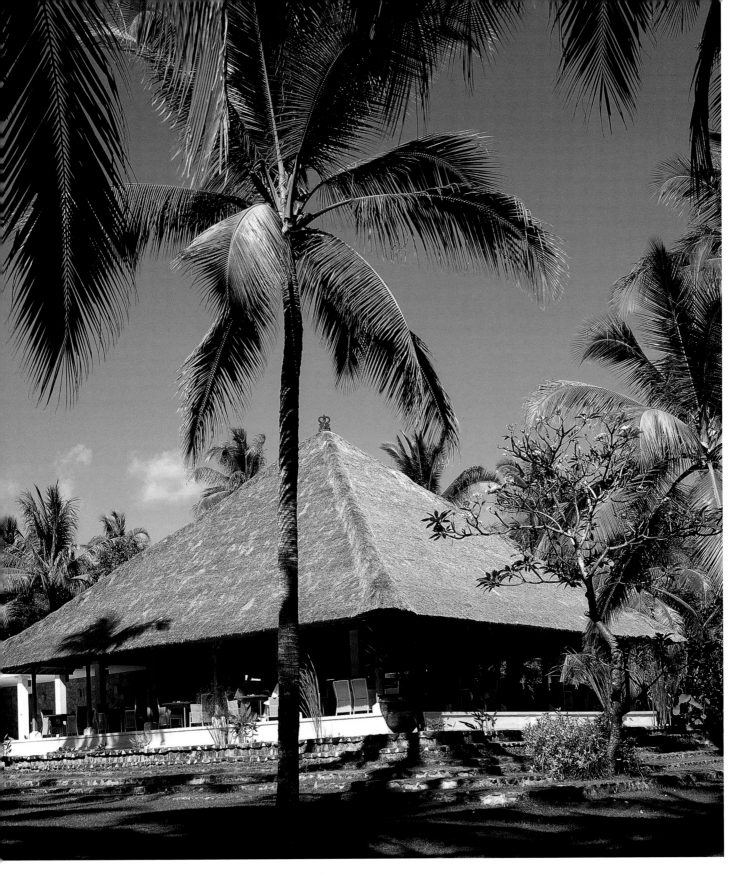

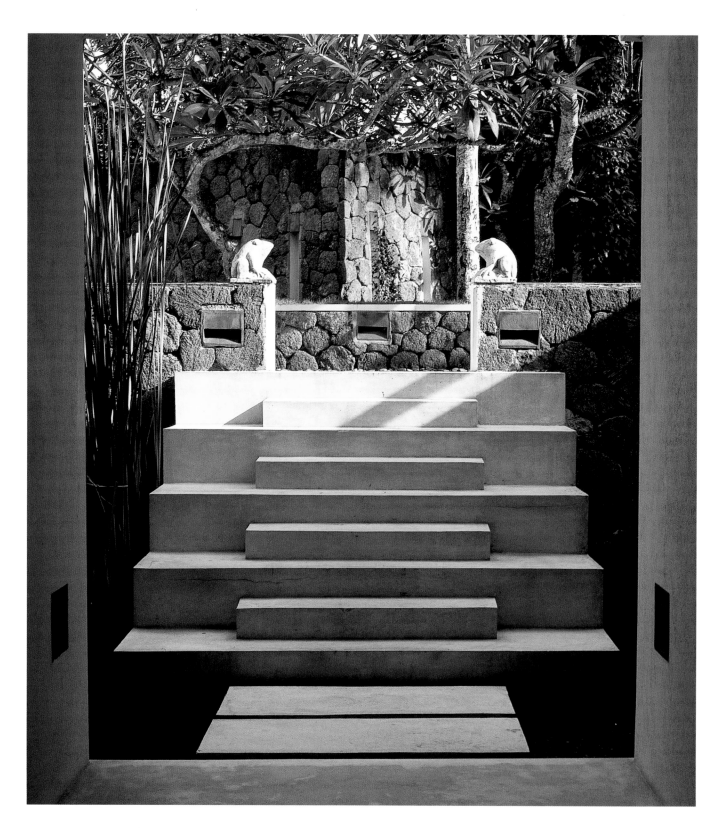

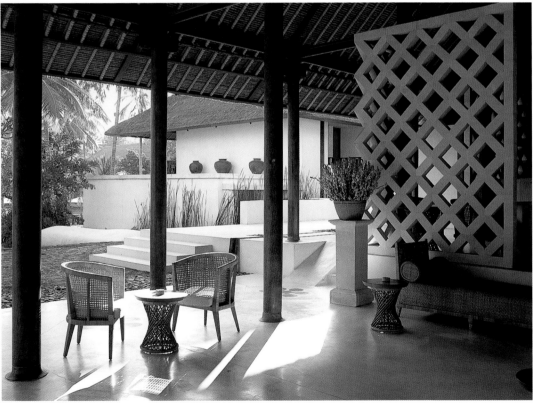

← ← This theatrical composition merges a traditional natural backdrop with a sculpture-like modern staircase. Purity of lines and perfect symmetry are aesthetically appealing.

↖ The contemporary design of these wicker and iron chairs are the perfect accent for this simple square dining table for two.

← Local materials are used unexpectedly for non-traditional applications, as in this stone trellis in the background.

The Art of Tropical Living　93

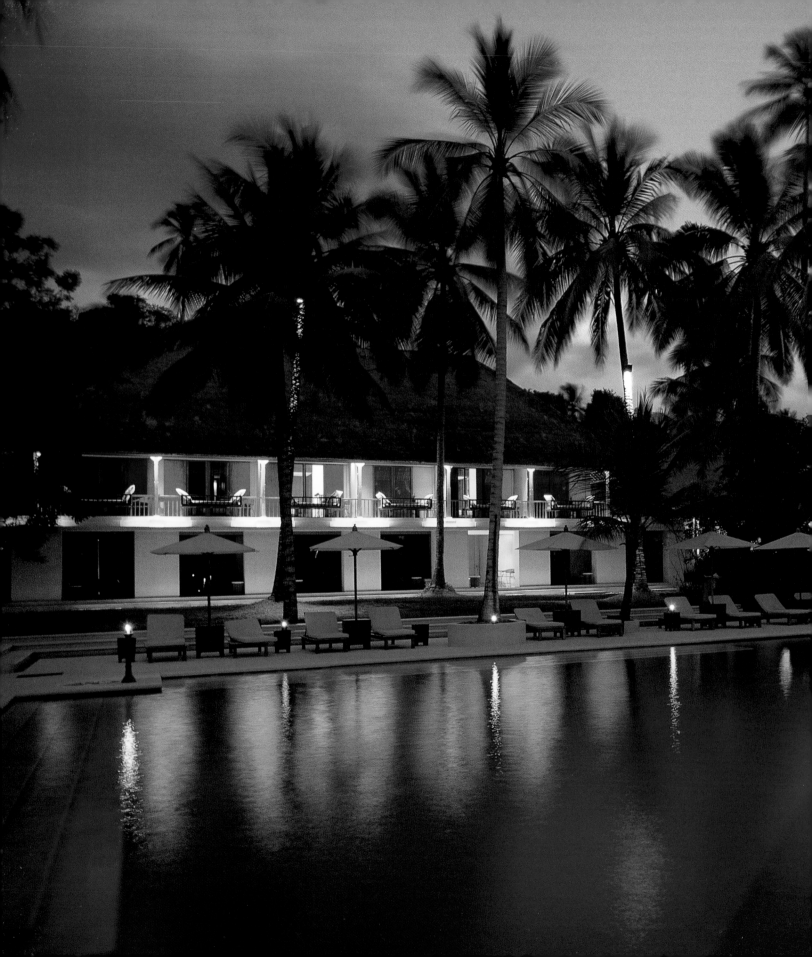

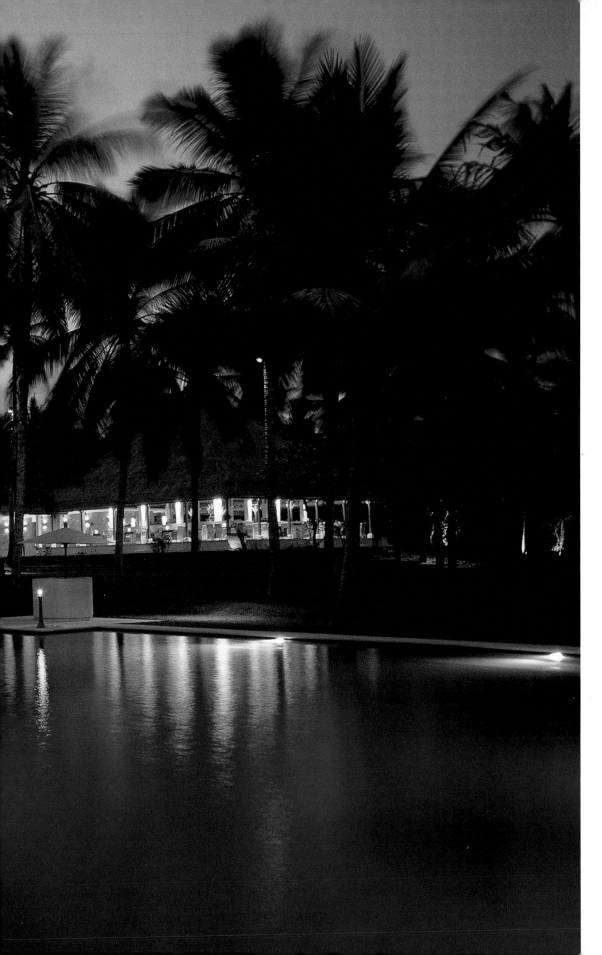

← A romantic view of the resort by twilight. The Serai's accommodation is situated around a large square swimming pool set in a coconut grove; lobby, restaurant and bar lie adjacent.

Grandeur Aman-style

Located in Nusa Dua, this exclusive resort designed by Singapore-based Kerry Hill Architects lies atop a hillside that gently slopes down towards the ocean. The hotel has sweeping views of tropical vegetation on all sides and overlooks a spectacular 18-hole golf course that stretches down towards the sea.

The complex comprises a central monumental double-storey building – where the entrance, lobby, bar, restaurant, shops and galleries are located – and 35 traditional thatched-roof, pavilion suites. All are connected by a series of landscaped pathways. The U-shaped front body of the main building encompasses a majestic rectangular pool. The strength of the design lies in a challenging interplay between solid and light architectural elements. A massive sandy-toned stone wall stands proudly between a transparent turquoise-blue water surface and a series of aerial thatched roofs. Long horizontal fretworked stone rails edge the galleries overlooking the pool from the upper level, while traditional wooden doors and ceramic ornaments are inserted at intervals. There is a powerful sense of solidity, but this is diluted by a delicate and sensitive composition of ivory and earth tones in the decoration. The resulting balance is perhaps the most innovative part of the property. Covered internal walkways connect the various parts of the building. Lined by rythmic sequences of ivory-toned rendered columns interspersed with artefacts and tropical plants, these pathways flow through the building to the lobby. Here, a dramatically lit relief of carved wood, framed by strategic lines of columns, gives visitors a truly majestic welcome.

→ Less is more in this seemingly limitless lobby, complete with outstanding Balinese carving.

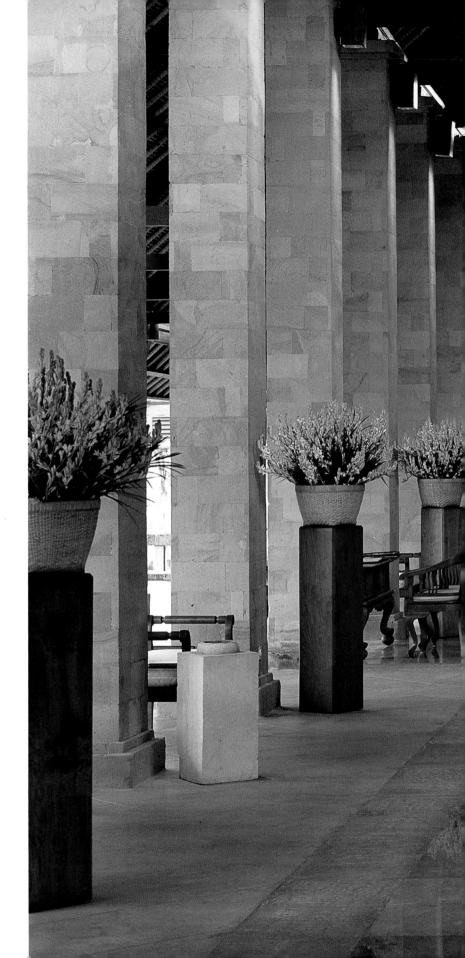

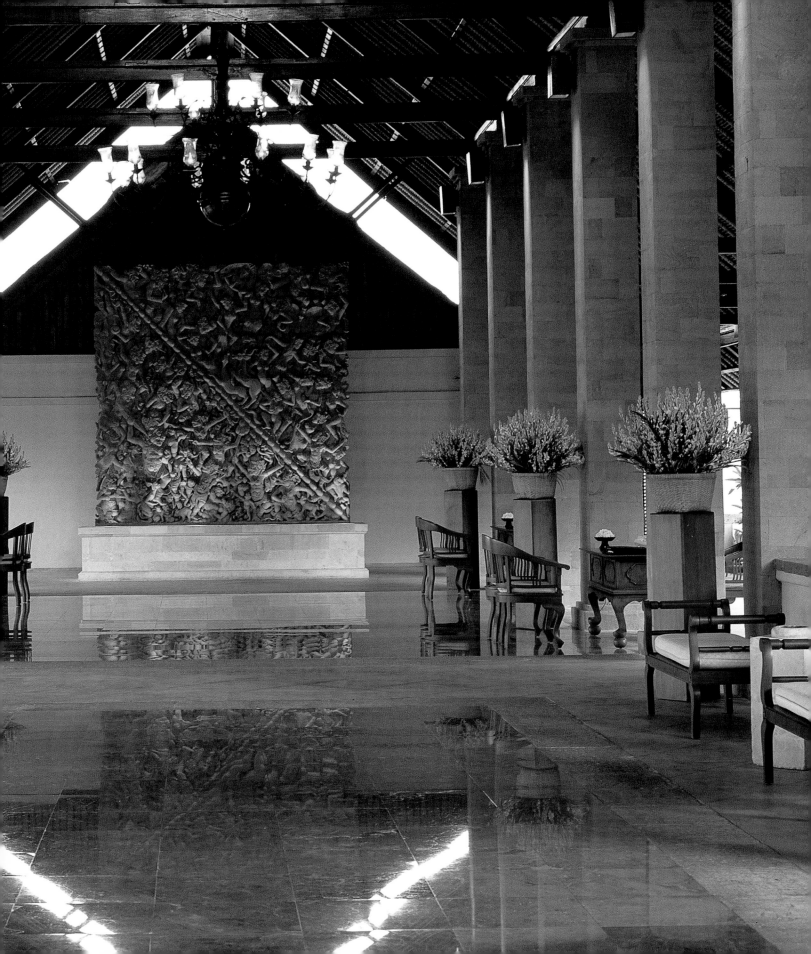

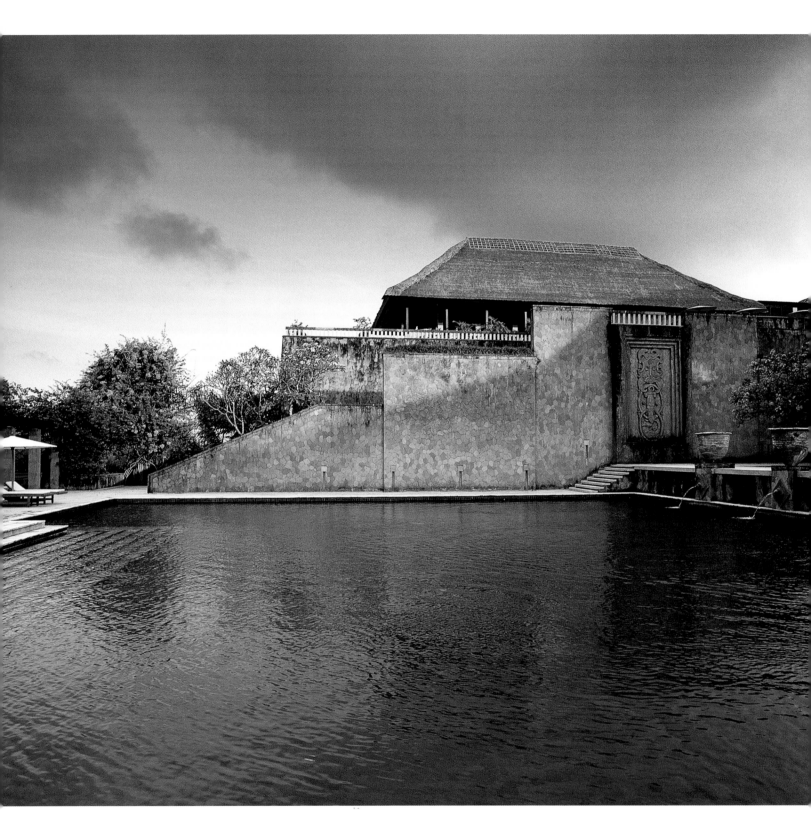

← A close up of the majestic pool enclosed by a solid earth-toned composition of stone walls and *alang-alang* grass roof.

→ The view from the terrace walkway above the pool gives one the opportunity to take in the spectacular landscape.

↘ Shadows cast by the natural light are the perfect complement for this clean columned walkway lined with primitive artefacts.

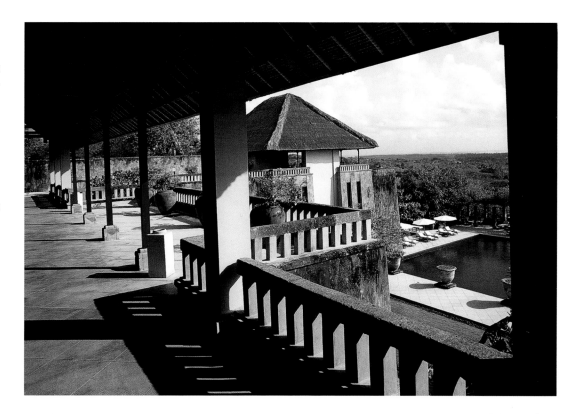

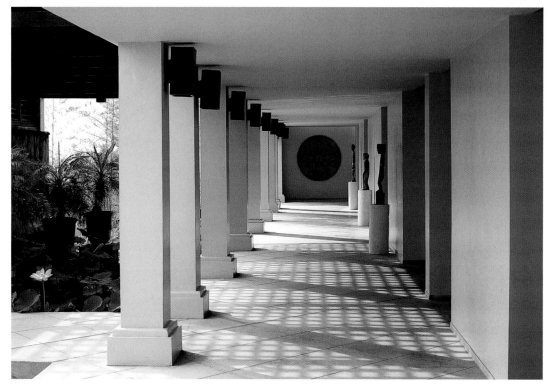

A Well-kept Secret

Tucked away in downtown Ubud along the road leading to the Monkey Forest, one finds the Komaneka resort. This well-kept secret, whether intentional or not, is built in vernacular style with one or two modern touches. If you take a stroll to the rear of the compound, Ubud's traffic outside fades and the timeless charm of ricefield life becomes the sole focus. The villas are open and breezy; gardens outside are invited in by the use of sliding doors, and the feeling of the whole resort is quiet and unhurried.

The Komaneka is anchored by its fine art gallery. Host to an exceptional array of local artists, many of whom have either acquired a higher education in the arts or had the opportunity to study abroad, it constantly unearths new talent. In fact, many of the hotel's artefacts are locally designed and made.

→ Mist clings over the hotel's thatched roofs, while palm trees soar above. This jungle refuge is urbanized only by the sun beds neatly aligned by the swimming pool's edge.

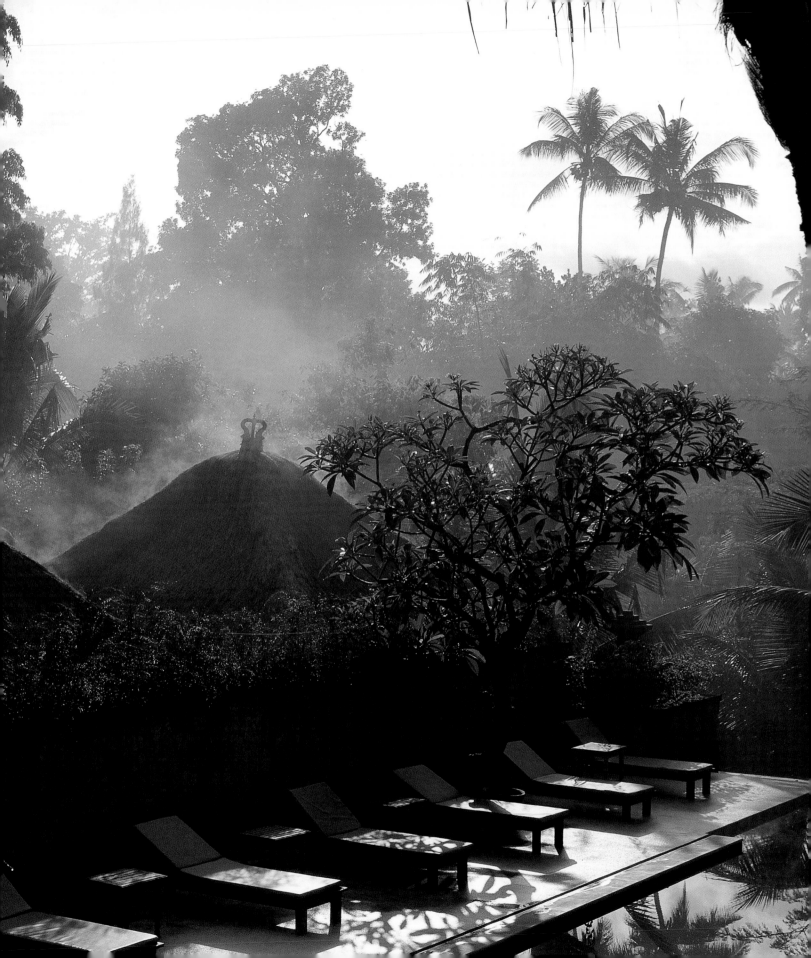

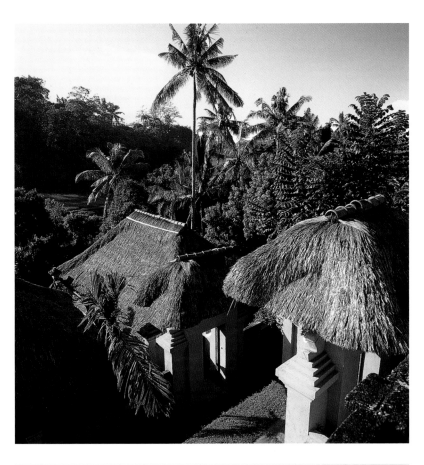

← Sandstone and *alang-alang* grass roofs merge into the tropical landscape.

↙ ↓ Guest bedrooms are furnished simply with an emphasis on the natural. Sliding doors open up the rooms with their foamy curtained beds to the tropical gardens outside.

→ Local wood artefacts seemingly casually arranged form an intriguingly simple still-life.

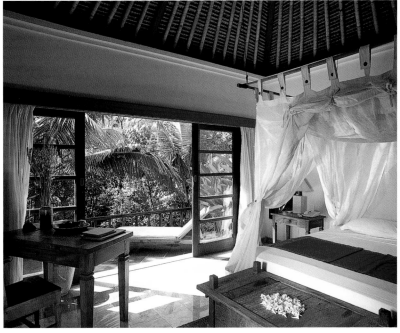

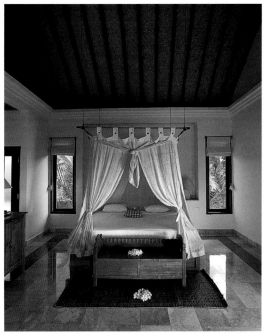

A Peaceful Hillside Resort

Perched above the cliffs on the eastern coast of Bali, the Amankila resort commands sweeping views of the ocean across the Lombok and Badung straits. It is located near the village of Candi Dasa, an area rich in fishing history. As with the other two Aman resorts in Bali, this lofty resort enjoys an enviable natural setting (its name in Sanskrit translates as "peaceful hill").

Designed by Ed Tuttle, around a dramatic, multi-layered poolscape (*see pages 4–5*), the resort is a fine example of modern symmetry combined with traditional elements. It is hard to choose between staying in the elegance of your own private villa with pool, or lingering around the grounds taking in the views of the sea. Early in the morning you can take a walk along the esplanade or reach, by a footpath through the palms, the private beach below. Here, at dawn, the sun rises as if from the sea in a spectacular burst of red and orange.

← The latticed *balé* overlooking the pool area is situated in a perfect position to catch cooling sea breezes.

↑ A cloister-like walled courtyard garden is a relaxing spot for al fresco dining.

→ Wide sweeping stairs concertina down to the pool and terrace with stunning 180 degree views over the Indian Ocean.

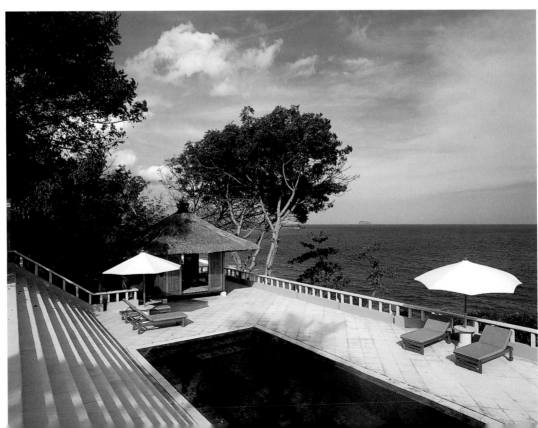

A Touch of Tropical Art Deco

Sensibly controlled materials and a linear design in the detailing and furniture are the distinguishing features of the Legian hotel, a four-storey beachfront building in Petitenggett. The overall design by the Indonesian architect Dedi Kusnadi follows more of an urban residential concept and imposes its structure very close to the beach, some may argue, a little too close. A subtle muted toned palette is used at the ground floor level, from the external hall through the covered walkways linking the public spaces, to the reception lobby and the restaurant.

The floors throughout the relaxed open spaces are patterned with the sand and ivory hues of various local limestones and *paras*. These are remarkably combined to produce a distinctive, modern balanced composition. The furniture, by the Indonesian interior designer Jaya Ibrahim, with its simple lines and an underlying vein of Deco, has character and elegance. The overall ambience is cool and muted: this provides the ideal backdrop for some large dramatic pieces of art and sculpture.

→ → A vibrant stone wall with leaf motifs produced by local craftsmen is the central focus of the lobby. On either side stand two life-sized guardian statues carved in teak; beautifully fluid, even the grain plays an essential role in their character.

→ Clean lines and local materials provide interiors that are almost ascetic in style. Symmetry and a sense of proportion are paramount.

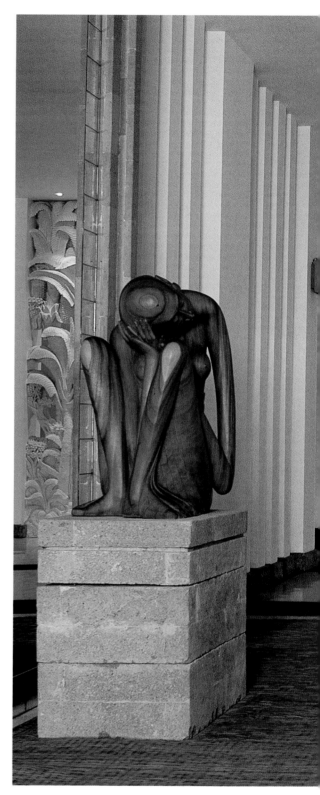

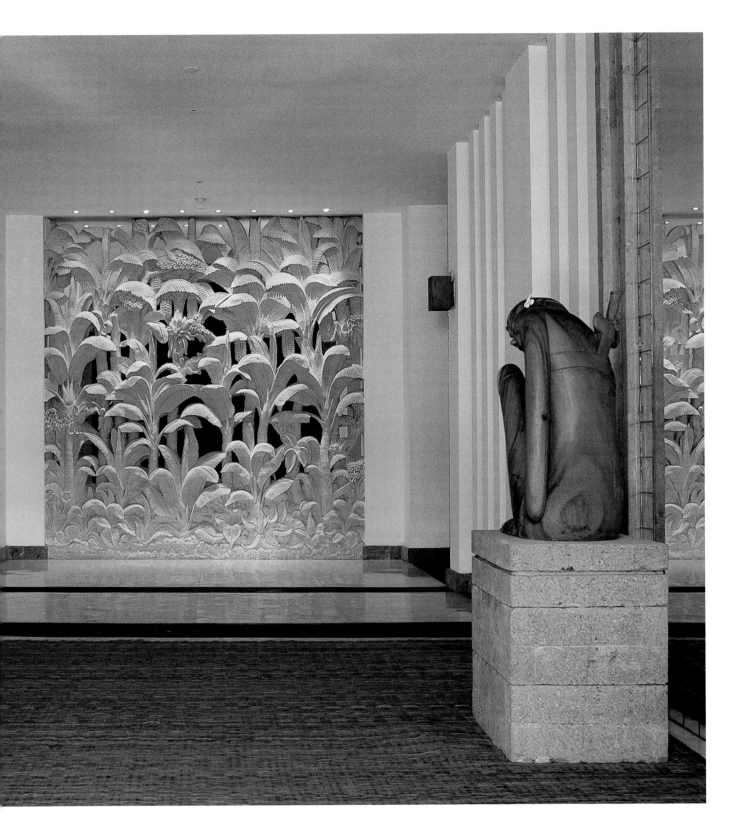

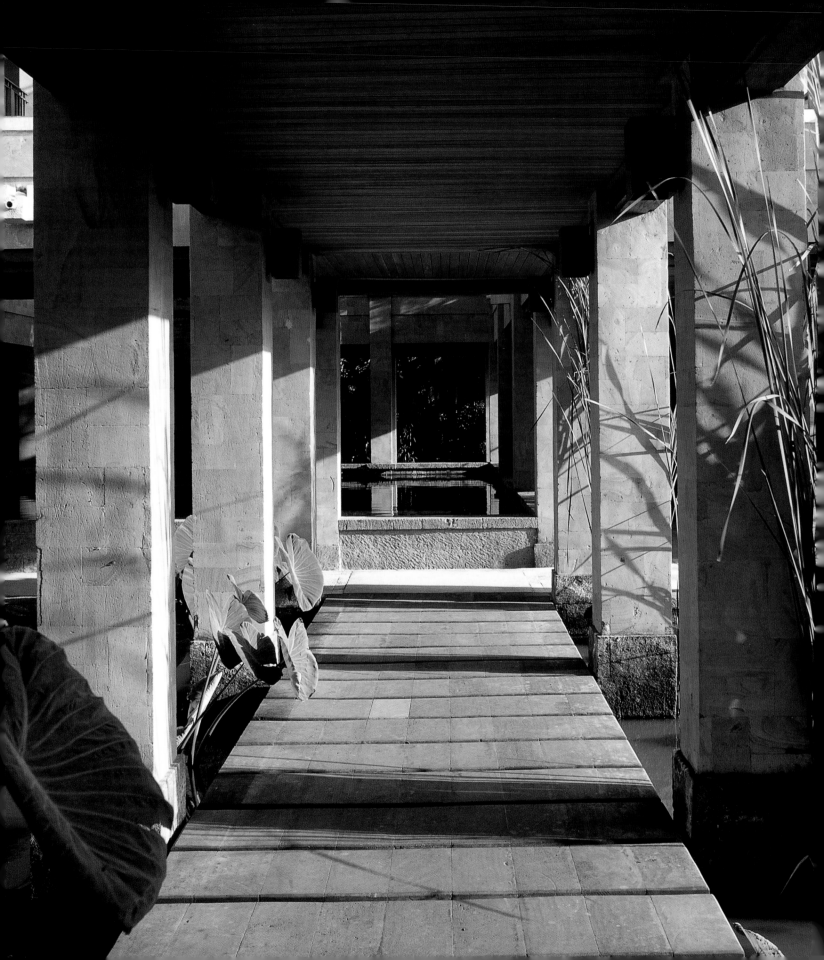

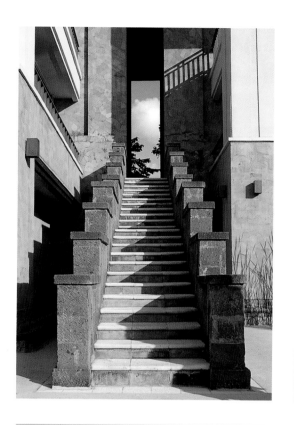

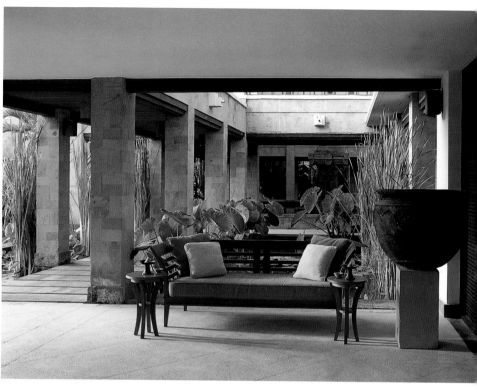

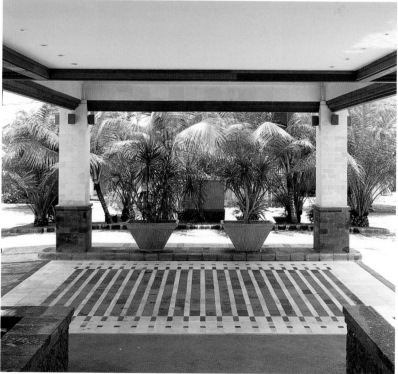

←← A muted sand-toned palette is used throughout all the walkways linking the different public spaces.

← The entrance to the hotel. Black and white chequered stonework creates a modern touch in the *porte-cochère*, while the low ceiling, framed by wooden beams and painted all-white, adds a sense of intimacy.

↖ Volcanic brown *paras* stone and ivory *palimanan* add solidity to this stepped walkway that leads down to the beach.

↑ An open-to-the-air relaxing area links the internal pathways running alongside cool water gardens. Simple furniture is paired with fine accessories to provide an overall sense of elegance.

Bali's Strip... of Sensations

Seven pulsating kilometres of bustling activity – the shopping strip that stretches from Kuta through Legian and on to Seminyak. Running parallel to the beach, this long road has always been a glorious hubbub of sensations for shoppers, food-lovers and sightseers. A myriad of treasures ranging from local handicrafts, textiles, batiks and sarongs to beach wear, sportswear, jewellery, designer fashion and rare antiques are seasoned by the equally exciting aromas wafting from the countless bars, cafés, *warungs* and restaurants.

Today, the area has expanded out of all recognition. With an ever-increasing and more up-market tourism market to cater to, "downtown Kuta" has evolved vertiginously into a unique triumph of architectural eclecticism. Simple market stalls are

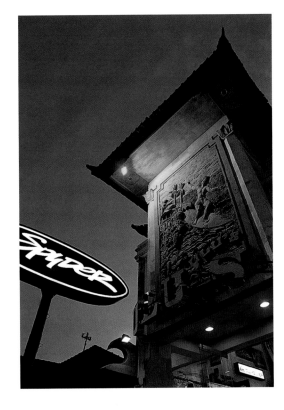

← Tropical motifs, such as these familiar floral arrangements, and the life-size surfers riding on the corners of this surf shop, have been carved in stone and mounted for decorative effect.

↑ An example of the Balinese ability to take on the new without losing the old: a carved stone plaque depicting "one day in the life of a surfer" is used to advertize a surf shop.

→ A futuristic structure brought to life by Balinese craftsmen; old traditions of workmanship are coupled with ultra-modern designs to produce shopfronts of startling originality.

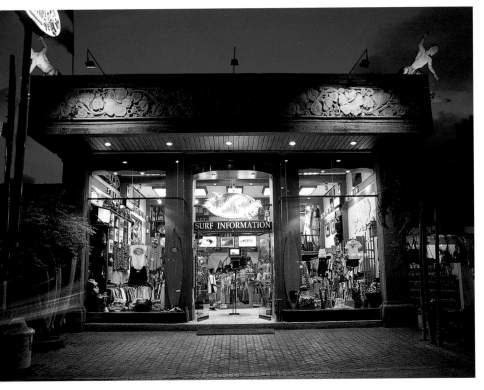

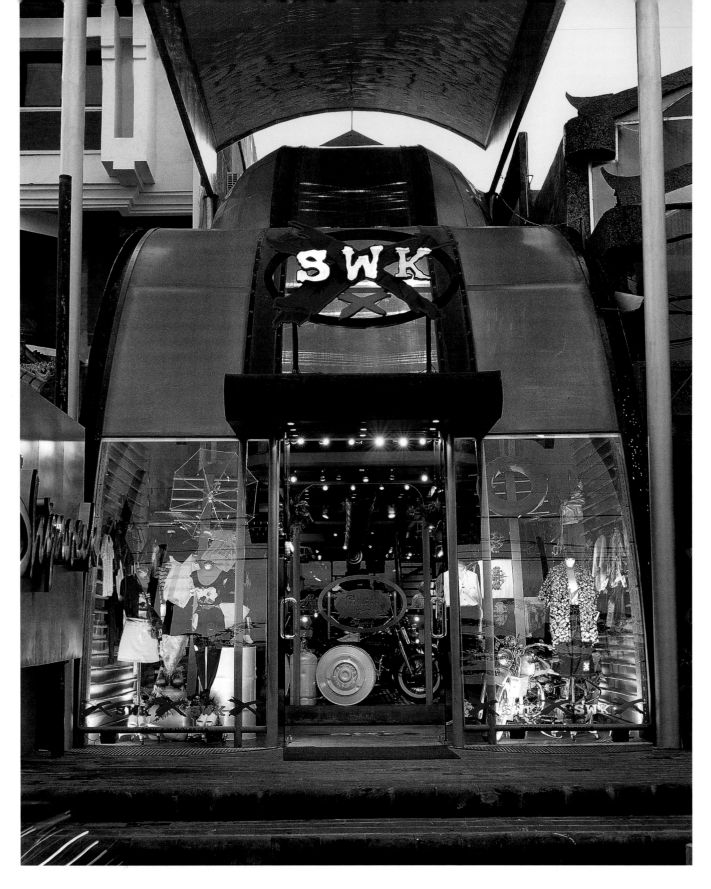

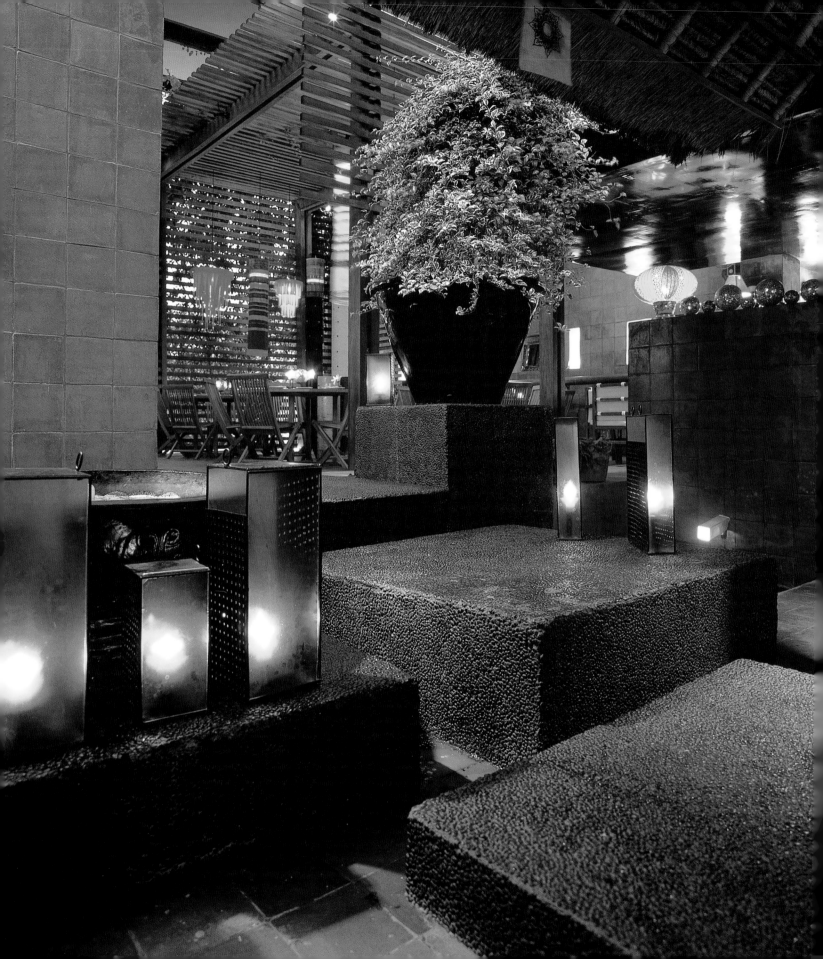

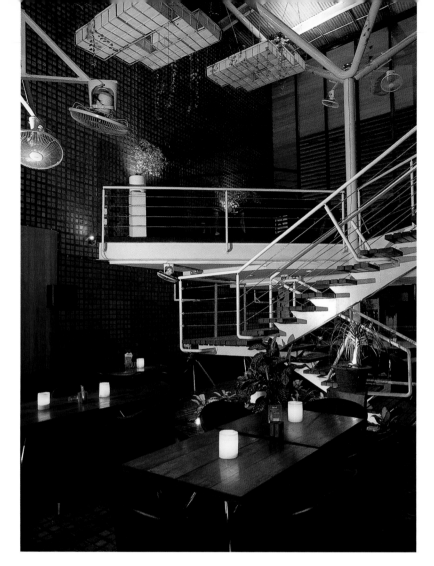

flanked by futuristic structures; shop facades may be a celebration of Pop Art, New Baroque, Classic 70s' Modernism, Art Deco, Neo Balinese, Arte Povera or Brutalism; all are different, all bright, gaudy and brilliant, but all are testimony to the ingenious craftsmanship of the Balinese.

Here you can buy a Versace jacket or a piece of cloth from Sumba, Haagen-Daas ice cream or a charcoaled corn on the cob, a primitive sculpture or a CD, listen to the latest hits or pause to enjoy the chimes of the *gamelan* played in one of the *Banjars*. And at night, when the rest of the island goes to sleep, the Kuta nightclubs, bars and clubs open their doors and come to life.

Then, when you're shopped-out and you've built up an appetite, this is also the area to eat. New restaurants in a plethora of styles are springing up daily. The range is staggering: typical dishes from all over the archipelago, be they served in a traditional *warung* or in a high-tech, fast-food bar, are available; Western cuisine or Eastern, simple or refined, casual or trendy-chic; all are there, and more....

After all, this is where it's at: the tourist strip of Bali, a hedonistic kaleidoscope of sensation and colour.

← A contemporary concept of space created by the young Italian architect Giovanni D'Ambrosio characterizes Pantarei, a Greek restaurant in Seminyak. Pebble-washed dark volcanic stone and wooden elements have been skilfully combined to attain a well balanced composition.

↑ A slim white painted tubular structure bearing the roof and an aerial metallic staircase leading to the mezzanine are the highlights of the Macaroni Italian restaurant. The designer, Giovanni D'Ambrosio, shows once again his fresh originality.

→ Under a locally made aerial wooden canopy, multi-coloured designer lamps in various forms add a touch of trendy-chic to the ambience.

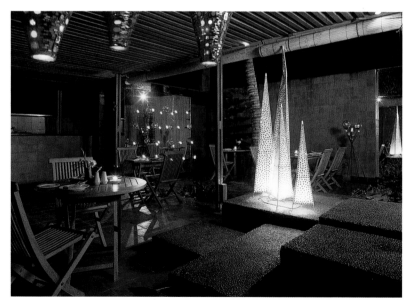

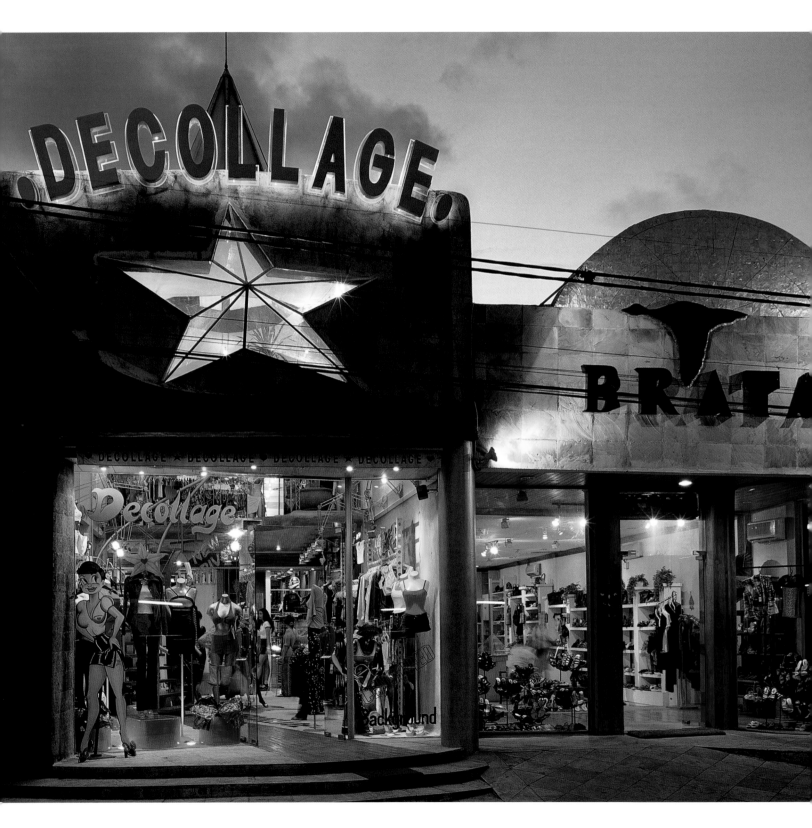

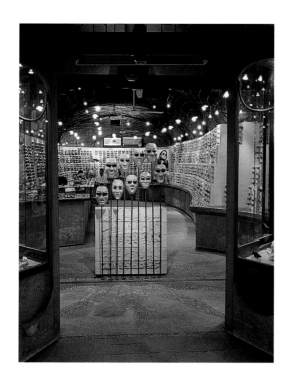

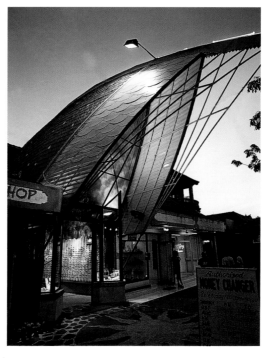

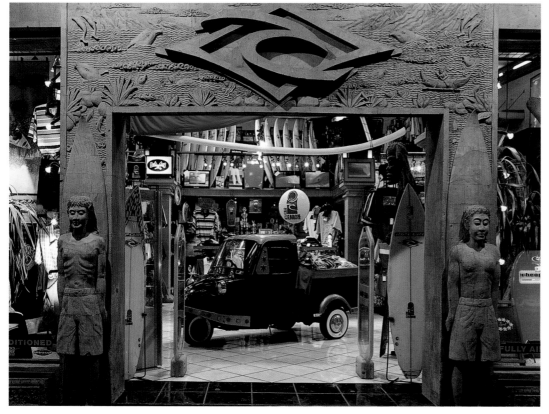

←← Local merchants are moving away from the makeshift stalls of the old-style tourist markets; today's tourists are more sophisticated, and the commercial strip reflects new tastes.

↖ Today's goods are sold in brightly-lit, interior-designed spaces.

↑ A bow-like resin and steel structure soars out over the entrance of a tourist shop.

← An example of pure Balinese pop art! A large square arch with scenes of beach life in relief doubles up as a doorway and a frame for merchandise.

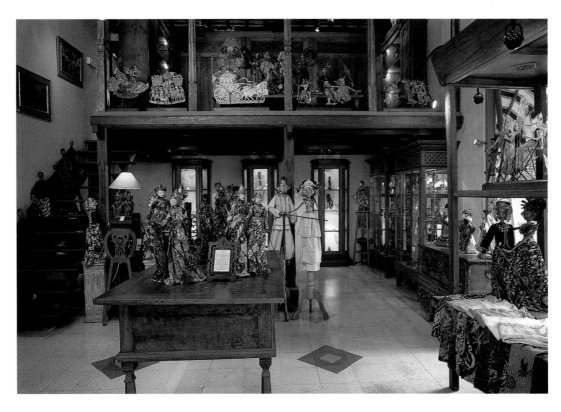

← Dimly-lit and rich in colour, this theatrical use of space displays a variety of puppets and jewellery collected from around the Indonesian archipelago.

↙ Typical in style and highly functional in design, this *balé* in the dining court of Madé's Warung in Seminyak is reinterpreted as a shop.

→ Scarlet is the theme at this boutique. Tastefully accessorized and furnished with Dutch Colonial period pieces, there is no need for a fuller colour palette.

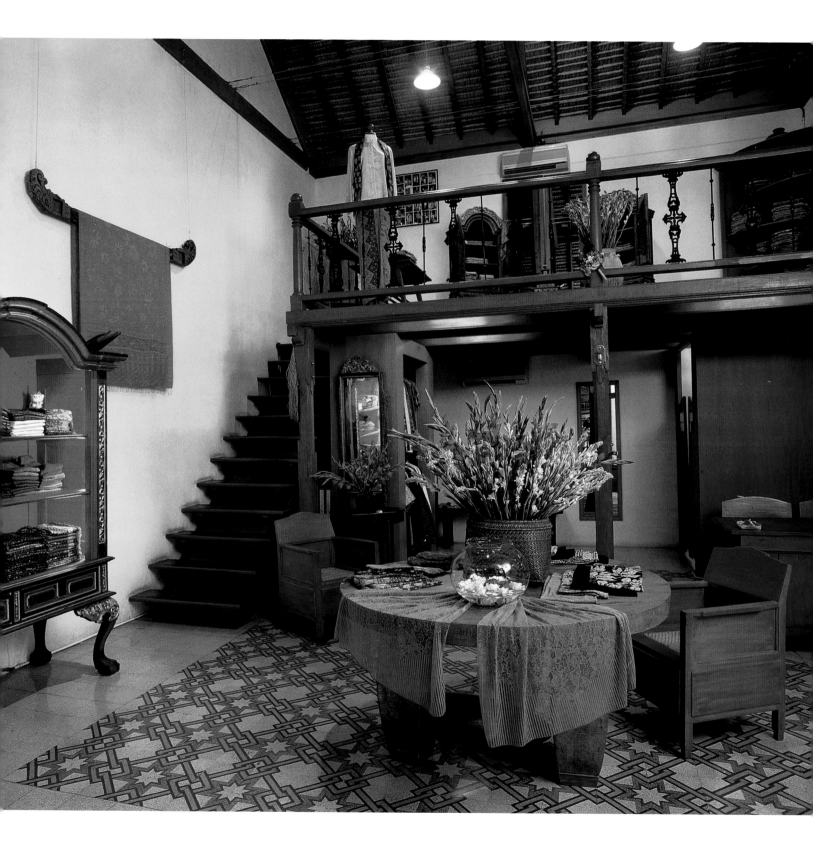

A Surf'n' Rock Combo

The Hard Rock Hotel commands the first corner of Kuta beach coming from Jalan Pantai and occupies a 3.2 hectare site with 150 metres frontage onto the beach. With its lagoon-like pool, restaurants, bars, memorabilia shops, and symbolic café where music is the unifying element, the resort is enthusiastically dedicated to fun, sun and entertainment.

The lobby is housed in a double-storey, hip-roofed pavilion with a clerestory enclosed by operable timber shutters. The vital gathering point of the resort is the giant central island bar, with attendant musicians' stage and multi-media, round-the-clock screen. Linking the lobby and the main facilities block is the retail and restaurant area accommodated in two glazed mono-pitched rectangular buildings protected by timber *brie soleil* screens. The glass cube which houses the staircase overlooks the vast pool area: with its coloured stained glass made by local craftsmen, it offers a remarkable spectacle, both externally and from within.

↑ The sun is reflected in this glass and timber structure which houses a very unusual stairway.

→ An internal view of the colourful stained glass stairway façade: a combination of Japanese and contemporary inspiration, but above all, a superb example of local craftsmanship.

→ → On the landing of the sinuous staircase a *barong* mask representing a mythical creature appraises this cathedral of colours and music.

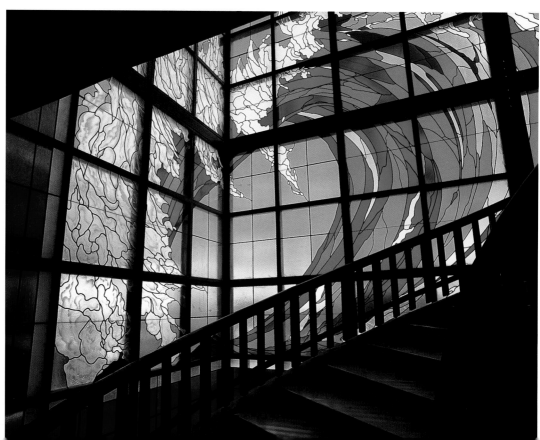

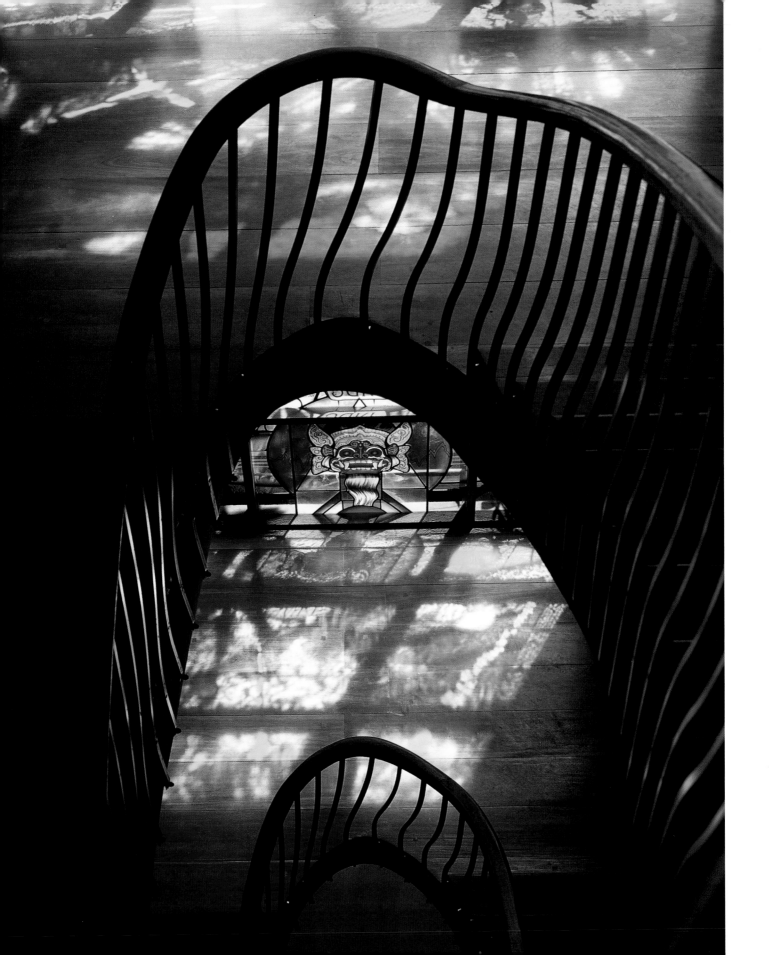

→ At the entrance to the hotel, the gigantic emblematic guitar welcomes fun-lovers!

↓ Wood and glass are the materials used here; the staircase leads down to the pool area.

↘ A view of the glazed, mono-pitched, rectangular building protected by timber *brie soleil* screens that links the lobby with the facilities block.

→ → A lobby like no other! A giant bar, surrounded by stage rigging, lights, speakers, televisions, a video wall and Hard Rock memorabilia, is located in the middle of the room. The use of vibrant colours for flooring continues the upbeat mood.

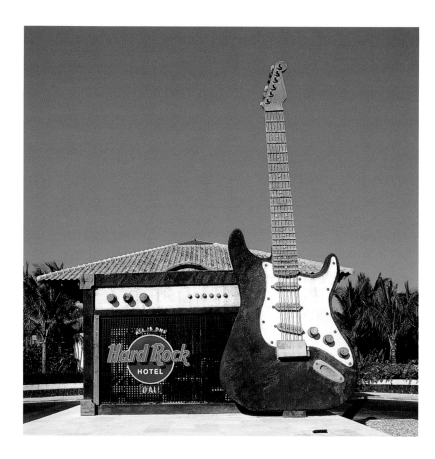

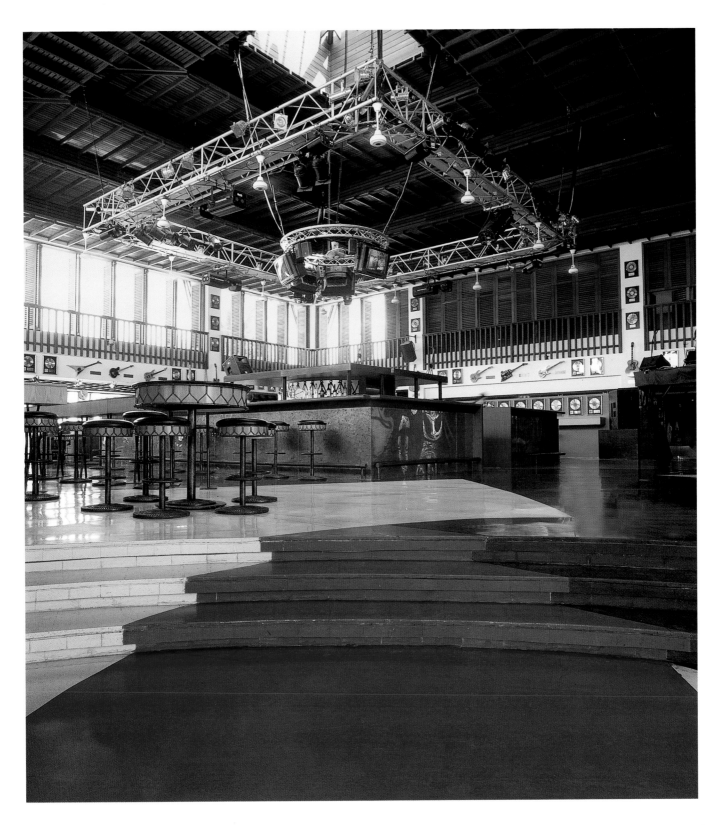

The Tropical Garden Revisited

New Landscaping Ideas

Tropical gardens in Bali are traditionally associated with a sense of fecundity, Javanese-inspired water gardens or junglescapes with mossy walls and hand-carved statues and fountains. Today's gardens seem to have taken this style one step further: firstly, they are designed more to complement the architecture that they are attached too, and, secondly, there is more order and definition in the planting. In this section we portray the crème-de-la-crème of Bali's private and resort landscaped gardens.

Global Landscaping

The bay of Jimbaran is a highlight on the Balinese coast. Clean, light blue waters are enclosed by six km (three miles) of semi-circular white sandy beach. Here, Four Seasons Resort Bali at Jimbaran Bay, designed by Australian Grounds Kents Architects, is set on 35 acres of coraline steep slope rising to about 45 metres (150 feet) above the waters of the bay. Combining traditional Balinese village planning with the required standard of a top quality hotel, the resort is laid out as a series of interconnecting "villages", each consisting of a village square with courtyard-house units connected by paths.

The layout of the project and its integration into terracing on the site, provided the opportunity for a type of "global landscaping" on the part of landscape architect Made Wijaya. Over 500 Hindu shrines built locally were incorporated into the architecture; 70 percent of the coralline limestone rock for many of the resort's walls was quarried from the site, individually chipped to size and put into place by hand; 1,500 hand-carved stone statues punctuate every corner of the compound; and 200 different species of tropical plants, shrubs and trees are planted and tended by 80 gardeners.

→ Through the extended branches of the sweet smelling frangipani tree, a perspective of the six kilometre semi-circular-white sandy beach of Jimbaran.

↓ Hand-carved stone statues and Hindu shrines nestling in the vegetation, punctuate each corner of the garden.

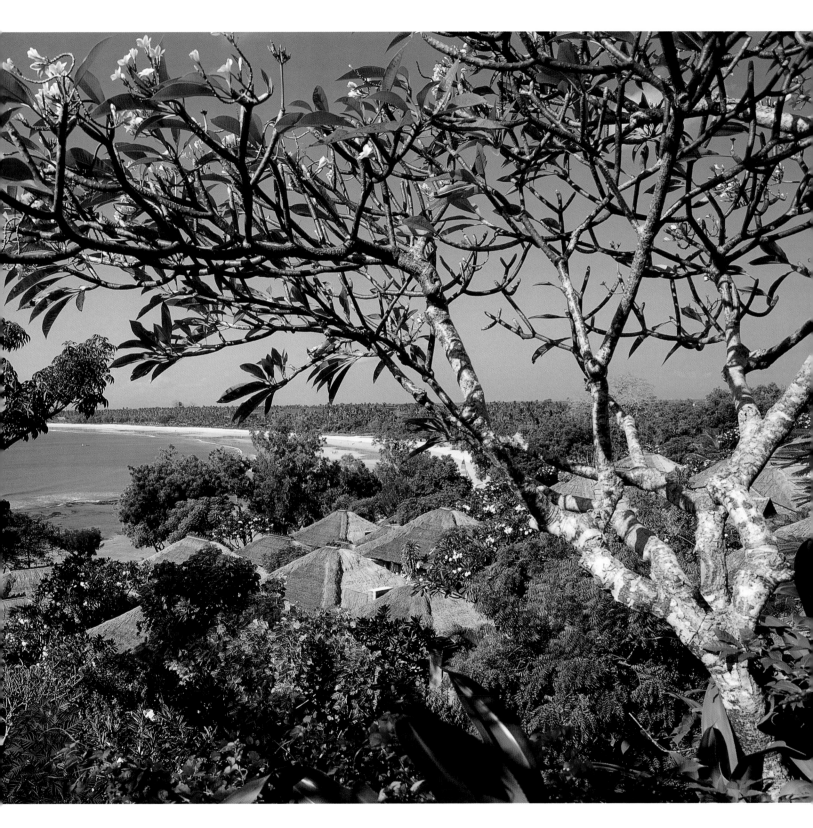

← Coralline limestone rocks, quarried from the site, are used for many of the walls in the resort; they were individually chipped to size and put into place by hand.

↙ The crystal clear water of one of the private pools, elegantly decorated with colourful plantings and attractive stone sculptures made by local craftsmen.

→ A monumental stepped walkway, in white *palimanan* stone and dark volcanic *paras*, flanked with a profusion of dense vegetation as well as hand-made vases standing on stone plinths.

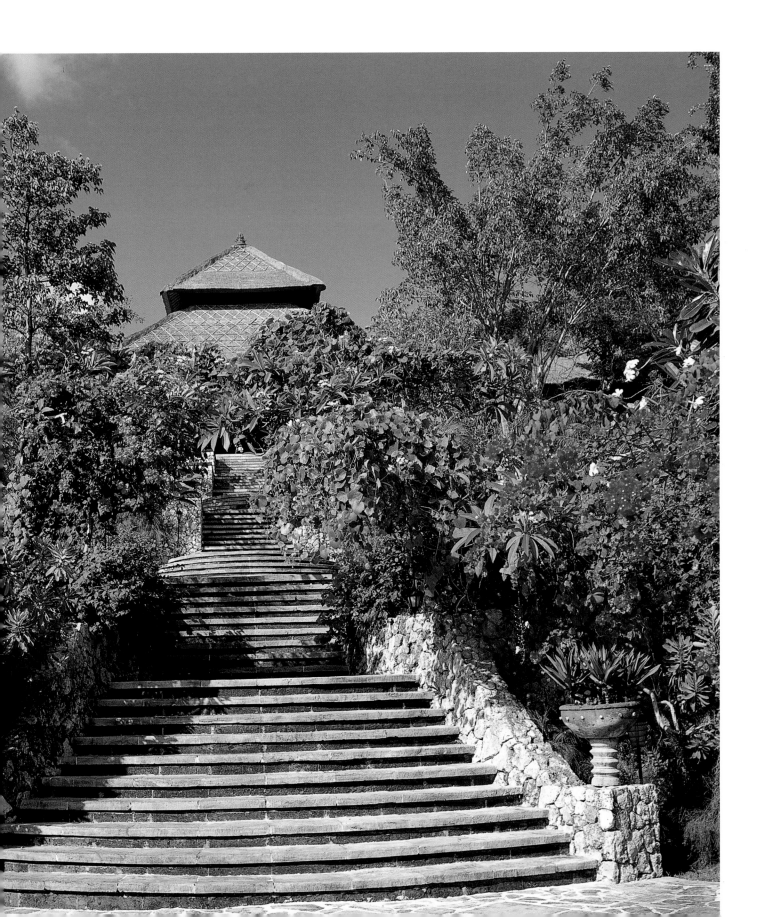

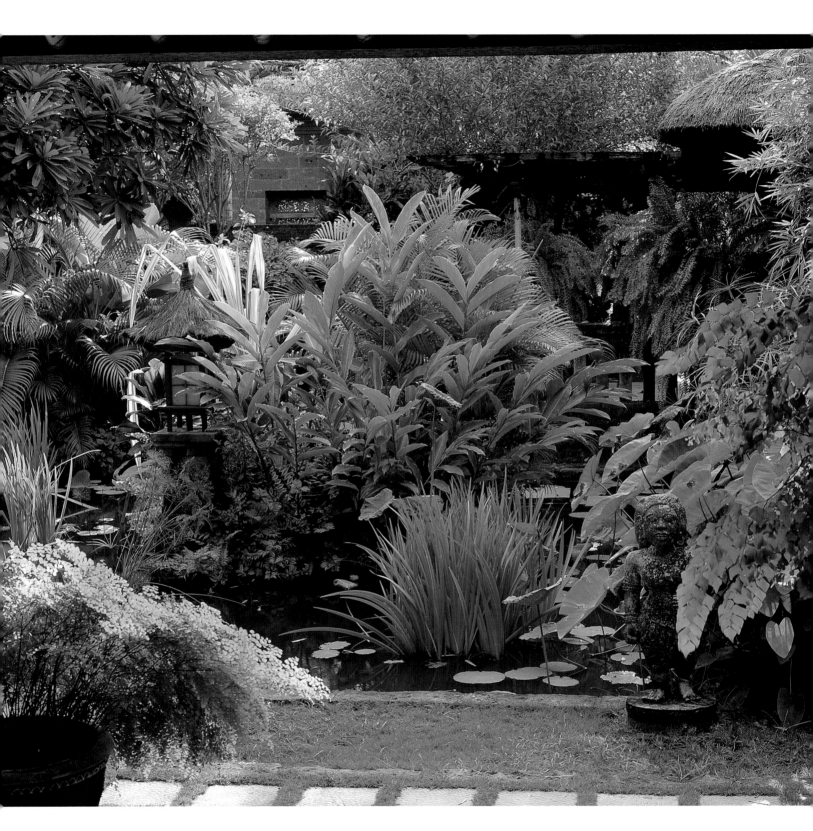

A Courtyard Garden

The garden at Villa Bebek, Made Wijaya's studio home in Sanur, is composed of over 50 small courts. Situated around a central, Hockneyesque swimming pool, there are 10 buildings, each connected by a network of paths, pergolas, terraces, gates and garden walls. A continuous work-in-progress, the garden acts as a testing ground for new garden design ideas.

Water is a unifying element, both in the form of the pool and various interconnecting ponds. There is a water garden section, complete with mossy statues, fountains and a folly-like water tower with carved panels by sculptor Wayan Cemul. Stepping stones lead from this to the central pool court which leads on to the terrace and garden area off the design studio. Here the accent is pure Balinese: statues, gates and decorative features abound and are always changing to provide new accents and atmosphere.

← ← Ponds act as barriers between pavilions at Villa Bebek. They are also great cooling elements. Wijaya's love of sculpture and silhouettes even extends to his choice of more "architectural" water plants, like the iris and the lotus.

↓ An azure lap pool – enticing, fresh, modern, Hockneyesque even – is the centrepiece of the Villa Bebek compound; around it the villas are gathered and the breakfast nook is perched. White *Thunbergia grandiflora* shades the premier pergola.

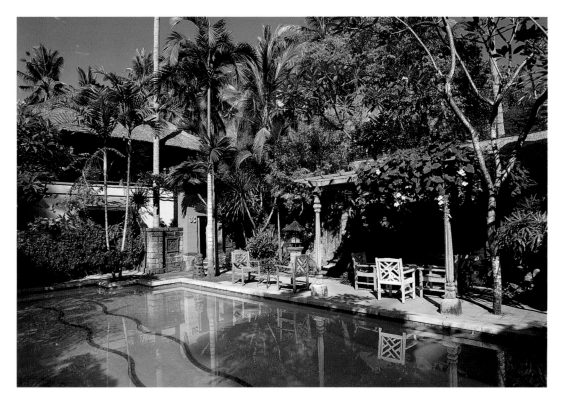

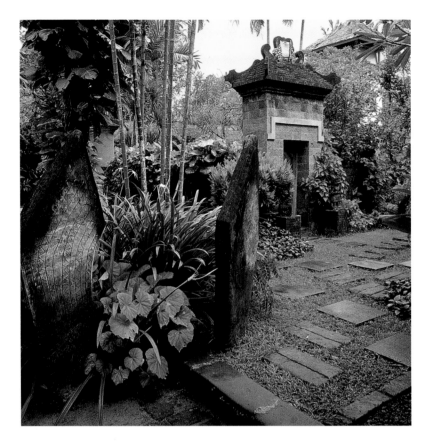

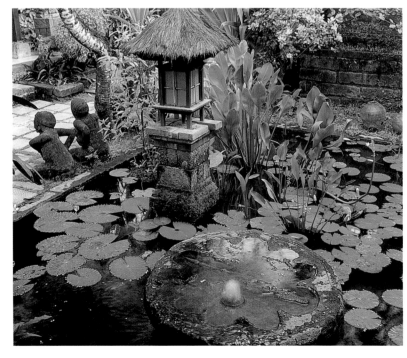

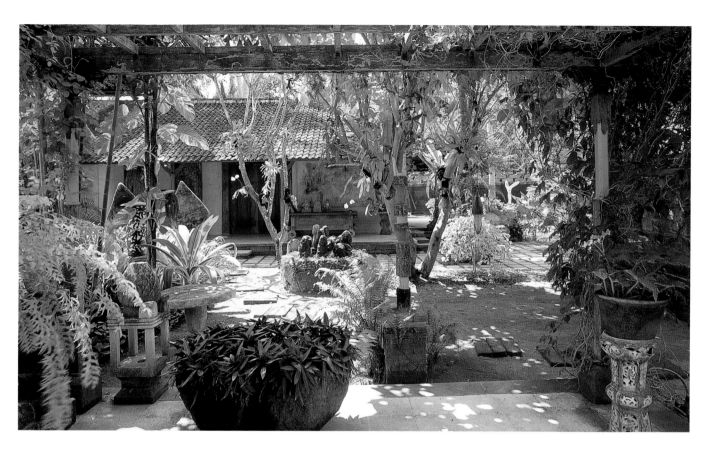

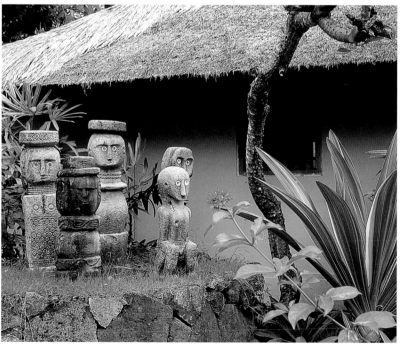

↖ A type of art deco gate is a noble backdrop to the megalithic court. Primitive garden art from eastern Indonesia mixed with modern elements is a recurring theme in the studio quarter of the Villa Bebek compound.

↖ A water tower stands sentinel behind the pond.

←← A water feature made from a boundary marker from Flores island. The pond welcomes visitors at the Wijaya design studio.

← A lantern from the Wijaya Classics range of garden accessories, here with a glazed ceramic hat, nestles amongst the begonias and spider lilies.

↑ The view from Made Wijaya's desk. The artist describes his garden as encrusted with decorative treatments as "a coral garden alive with tendrils and crustaceans'. A modern landscape painting by Jonathan Collard is visible across a Sanur coastal-style garden inspired by gardens Wijaya discovered in the pre-Hindu *pesisir* style along the nearby coast.

← A family of stylized crouched figures from Timor island sits atop a stage made from soapstone in one corner of the central studio court.

A Sculpture Garden of Installation Art

Adjacent to the famous water garden and parklands of Tirtagangga, in Karangasem in East Bali, lies a strip of land housing an on-going private sculpture garden. Begun in 1994 and still a work-in-progress, it is the creation of American artist E. S. Baxter and garden designer W. H. Seeley.

The on-going collection features a number of contemporary pieces and installations spread in a natural, tropical setting. The local environment of moss-covered walls, old tiles, water plants and vegetation provides a foil for the creative use of steel, reinforced concrete, mirrors and ceramic or vitreous stone. The result is a very unusual abstract composition, displaying many different textures, colours and forms. It is certainly unique in Bali and probably within southeast Asia as well.

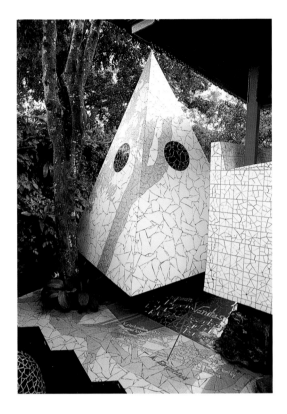

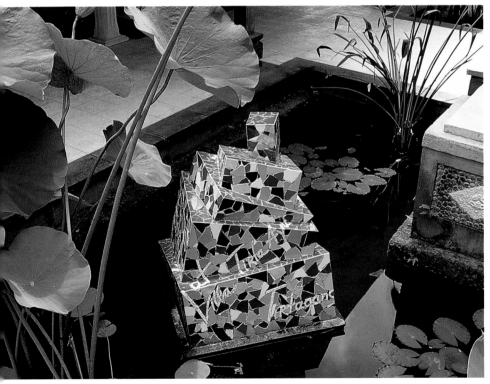

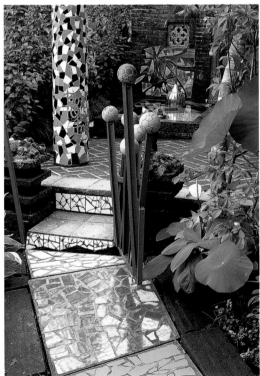

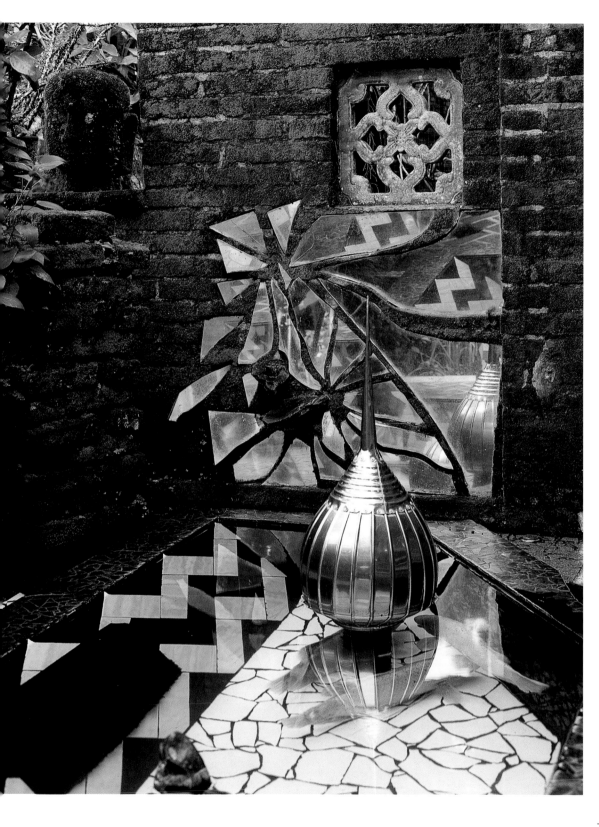

← "Vanitas" a 3.4-metre (10-foot) high ceramic-mosaic over steel-reinforced concrete hollow pyramid, a cenotaph for Diana, Princess of Wales.

↙ ↙ This mosaic sculpture "Ziggurat" sits in the moat surrounding the *balé* in a private residence in the park of the water garden.

↙ A mosaic pathway leading to the sculpture garden becomes an installation in itself.

← This installation – "Wish-a-Wish" – comprises the pool, ceramic mosaic over steel-reinforced concrete with stainless-steel mosque-finials, mirror and vitreous stone and the adjacent aged brick wall.

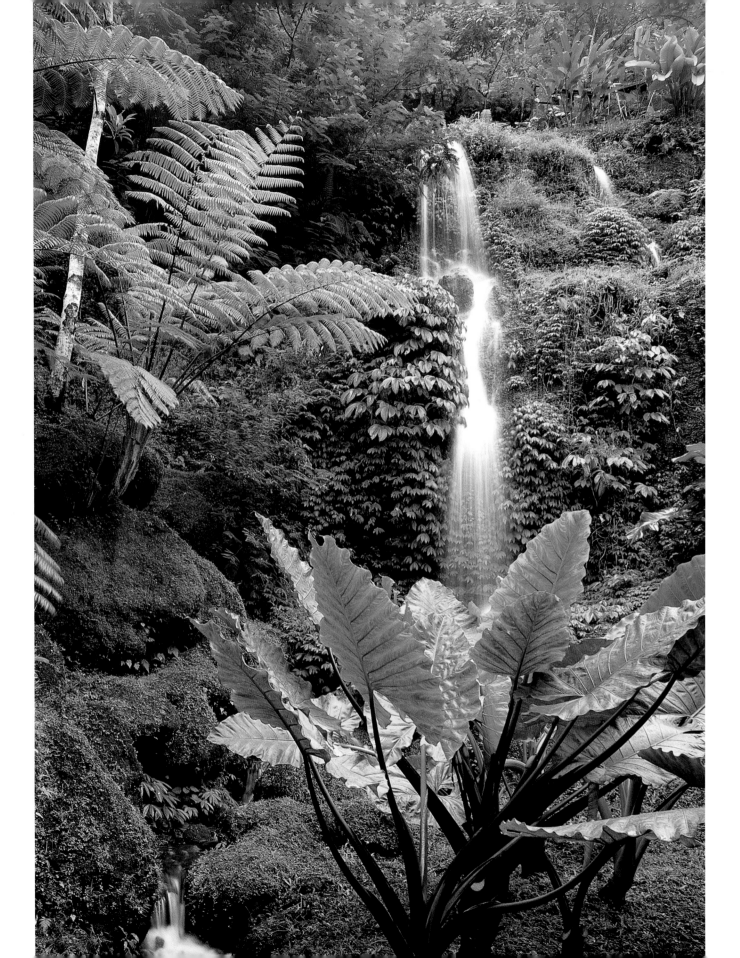

← Several rock pools, framed by timber decks, and lush vegetation, have been created by capturing a 20-metre natural spring waterfall.

→ The paradisiacal scenery of luxuriant tropical flora shadowing the clear water of a natural spring-fed rock pool.

↓ Indigenous hardwood trees and high *bengkerai*-wood poles supporting a structure fuse seamlessly to create a harmonious whole.

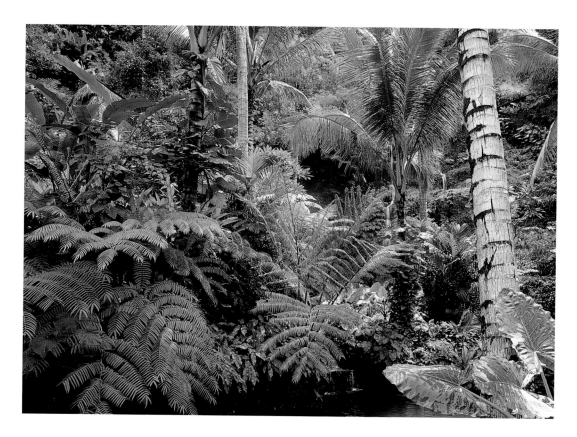

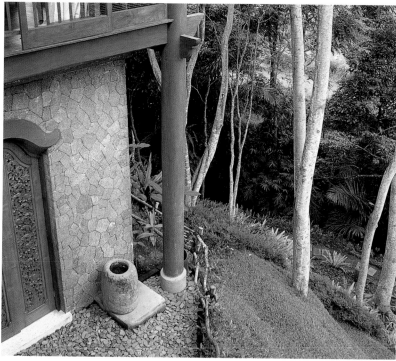

A Junglescape Tamed

Eight hectares of landscaped gardens overlooking the Ayung River near Ubud are the pride of Begawan Giri Estate. For almost a decade, gardeners have worked on re-presenting the original junglescape into a semi-tamed version. Over 2,500 indigenous hardwood trees, as well as shrubs, wild ferns, heliconias, gingers and orchids have been replanted in order to maintain the original environment, but present it in a more defined manner. Water, also, plays an important role in the landscaping. The grounds are fed by three holy springs that converge into a natural waterfall and thence into a series of sculpted plunge pools. The end result is an extended Water Garden, conceptualized as an orchestration of textures, colours and experiences engaging the senses and the intellect. Charmingly, it appears as a seemingly natural evolution, an "out of the jungle" extravaganza designed to soothe and relax.

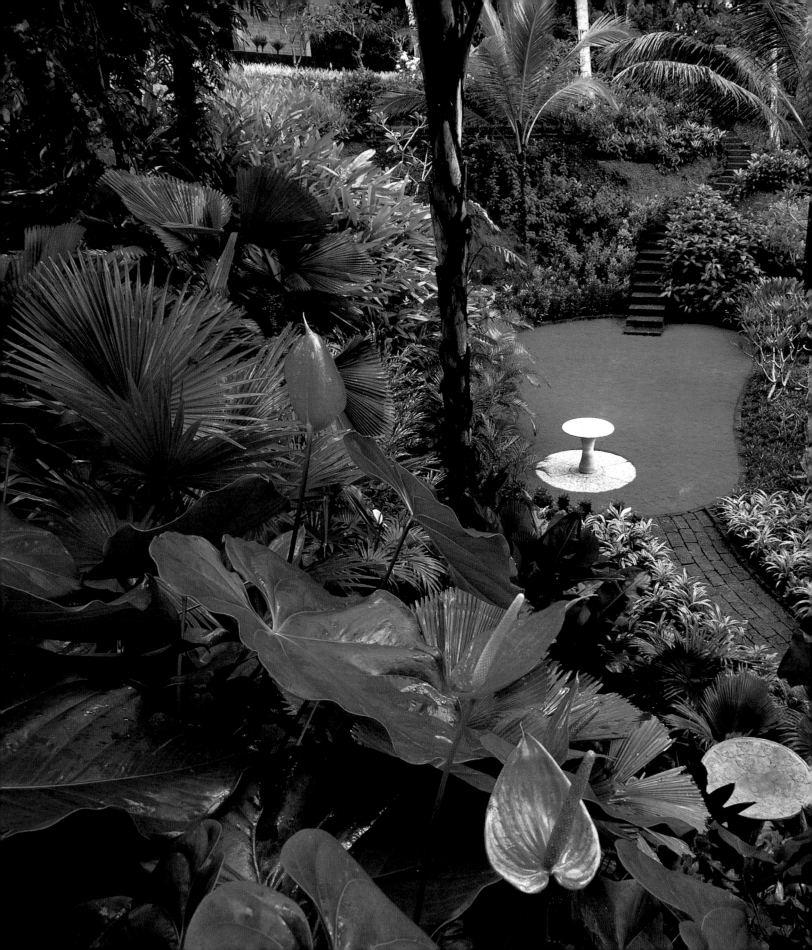

Spectacular Modernist Landscaping

This tropical garden on the slope of a secluded valley in Ubud is – quite simply – spectacular. Both the species used and the combinations therof give a result both modern and surprisingly restful.

A variety of palm trees – some tall, others relatively low-lying with feathery fronds – contribute to the overall form and shape of the scene, while a profusion of rhoeos, ferns, pandanus and many other specimens are used as ground covers. These two elements, combined with imaginative decorative plantings, result in a gorgeous natural panorama of brilliant greens and reds. As a haven in the midst of the luxuriant vegetation, a well-kept lawn of intense green forms the focus of this artistic landscape and gives balance and solidity to the overall composition.

← In the foreground, a group of Anthurium display their flashy, glossy inflorescences. A staple of the cut flower trade, here they appear the epitome of glamour.

↑ Another view of this well-balanced landscape shows a volcanic stone paved footpath that meanders among trees, creepers and a variety of flowering shrubs.

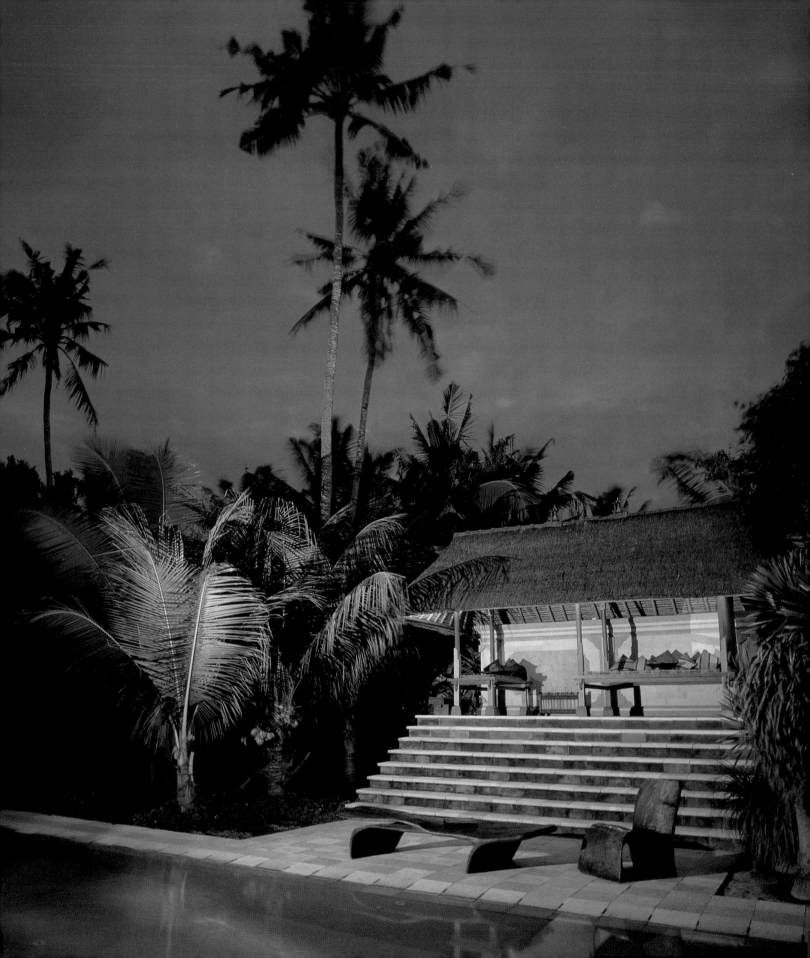

The Delightful Balinese Pavilion

Relaxing in the Balé

No longer is the *balé* simply a 4-poster wooden platform protected by a thatched roof. Innovative designs are emerging: be they modernist stone structures shaded by canvas "umbrella-roofs" or vernacular-inspired, poolside loungers, all are excellent dens for the those seriously committed to languour-induced afternoons. Here, we showcase a selection of contemporary reinterpretations of the classic Balinese pavilion.

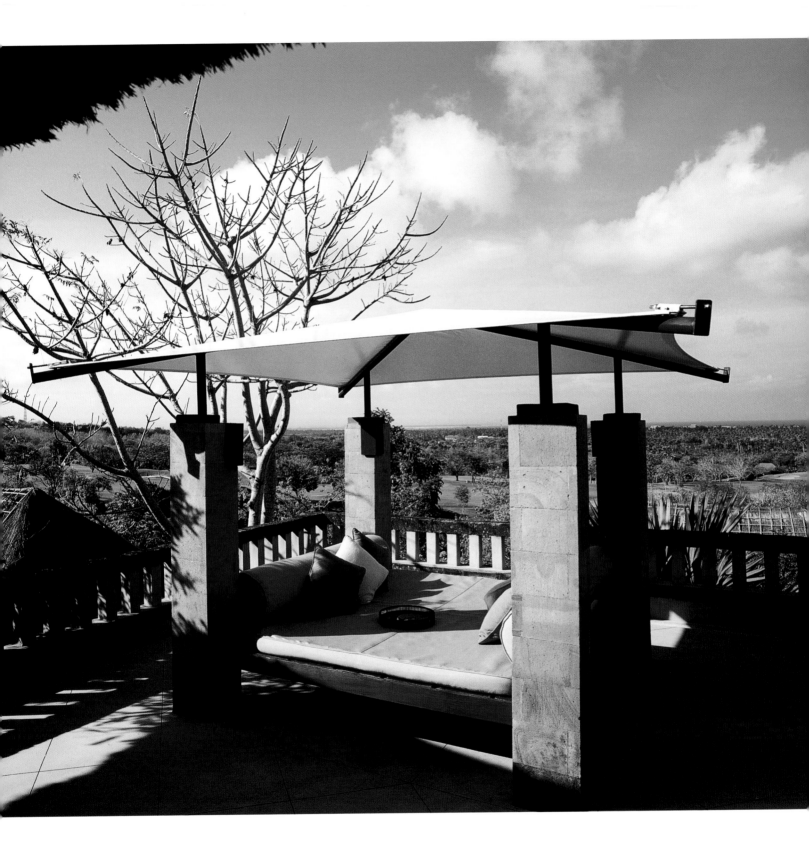

The Romantic, Open-air Pavilion

The word *balé* translates loosely in Western terms as "pavilion", and can be identified in all sorts of areas on the island of Bali. The first Balinese *balés* were built on holy ground, in the precincts of temples, where they were used by the locals to perform ceremonial duties. Later on, only members of the highest caste were able to have *balés* built in their family compounds. Today, they are constructed for many different uses by many different people.

There are myriad styles, forms and functions of the *balé*. In its simplest incarnation, the traditional *balé* is quite rudimentary in execution – the raised floor is slatted together, the roof is thatched with *alang-alang* and square wooden pillars act as support. Such a *balé* would normally be used by a village as the main gathering place to discuss communal affairs. At other times, people might meet at the *balé* to take a break, relax or even to sleep. Because the structure is open on all sides, it is particularly well suited to the hot, tropical climate and is ideal for the culture of the Balinese people.

Highly decorated *balés* are built following the same basic design of this traditional style, but the pitches are tighter and covered with shingles of ceramic or dense wood and the pillars are ornately carved and finished with paint or covered in *prada*. The number of pillars may multiply, and verandahs may be added on one or more sides. Often a *mandi* (washroom) or kitchen is added nearby. These structures may be used in palace courtyards, or as courts of justice, or simply as indications of wealth or prestige. Ceremonial pavilions are often dressed up in a sarong and sash for special occasions.

In the present day, *balés* continue to be built in temple courtyards and family compounds and they are still used as the main meeting place for the village's organizational group. However, time has

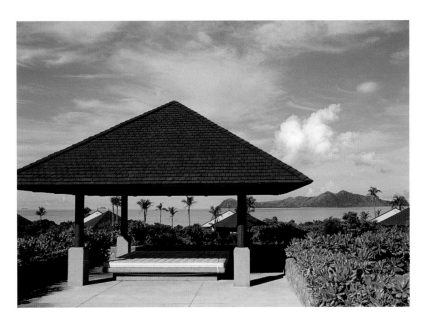

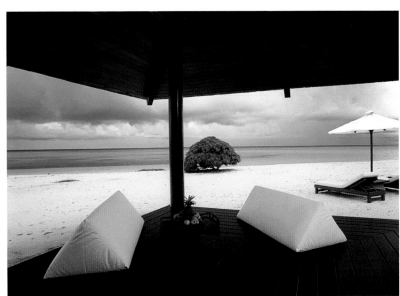

← ← Contemporary in design, with stone pillars and an umbrella-style roof, this modernist reinterpretation of the *balé* is functional and clean.

↑ ↑ A *balé* with a view: simple in form, the oversized hand-stuffed mattress adds just the element of comfort needed.

↑ Location can be everything. Even a simple, plain *balé* can be romantic in a setting such as this.

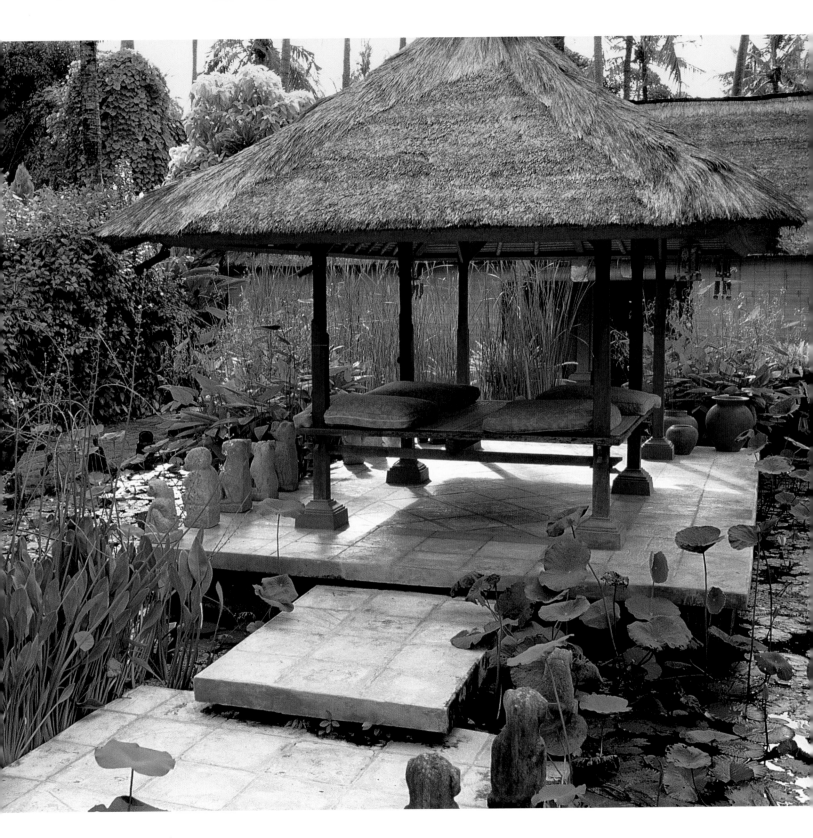

changed the utility and style of this once simple structure and today's functions and forms have multiplied. You may see *balés* situated poolside acting as massage areas in resort grounds; or they double up as funky, outdoor bars or dining pavilions in residential villas; and in some western compounds they house the television room or library. Exclusive hotels house *gamelan* orchestras in them or utilize their romantic shape for dance performances. The silhouettes have changed too: absorbing influences from elsewhere in the archipelago or from Western taste, they have been substantially adapted. Even the materials used are different: glass, metal, organic materials and stone *balés* are increasingly common.

Regardless of their shape, size and function, the *balé* remains an integral part of the Balinese architectural scene. Marvelously flexible and beautiful to behold, they are indeed gems in an island full of wonders. As Miguel Covarrubias wrote in his seminal work *Island of Bali* (1937): "The well-built *balé*, the archetype of Balinese construction, is a masterpiece of simplicity, ingenuity and good taste." The same applies as well today as it did 60 years ago.

← Built on a platform atop a lily pond and adjacent to living quarters, this *balé* is serviced by air cooled from the water.

↙ A *balé* in a bathroom, truly a novel interpretation of the traditional form.

↓ With an over-sized roof and simple clean pillars, this *balé* leans towards a Japanese influence in style and locale.

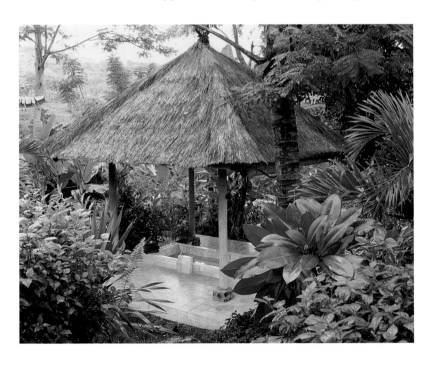

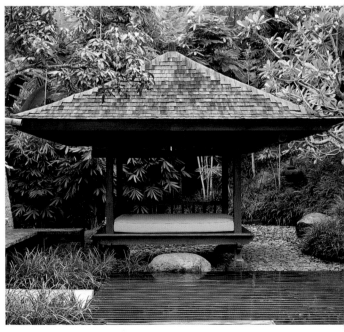

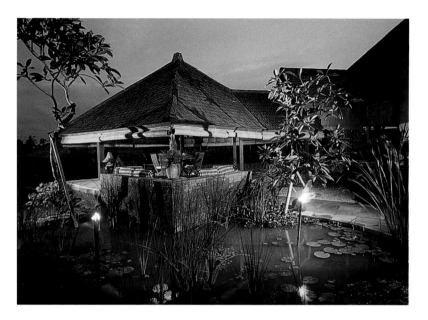

A Private Retreat

At the rear of this compound on the outskirts of Seminyak, tucked away in its own little corner, sits a cozy dining area. It mimics the form of a traditional *balé*, but has a significant new twist. This comes in the form of the "bridge" that connects it with the main villa. Surrounded on all sides by tropical foliage and a lily pond overflowing with water plants of all descriptions, the *balé* has a very private feel. Follow a covered walkway from the living room, and you will arrive at the *balé*; it is almost like a secret passageway connecting the main house with its own private retreat.

Despite the walkway, the *balé* is constructed as a completely detached structure using the same materials as were employed in the main house. *Bengkerai* wood is used for the pillars and roof structure, *palimanan* covers the floor, and woven rattan matting layers the internal workings of the roof. The warmth of these textures, combined with sunlight by day or candlelight by night, creates an intimate, welcoming atmosphere. Either way, the setting lends itself both for dining and entertaining, or simply as a getaway spot for relaxing.

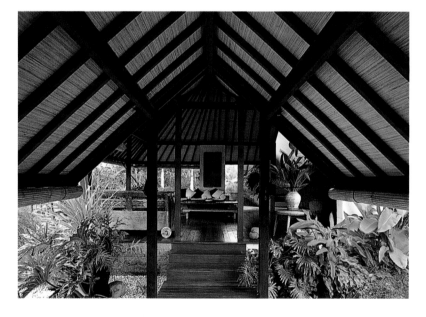

↑↑ The warm glow from torches located in the lily pond evokes a special atmosphere in this open dining area. Add the Balinese sky, with its magical constellations, and the scene is set for a romantic evening.

↑ A covered walkway leads one across a bed of pebbles to the main house.

→ By day, the *balé* doubles up as a quiet spot for contemplation. Built-in sofas provide the right level of required comfort.

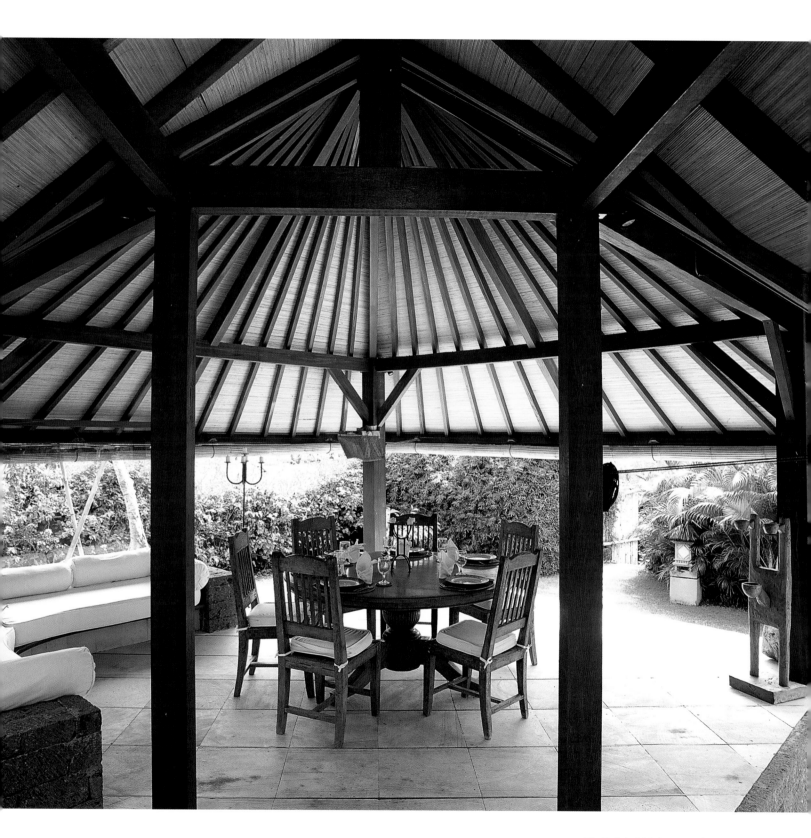

Relaxing in the Shade

At the Novotel Benoa, Thai architect Lek Bunnag makes extensive use of uncut grass for roofing. This aesthetic is confined not only to the main building and rooms, but also to any recreational or relaxing covered space. A low-level design concept was adopted on purpose to give the property a traditional village theme.

Combining the simplicity of the traditional granary (*lumbung*) shape or a basic square pitch hut, with more modern ivory stone and wooden elements, the designer was able to reinterpret the concept of the *balé*. The result is a varied collection of unusual settings for relaxation dotted around the resort and in the vicinity of the swimming pool. Some are little more than planks of wood covered with a simple thatched roof. Others are more intricate, and include tree-house type designs, monolithic stone constructions and "fairy-tale style" hideaway homes.

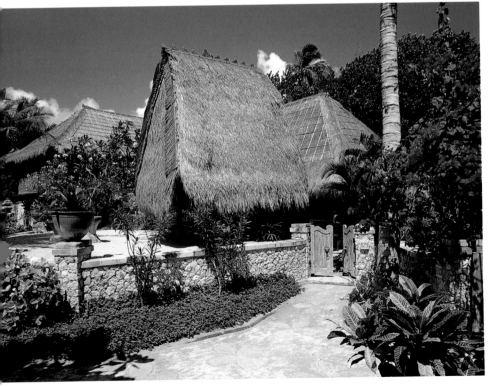

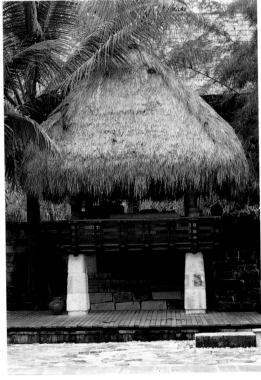

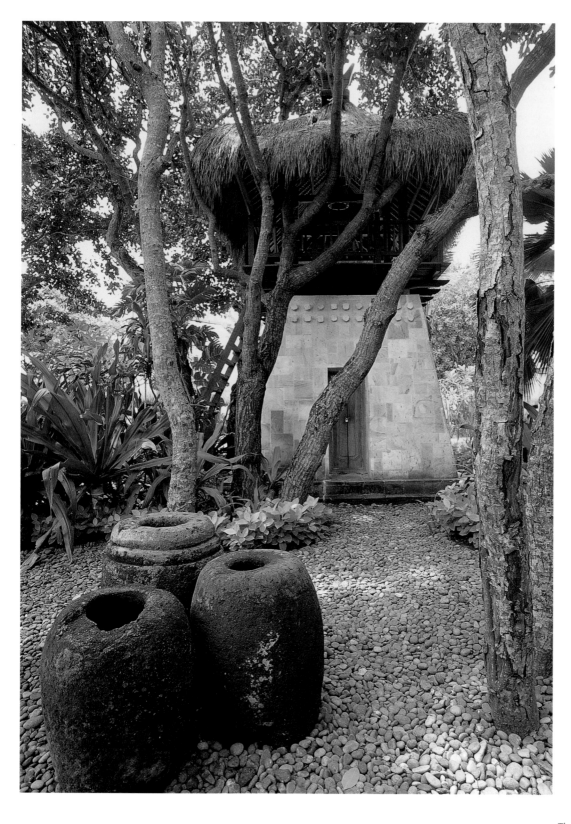

↙ ↙ A view of one of the so called "beach cabana" suites with its own private sunning garden and 110 square metres (330 sq ft) of living space. The overall feeling is of an individual beach house. The blending of modern and traditional Balinese design gives an atmosphere of low-key tropical luxury.

↙ ↙ and ↙ The uncut drape of the thatched roof and the high back of the sitting areas adds intimacy and privacy to these two cozy *balés*, each elevated by ivory limestone pedestals. They are perfect places to climb into and unwind.

← A monolithic-looking structure faced with *palimanan* stone and enriched with embossed geometric patterns. It houses the musical instruments for a *gamelan* orchestra. From this unusual contemporary reinterpretation of a *balé*, the melodies of local Balinese musicians can be heard floating out from the light wooden deck aloft.

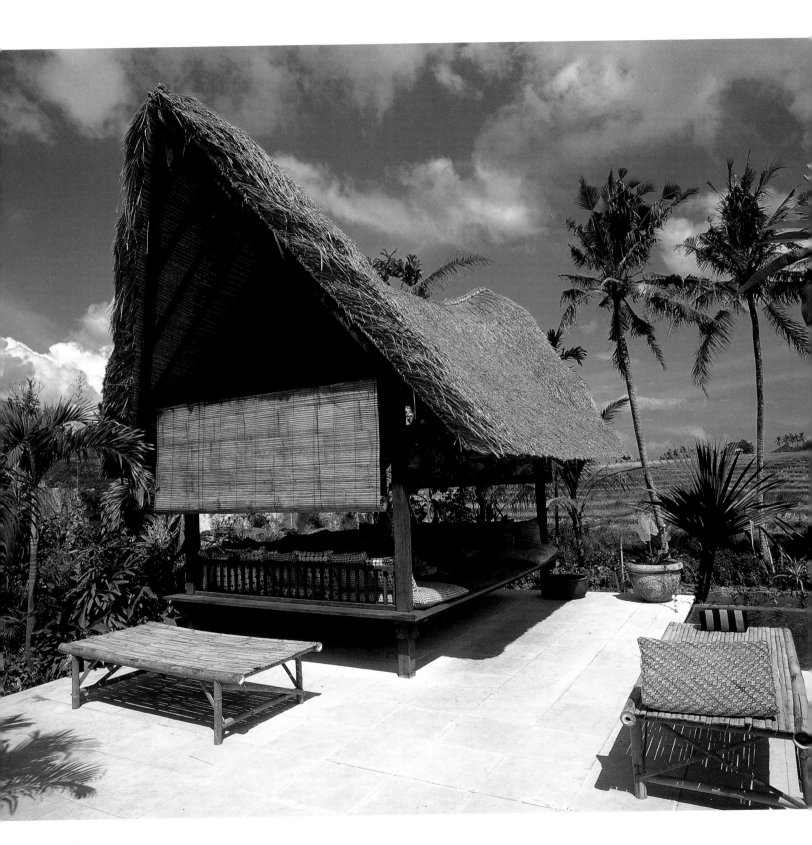

A Batak Inspiration

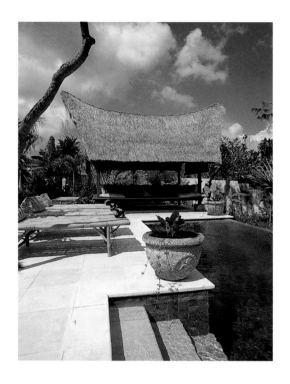

Set in 1,600 square metres (5,000 sq ft) of land some ten minutes from the tourist attractions of Legian, this holiday home getaway was designed by Ross Franklin for a young New York-based couple. The main house and the open *balé* form a broken U-shape that surrounds a long, slim, rectangular natural stone pool.

The highlight of the composition is the imposing *balé*. Inspired by the architectural traditions of the Toba Batak people of Sumatra, it enriches the whole compound with its characteristic upsweeping roof ridge. Plenty of lounging space beneath makes it the perfect place to unwind in the shade. An all-round, uninterrupted view of the terraced rice fields completes this unique open-air, back-to-nature experience.

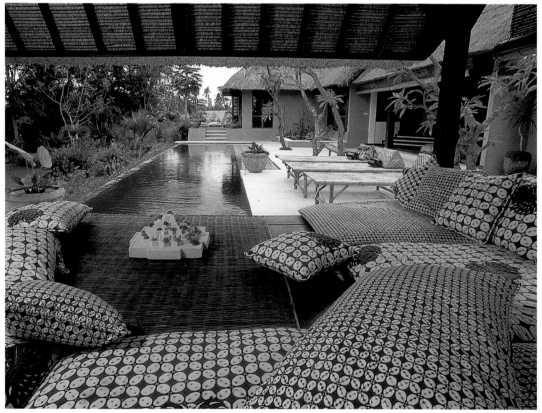

← ← Because of its size and shape, this unique *balé* has ample room to accommodate several people comfortably with all the conveniences of a living room.

↖ Given its interesting roof-line, this *balé* rests poolside in grand fashion.

← Because of its size and proportions, a number of decorative pillows are used to add more comfort and for additional flair. An antique rattan mat completes the ensemble.

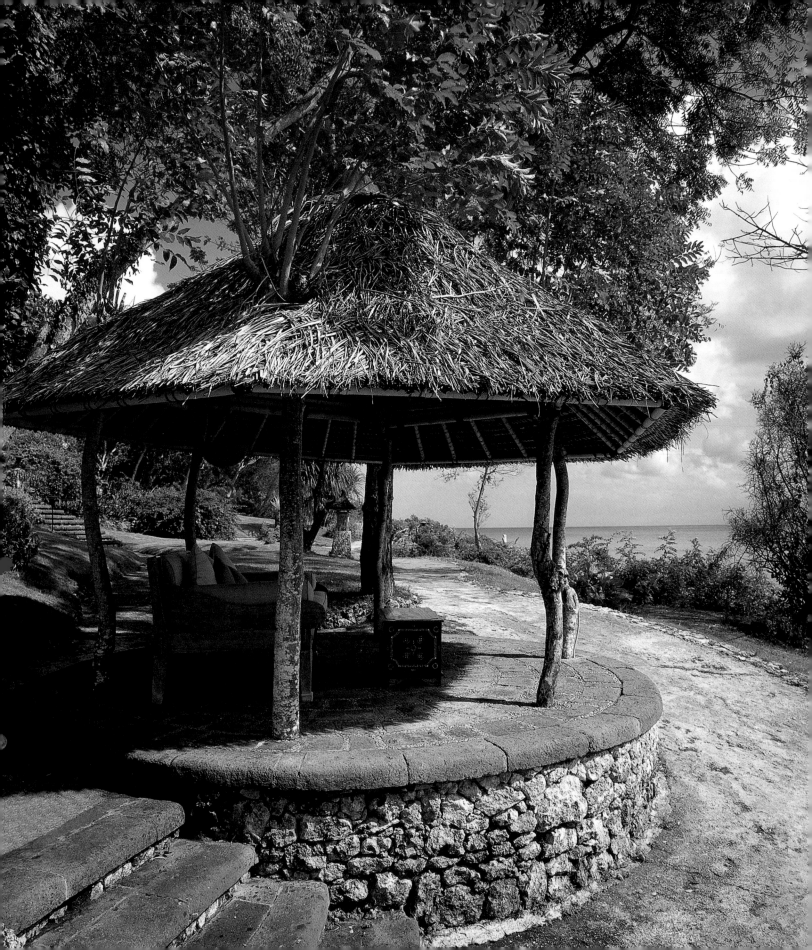

Branching Out

If you go for a stroll along the meandering paths of the lush tropical landscape of Four Seasons Resort Bali at Jimbaran Bay, designed by renowned landscape architect Made Wijaya (Michael White), you should keep an eye out for some of the grass-roof gazebos. Dotted amongst the existing trees and shrubs and some introduced seashore varieties, are a number of quite particular *balés*. At a first glance you may only notice the irregular shape of the limbs used to bear the roof structures. But then you will discover they pierce the grass of the roof and have their own foliage on top: in fact, they are living trees, providing shelter for the thatched roof of the *balé* underneath!

Quite unique, they integrate naturally within the overall landscaping. Indeed, they complement the "tamed jungle" effect that Wijaya has managed to produce as if effortlessly.

← With sprouting limbs supporting the roof structure and lacking the traditional sitting deck, this *balé* overlooks Jimbaran Bay. It is the perfect mini-pavilion-cum-lounge complete with seating and coffee table.

↑ Blending in with ease because of its rudimentary use of materials, the landscape seems to be unaffected by the presence of this charming structure.

→ Here is a closer look at the furnishings underneath: an ancient bench from Java decorated with bright woven textiles and a trunk used as a coffee table inlaid with mother-of-pearl from Lombok.

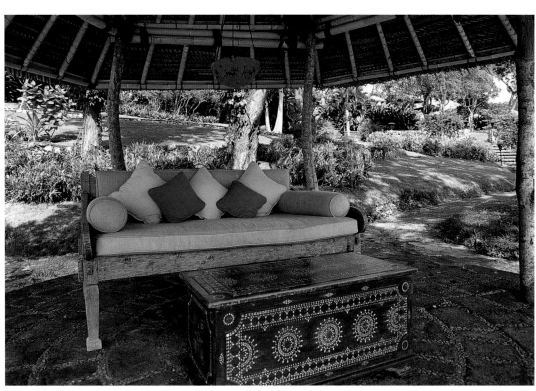

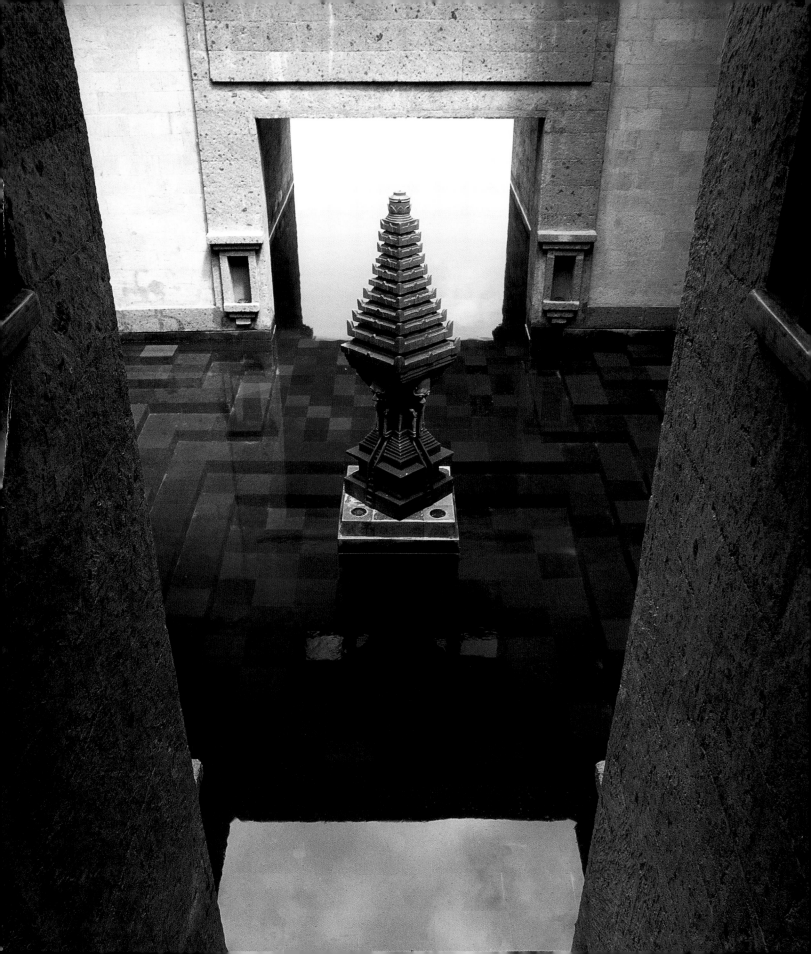

Tropical
Water Features

Pools, Cascades and Springs

Water is the source of life for the Balinese; it is also a wonderful cooling element in hot and humid climates. It's not surprising, therefore, that virtually every architect and landscape artist incorporates some type of water feature in their designs. Here, we present an array of contemporary water features: gardens, open-to-the-air bathrooms, numerous cascades, fountains and springs, modernist pool-scapes, even a giant, eleptical, rooftop lily and lotus pond. Water as play, water as architectrual element and – of course – water as a natural source of nourishment for garden and soul alike.

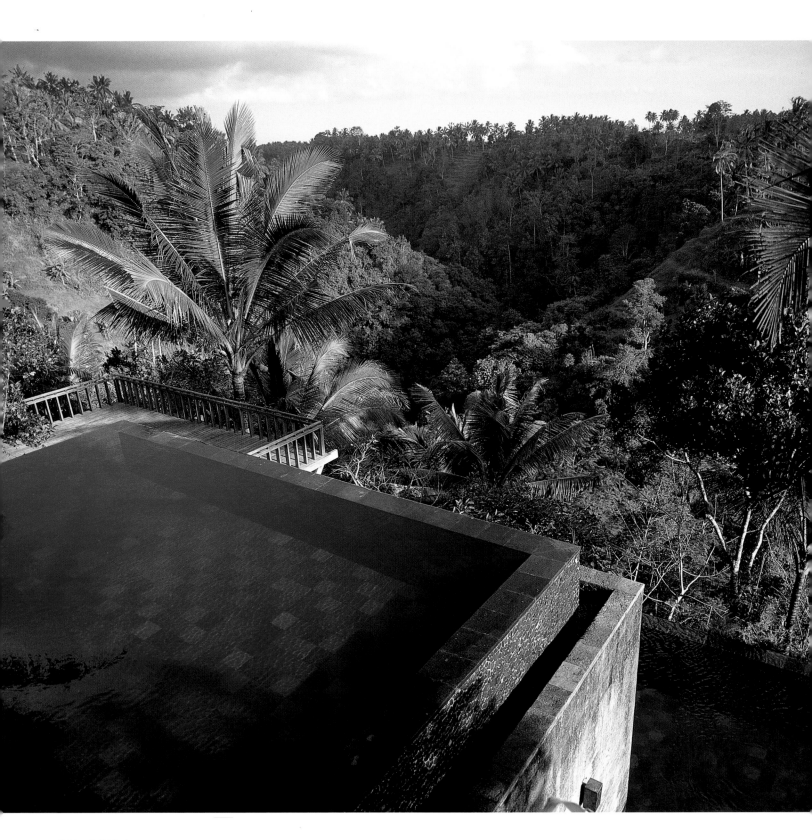

Spring-fed Pools:
A Natural Source

The village of Begawan not far from Ubud is renowned for its three holy springs which are of prime importance in everyday Balinese life. Holy water is necessary for all Hindu ceremonies, and when blessed by a high-caste priest with prayers and floral essences, it is even more sublime. One of Begawan's springs is located in the grounds of the Begawan Giri Estate. This natural spring plays a vital role in both the landscape and in the residences, feeding not only the rock pools in the grounds and the private swimming pools, but also the other impressive water features dotted here and there throughout the villas. In fact, water is not only an essential landscape feature but an integral architectural element in the Estate's overall design.

← The view from the master bedroom of the "Umabona" villa: an upper pool overflows into a lower one ten metres below. The scenario is unrivalled.

↓ Water and jungle are the main players in this breathtaking sunset.

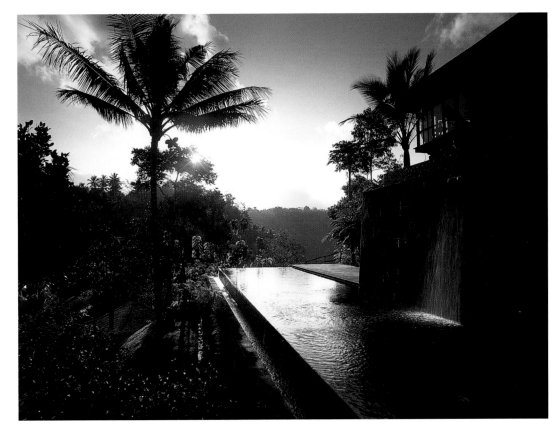

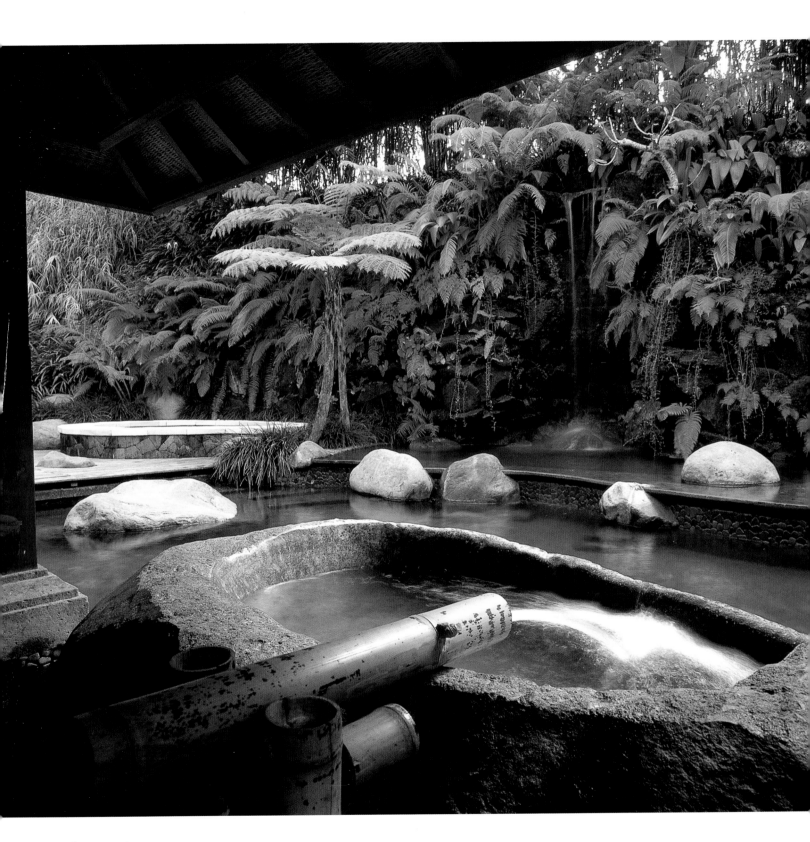

The main living and dining pavilion, in the "Tirta Ening" or "Clear Water" villa, seemingly floats on a vast water garden as in the old Javanese homes. The serenity of a water palace is conveyed here, through the sight and sound of the calming water element everywhere. Water and fire are combined in the "Teja Suara" or "Sound of Fire" residence, while the "Umabona" or "House of the Earth Son" complex comprises several pavilions arranged around an open water-filled courtyard (*see page 154*). From this mysterious hub fresh water overflows firstly to an infinity-edge pool and secondly to another pool ten metres below.

In this villa, as in many other places in this extraordinary compound, water is a true "source" that nurtures the earth as well as the inspiration of its designers. Indeed, many open-to-the-air bathrooms utilize the natural spring, and the resort's spa (the brainchild of Debbie Gardner and aptly named The Source) is housed alongside the spring-fed pools and overlooking the mighty Ayung River.

← ← ← The open-air bathroom in "Tirta Ening" villa. Stunning features include a six-tonne single stone carved bathtub, a jacuzzi set amidst a fresh water garden pool and a waterfall hidden among the ferns.

← ← The minimalistic modern design of this outdoor shower, made of bamboo and stone, has old Japanese inspiration.

← The outside water garden pool of the bathroom is accessed by large natural stepping stones.

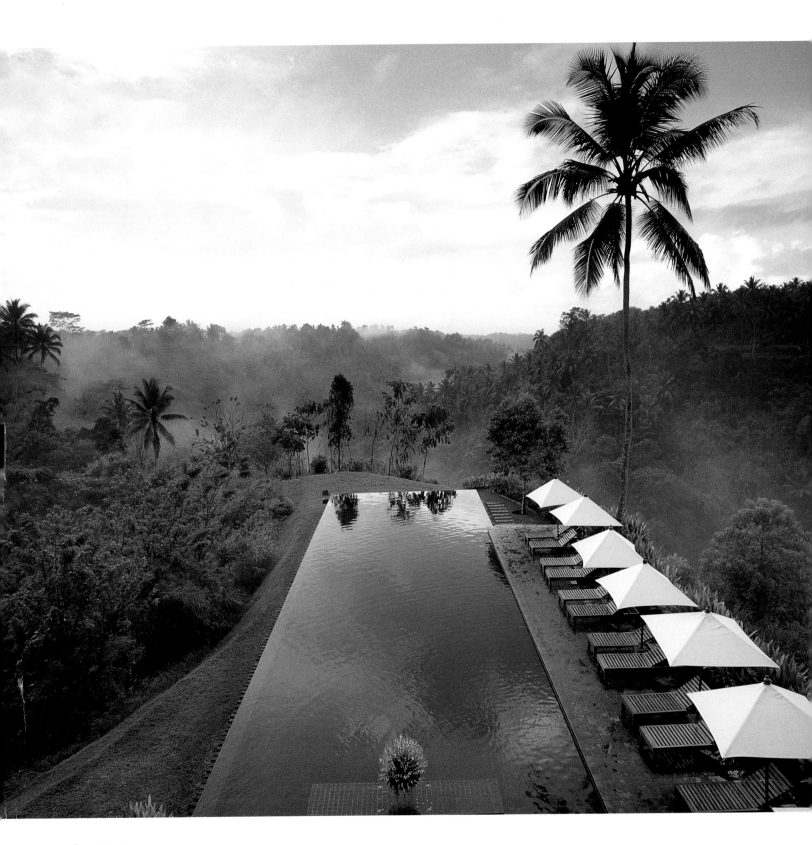

Where Water meets the Horizon

An unspoiled tropical valley provides the unrivalled panorama (*on left*) for this stunning, rectangular swimming pool. The Chedi, set amidst the luxuriant hills outside Ubud, offers you this scenario. The design of the pool reveals the sensibility of the architect, who manages – in the presence of such a powerful natural context – to tone down in an almost minimalistic way the expression of his creativity. The unusual length of a perimetric "free overflow" adds lightness, while the asymmetrical position of a side stone deck gives rhythm to the composition.

At the Legian, on Bali's Legian beach, there is a similar use of an overflow pool and a horizon, but this time the eyes are drawn to an infinite ocean horizon. Sea and swimming pool combine with a subtle interplay of acqua marine and cobalt blue.

← The sheer edges and absence of light-coloured stone give the infinity pool at the Chedi an overall illusion of denseness; in the misty early morning it appears as an abyss below.

→ The Legian pool brings one's eye down to the breakers with this cleverly designed infinity pool. Since the walls of the pool visually meet the waves, it gives the impression of bathing in the sea.

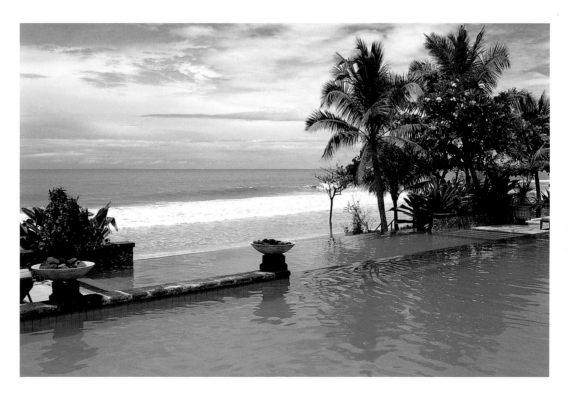

Water, Water Everywhere...

The sound of water is ever-present at Four Seasons Resort Bali at Jimbaran Bay and takes the form of pools, jacuzzis and other assorted water features. The main swimming pool, with its clear azure water and infinity-edge design, has fabulous views over the ocean below. Just beneath this and engulfed by a variety of tropical plants, is a free-form rock pool. It receives the run-off from above in the form of a glorious waterfall backed by a scaling wall with geometric design. Just to one side are cold and hot jacuzzi plunge pools, hidden in a thicket of flame-red *russelia*.

What is perhaps most impressive is that each pool appears to blend seamlessly with the site and its surroundings. Careful attention to detail in the planning has resulted in a series of jungle pools, each designed to give maximum pleasure. Elsewhere in the resort, are a water-lily pond where stepping stones lead to one of the restaurants, a plethora of water-statues and fountains that cool and visually entertain, and private plunge pools in every villa.

→ → Above the Bay of Jimbaran you can spend your days poolside taking in a new view at every glance.

→ A jacuzzi set in a private nook surrounded by the vibrant colours of *russelia* shrubs. The stark shape of a *pandanus* adds texture; this plant withstands sea winds well.

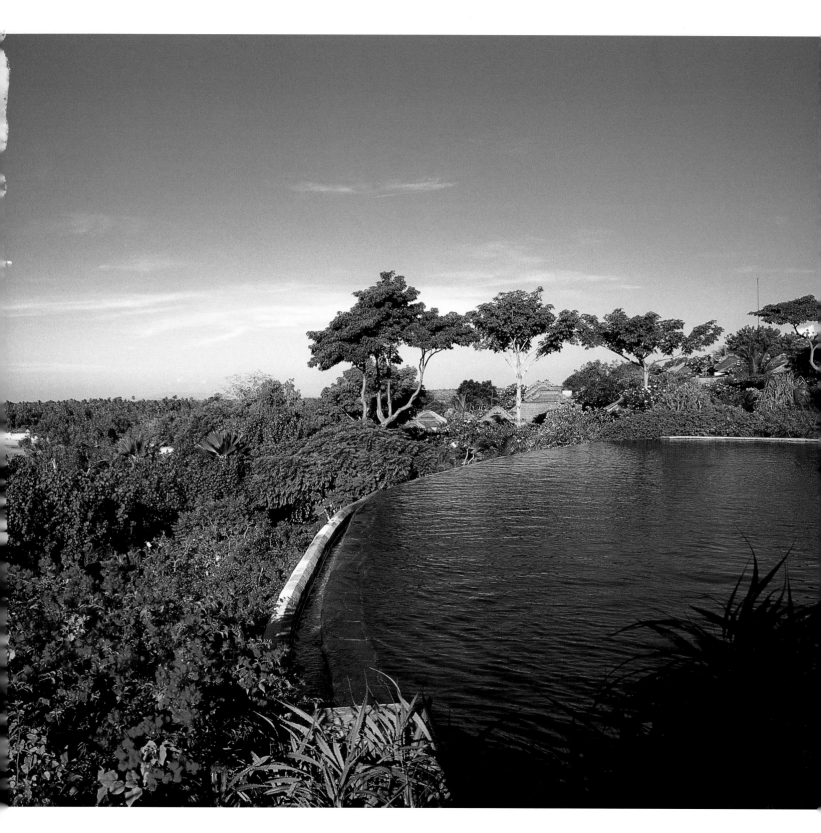

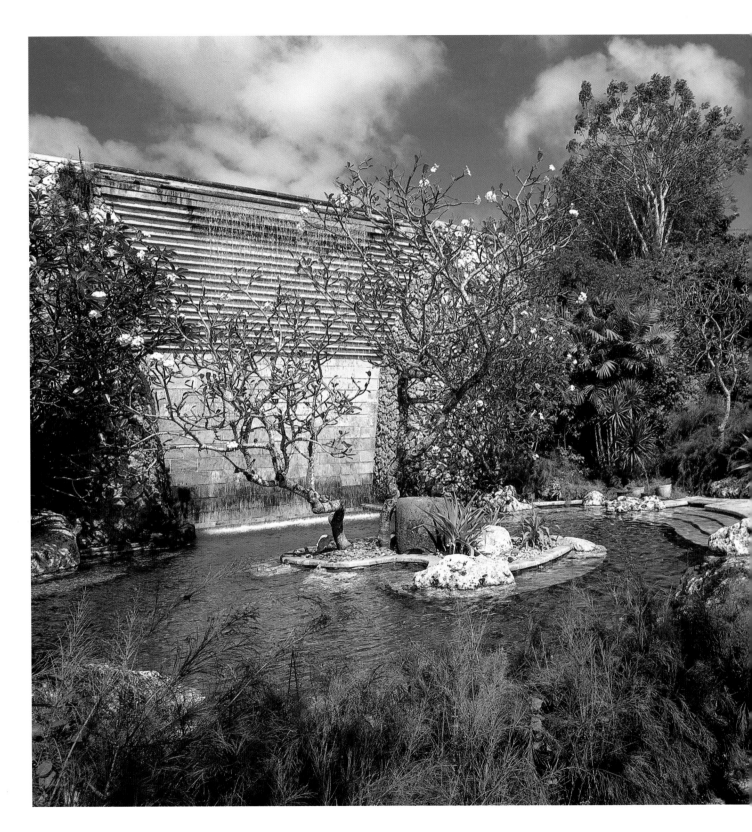

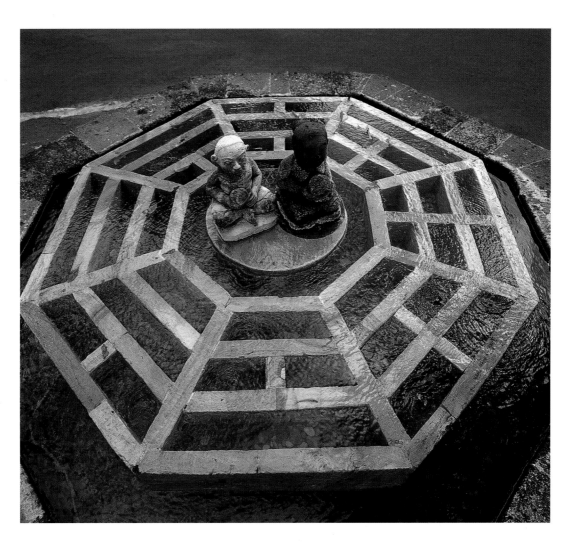

← A free-form rock pool collecting water that cascades down from the main swimming pool above. Indigenous stones are used to create an "island" holding *Plumeria* trees, while the edges are "softened" with *russelia* and *pandanus*.

↑ A stark geometric patterned fountain; the presence of two small statues at centre are a quirky touch.

Poolside Allure

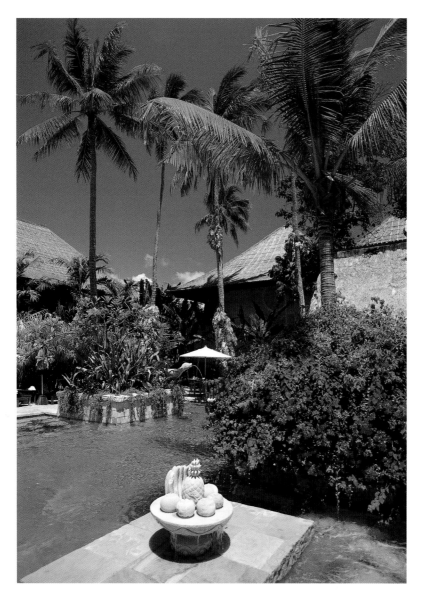

The Novotel Benoa resort is located on the outskirts of Nusa Dua beach, near the fishing village of Tanjung Benoa on Bali's southern coast. The project, in trying to create a Balinese-village atmosphere, emphasizes traditional local materials. The architect Lek Bunnag, of Bangkok's Bunnag Architects, has employed the design concept of a low-rise village, with an extensive use of local crafts, materials and techniques. Thick grass-thatched roofs cover the all-timber traditional structures either in the articulated wide lobby area or in the more simple detached pavilion rooms. Their warm-grey tone interplays with the creamy hue of the *palimanan* stone used throughout the landscaped garden and around the three swimming pools.

The gardens and the three swimming pools were designed by Bangkok-based Bill Bensley Design Group. Paved paths interconnect the many relaxing *balés* (*see pages 146–147*) with the various swimming options and the beach. A touch of whimsy and a strong tropical allure are the hallmarks of the pools which act as the perfect foil to the many free-fantasy carved limestone sculptures situated around them. In fact, a variety of sculpted artefacts and statues are placed at every corner of the grounds as well as alongside the pools or even inside the water. Be they a line of gargoyles, a stone bowl of fruit, or a lounging figure, they are attractive features that both amuse and surprise.

↑ Several areas of this pool are shaded by planters located inside the water; this feature adds a fragrant new twist.

→ Built-in-the-pool lounge chairs carved of stone are accented by fountain heads; shady *balés* provide other relaxing options.

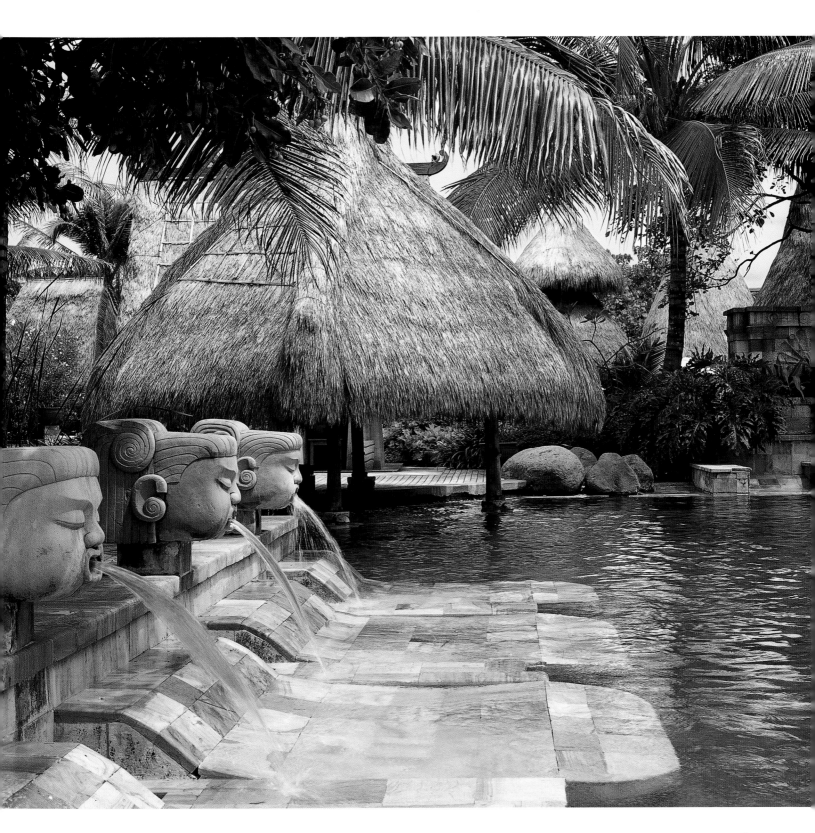

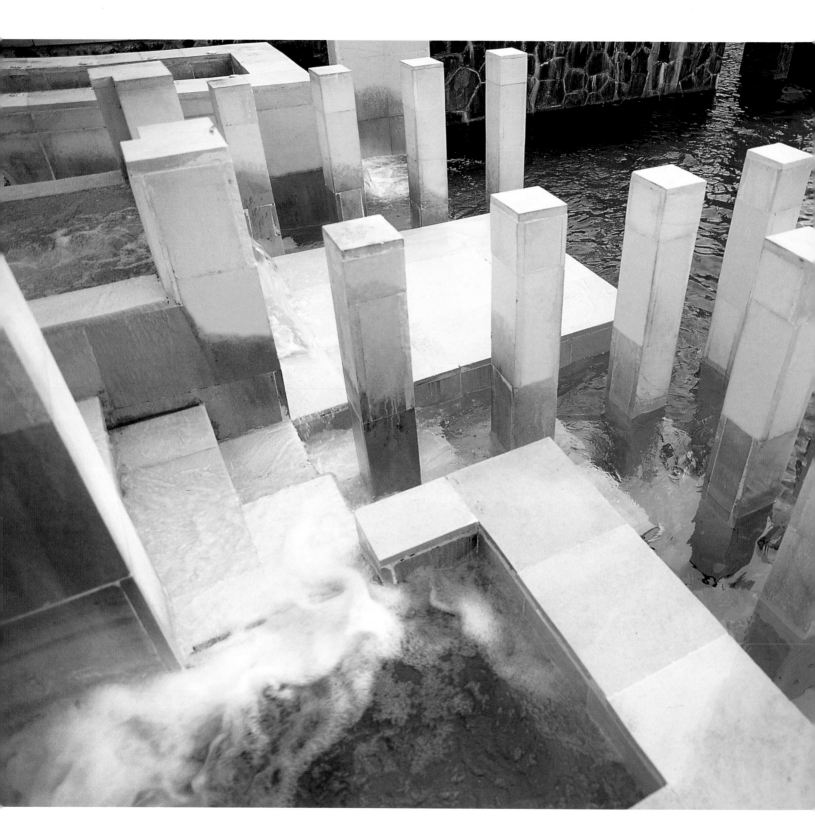

Rock 'n' Water

A 3,750 square-metre (12,000 sq-ft), lagoon-like, free-form swimming pool complete with sand island, and just 30 metres (100 ft) from Kuta beach! We are in the Hard Rock Resort, where the entire pool-cabana club area has been raised 2.5 metres (8 ft) to conceal the road along the beach front, thereby creating an illusory connection with Kuta beach just beyond. The sand island in the middle of the pool is the entertainment heart of the outdoor area of the resort. As well as serving as a wet bar, it is a stage for dance and musical performances and for volley ball matches. You can idly laze by the pool, enjoy the privacy of one of the cabanas, play in the spa-fountain sculpture or throw yourself into any of the many organized aquatic activities (water aerobics, water volley ball or beach soccer). Even the kids have their crèche, play pool and sand garden.

← A modernistic spa-fountain sculpture features columns of white stone around solid, square jacuzzi pools.

↓ When the afternoon's limbo-dancing gives way to cocktails and the "sunset dance" you cannot but agree with the publicity philosophy of the Hard Rock Hotel: "...the resort demands enjoyment from all who pass its portals: it transcends age, gender and race."

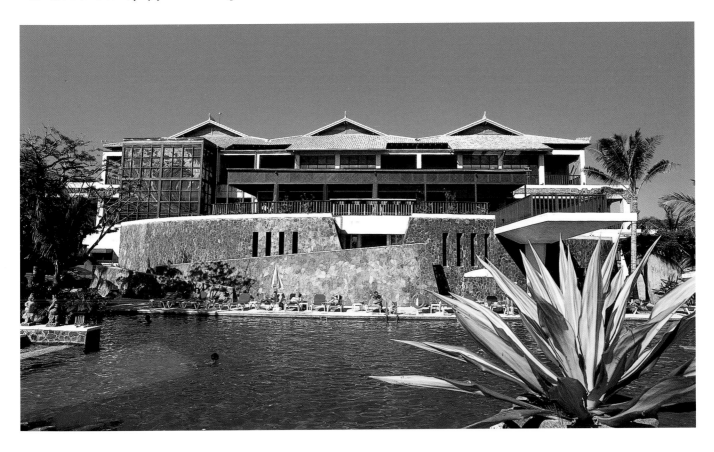

← The colourful tubes of the water slides twist and turn through the garden and coconut groves, and propel you down to your final destination.

→ For the daredevil, the Macaroni tube rises 16 metres (50 ft) above the ground. It is supported by an intricate scaffolding of indigenous lumber and is surrounded by tropical vegetation.

↓ At the end of the Race Track waterslide, the Lazy River catches you and meanders slowly through the manicured tropical gardens of the park.

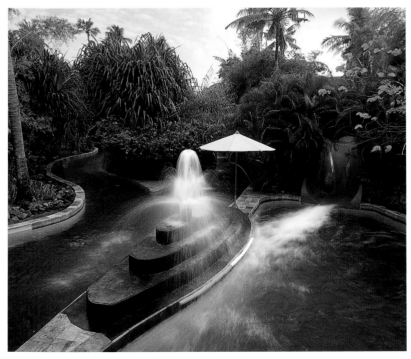

Acquatic Excitement

Located in the heart of Kuta, within 3.5 hectares of landscaped gardens, Waterbom is a unique fun-filled facility on the island. The park offers an amazing range of aquatic features, including eight waterslides each designed to carefully blend in with the landscaped tropical grounds. In total, there are 1,000 metres (3,300 ft) of rides providing thrills, spills and adventure for children (and adults!) of all ages. For the less adventurous, there is the winding Lazy River, which allows you to relax while floating through jungle-simulated surroundings. Another great way to cool off is under the *balé* of the sunken splash bar in the main pool. And daredevils may launch themselves off the higher slides. For sports enthusiasts there are games of waterpolo and the youngsters have their own own kiddie park with three slides and a swimming pool.

Water at every Turn

Water, at Four Seasons Resort Bali at Sayan, just outside Ubud, is not just an important natural complementary feature of the landscape; it is a real irreplaceable architectural element that provides cohesiveness and poetry to the whole project.

At the entrance, a striking teak and painted steel footbridge spans a steep waterway. This, in turn, leads to a spectacular elliptical 850-square-metre (2,800 sq ft) lotus pond that forms the roof of the main three-storey complex and gives the impression of floating flying saucer-like in mid air. From the lobby one descends to cavernous angled hallways, where the suites are located. These are all lined by massive, inclined rubble walls with underground rivers; endless, dark, glassy pools curve and step down around the temple-like walls. Descend even lower to discover private villas with lily ponds on the roofs, each sunken amidst the rice field and tropical garden; then finally, through rice paddy terraces to a double-level paddy-field shaped pool, dramatically fringed by the roaring rapids of the Ayung River. It is truly an architectural water theme taken to its ultimate conclusion!

→ → A deep perspective of the hallway leading to the rooms showing the massive inclined stone walls that flow into dark glossy pools.

→ A close-up detail of this unique glazed terracotta composition which acts as a fountain.

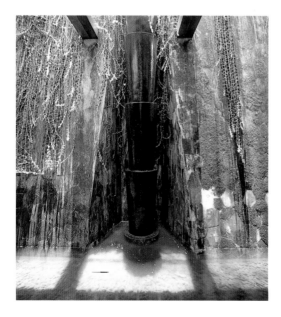

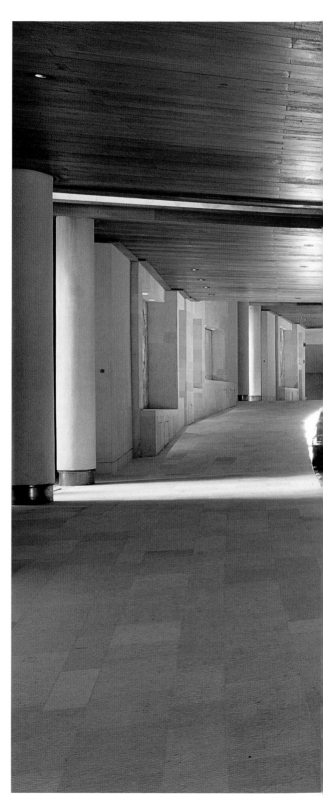

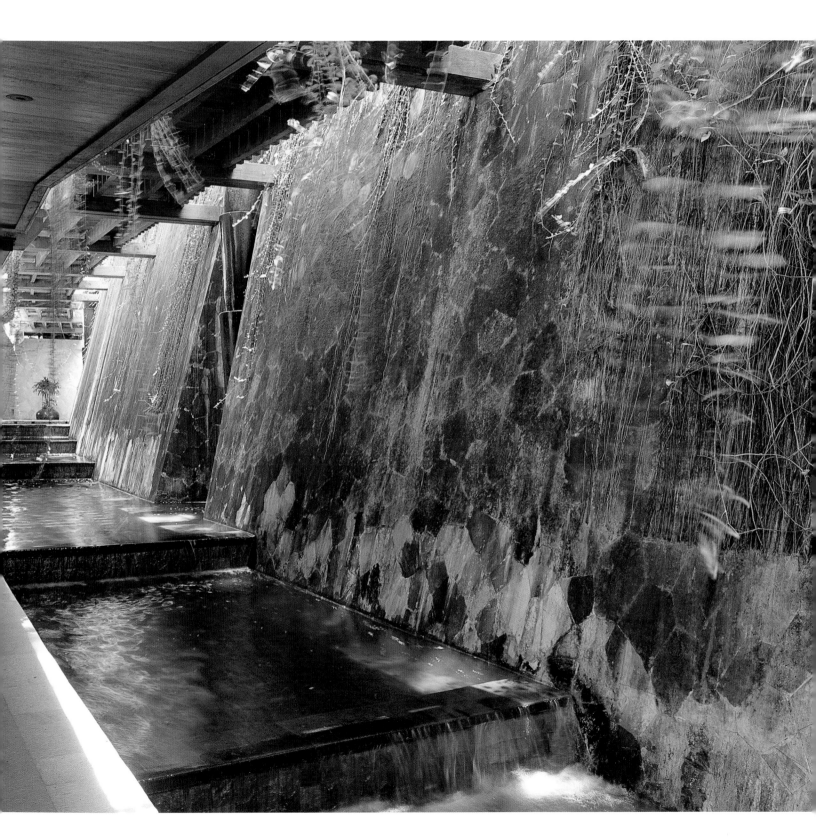

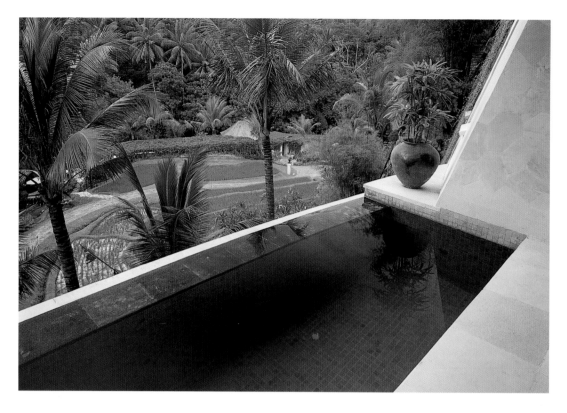

← From the relaxing waters of the razor-thin edged spa pool, you can enjoy the wild beauty of the tropical flora below.

↙ One of the private villa's flat roofs complete with lily pond and a distant view of the rice paddy terraces.

→ Overlooking the rushing waters of the Ayung River, the infinity-edge bi-level pool with its swirling free-form lines. Their abstract modern design amazingly merges with the raw green energy of the jungle.

Overleaf: A massive lily and lotus pond covers the entire roof of the resort. One accesses the resort from this point via a walk-way bridge; the descent from here is down a spiral staircase to the lobby and restaurants below.

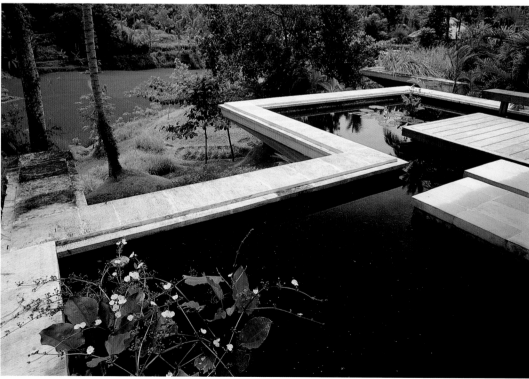

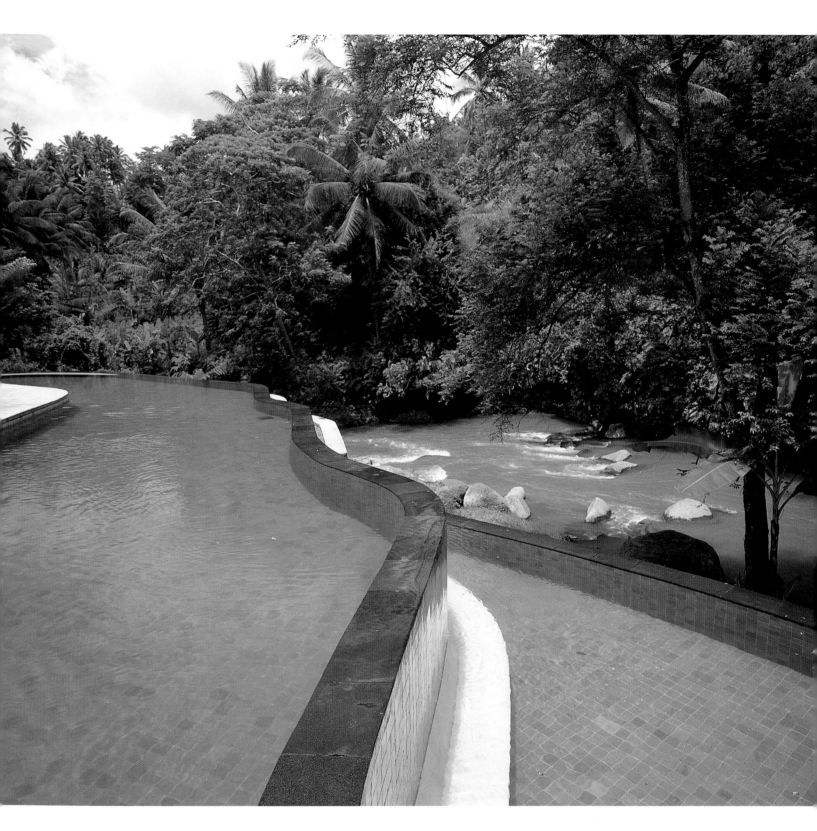

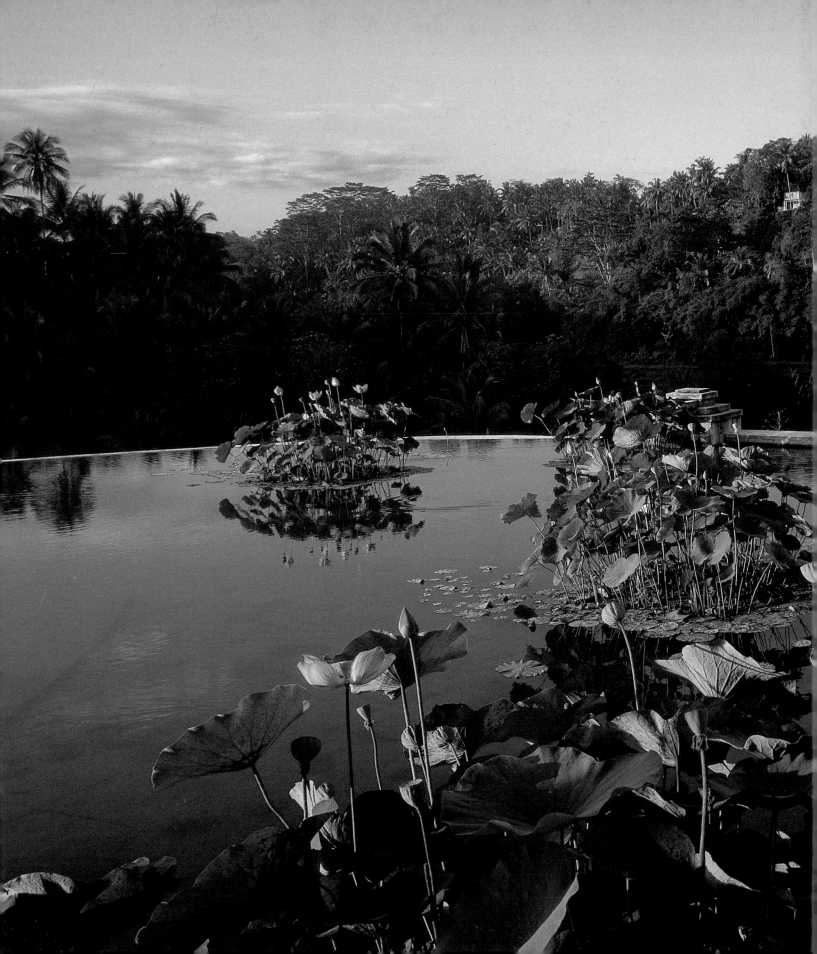

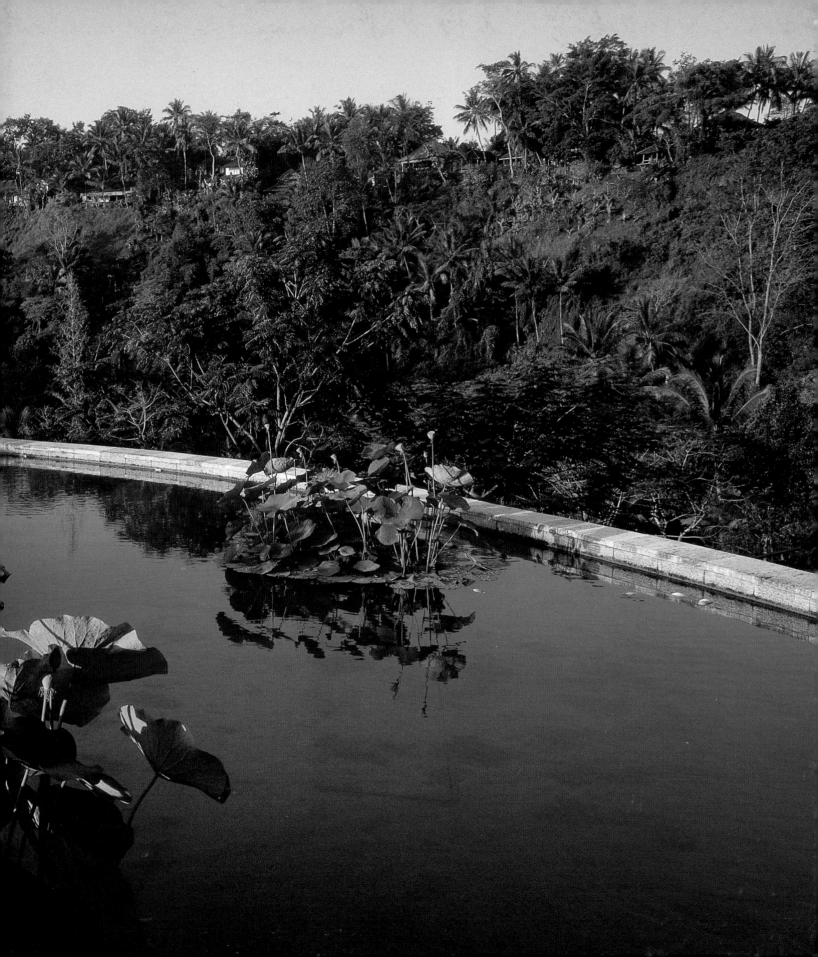

Glossary

adat	Balinese traditional, religious and social laws and regulations
alang-alang	Type of grass used for thatching
aling aling	Screening wall, located at the entrance of the traditional house compound
Asta Kosala Kosali	Book containing the principles of Balinese building
balé	An open pavilion – usually refers to an open structure within a house compound
banjar	A village ward; a social and political community within the village
barong	A mythical beast of great magic power
batu Singaraja	Black volcanic stone from north of Bali
batu Jogia	Ivory soft stone from Java
bedeg	A woven bamboo mat
bengkerai	Tropical local wood
gamelan	A general word for any of the many types of Balinese orchestra
garuda	The eagle-like vehicle of Wisnu, often the subject of traditional wood carvings
grobok	Javanese trunk on wheels
Gunung Agung	The highest mountain in central Bali
lopo	A cone-shaped granary of the Atoni people in Timor
lumbung	Traditional Balinese rice barn
mandi	Bath; take a bath
merbau	A reddish tropical wood used for flooring
palimanan	A type of ivory-coloured compact stone from Java often used for flooring
paras	Volcanic ash sandstone used for any kind of Balinese stone carvings. It is the most common material available in Bali and can be found in many different earthy tones
prada	Fine sheets of gold pressed into leaves used to apply on surfaces for traditional decorative purposes
wonosari	White ivory stone from Java

Note from the Author

Completing this book within a relatively short timeframe has been an arduous task for me. Without the help of the people below it would not have been possible. I would like to extend my gratitude to the following:

To all the people who lent us their houses, shops, restaurants and beautiful interiors for photography. Also a special thank you to the staff and owners of the hotels and resorts included in the book.

To Martina Urbas for working as my assistant during this project. Her commitment was precious during the crucial moments of the preparation of the book.

To Kate Moloney and to Dionne Christianne for their contributions to prepare the literary issues of the book.

To Pino Confessa, the Honorary Vice Consul of Italy in Bali, for his help and support.

To Mary Rossi, for all her assistance.

A special thank you to my editor Kim Inglis for her continuous and patient support in every stage of the layout and compilation of the book.

The collaboration with my good friend Luca was a great experience for me.